*Normal and Anomalous
Representational Drawing Ability
in Children*

# Normal and Anomalous Representational Drawing Ability in Children

## L. Selfe

Education Department
County Psychological Service
Hereford, UK

1983

 ACADEMIC PRESS

*A Subsidiary of Harcourt Brace Jovanovich, Publishers*

LONDON · NEW YORK
PARIS · SAN DIEGO · SAN FRANCISCO
SÃO PAULO · SYDNEY · TOKYO · TORONTO

ACADEMIC PRESS INC. (LONDON) LTD.
24/28 Oval Road
London NW1

United States edition published by
ACADEMIC PRESS INC.
111 Fifth Avenue
New York, New York 10003

British Library Cataloguing in Publication Data

Selfe, Lorna
    Normal and anomalous representational drawing
    ability in children.
    1. Autism        2. Children as artists
    3. Art and mental illness
    I. Title
    155.4,5,4        RJ506.A9

    ISBN 0-12-635760-9

Phototypeset by Dobbie Typesetting Service, Plymouth, Devon
and printed by Fletcher & Son Ltd, Norwich

# Preface

This book is the result of many years of part-time research into the development of representational drawing in children. An interest in the area was originally aroused by the discovery of a single case; Nadia was a severely retarded autistic child of six years of age but she had a remarkable representational drawing ability. (Nadia — A Case of Extraordinary Drawing Ability in an Autistic Child; Academic Press, 1977).

There is a considerable corpus of research that has established that representational drawing shows an age-related, systematic development. Certain identifiable features of children's drawings are assumed to correlate with their general cognitive development (Harris, 1963; Freeman, 1980). Normal children's representational drawing is generally described as symbolic and schematic between 4 and 9 years of age, with a gradual development towards more realistic representations.

The book therefore begins by a critical discussion of general theories of representation in children's graphic productions and then reviews studies of the development of certain representational devices which children in Western cultures adopt in the acquisition of more realistic representations. The first half of the book is concerned with the development of representational drawing in normal children.

Following from a systematic search, further cases of exceptional drawing competence in association with severe cognitive and intellectual deficit were found. A systematic attempt to describe and elucidate common characteristics of these children was undertaken. It was found that all the subjects had or had had delayed and deviant language development and all the subjects were autistic using Rutter's (1978) and Newson's (1977) criteria.

The drawings of this autistic group of children differed from normal children's drawings, in particular in their ability to depict aspects of photographic realism from an early age. Four specific devices required to depict photographic realism were isolated. These were: the depiction of realistic proportions within objects; depiction of further dimensions other than flat elevations; depiction of diminishing size with distance; and the depiction of hidden line elimination. A number of experimental studies confirmed that, in normal children's drawings, the production of these devices show age-related trends and, furthermore it was difficult to promote substantial changes in the direction of the production of photographic realism, at least using the methods employed.

The concluding chapter of the book is concerned with examining possible explanations for the highly anomalous representational drawing of this autistic group. A hypothesis based on Paivio's (1971) model of spatial and verbal modes of thinking is proposed and critically examined.

I am deeply indebted to many people for their help in producing this book. In the first place I am grateful to all the parents and children who took part in the research. Elizabeth and John Newson provided not only professional supervision, but much more in terms of inspiration and guidance. Trevor Jellis gave me unstinting support for the time to conduct research as part of my professional work. I acknowledge the generous support of the Medical Research Council in funding part of this research in the form of a one-year Training Fellowship. I am also grateful to Hereford and Worcester County Council for their help with this project. The following schools helped me with data collection: Dilwyn Primary School, Kingsland V.C. School, Kington Primary School, Leominster Infants School, Leominster Junior School, Trinity Primary School (Hereford), Weobley Primary School and Wigmore Primary School. I would like to thank staff and children in these schools. I should also like to thank Zena Matthews and Hilda Pink for typing the manuscript. Finally, to my husband Paul, to my parents and many good friends who gave constant encouragement, my love and gratitude.

Hereford                                                    Lorna Selfe
January 1983

# *Contents*

Preface  v

*Chapter 1*
Introduction: History and Overview of the Study  1

*Chapter 2*
A Review of Some of the Theoretical Approaches
to Children's Drawings  9

*Chapter 3*
An Alternative Approach to the Study of Children's Drawings  24

*Chapter 4*
The Development of the Representation of
Depth in Children's Drawings  45

*Chapter 5*
An Experimental Examination of the Development of the
Representation of Photographic Realism in Children's Drawings  30

*Chapter 6*
Final Comments and Conclusions to the Previous Studies  78

*Chapter 7*
Anomalous Graphic Representational Drawing Ability  88

*Chapter 8*
General Results of the Questionnaire on
General Cognitive Development                                      139

*Chapter 9*
Results of the Questionnaire on Drawing Behaviour                  163

*Chapter 10*
Standardized Tests of Intellectual Functioning                    170

*Chapter 11*
Conclusions                                                       199

Appendix I                                                        205
Appendix II                                                       211
References                                                        241
Index                                                             249

# 1

# Introduction: History of the Project and Overview of the Study

The assumption that children's drawings relate to their general cognitive or intellectual development is universal. The presumed relationship is so well established and entrenched that in the last fifteen years there have been no studies undertaken that have thought it necessary to challenge or even reconsider this basic relationship.

Many of the standard tests of intelligence, for example, contain an item where the child is required to draw, and his competence at drawing tasks has been shown to correlate with his abilities on a range of other intellectual skills (Harris, 1963). In fact, the correlation between drawing ability and general intellectual maturity is so trusted that one I.Q. test, Goodenough's Draw-a-Man Test (1923), is based solely on the child's drawing ability. This test is widely used by educationalists and by developmental psychologists.

This book sets out with the broad intention of exploring this relationship and in challenging the assumption that such a relationship is universal. The project directly derives from an earlier study made by the author of a single child with exceptional and anomalous drawing competence (Selfe, 1977). This child, Nadia, was six years old when her mother referred her to the Child Development Research Unit in the University of Nottingham. Nadia had failed to develop any spoken language and it became apparent that her developmental patterns closely followed the autistic syndrome. Nadia was born in Nottingham to Ukranian *émigré* parents in 1967. She was the second-born child in a family of three children. The development of the other two children was proceeding normally and they were bilingual.

Nadia failed to develop language properly and the few words she had at the age of 9 months disappeared. When the author worked with Nadia, from March to September 1974, she had an extremely limited vocabulary of some ten single-word utterances heard over the entire period. At this time she attended a local school for severely subnormal children. The overriding impression of Nadia was one of lethargy and impassivity. She was very clumsy, poorly co-ordinated and excessively slow in her movements. She did not respond to questions or commands. It was extremely difficult to know whether she did not comprehend or whether she was refusing to co-operate.

1

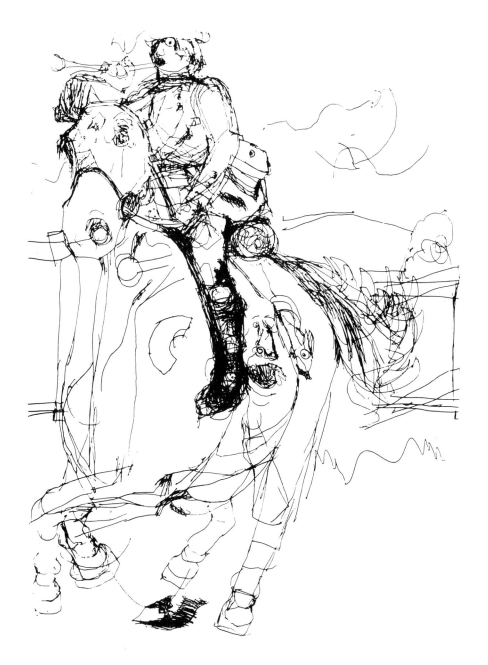

*Fig. 1.* Drawn by Nadia at five and a half years of age.

At three and a half years of age, Nadia suddenly displayed an extraordinary drawing ability which was marked from the outset by outstanding manual dexterity sadly absent in all other areas of functioning. Her drawings were remarkable for their quality of photographic realism. The drawings were in perspective. Proportions between and within elements were accurate. She used occlusion or hidden line elimination. The whole production was not only highly photographically realistic, but also gave the adult viewer the impression of movement and vitality. The drawings were totally different from those normally produced by children of this age, and such competence is therefore described as ''anomalous'' to distinguish it from either accelerated or talented drawing ability.

The author witnessed Nadia drawing on many occasions, although she would not draw to request. Her drawings were not copied from pictures but drawn entirely from memory, although on rare occasions she also drew from life. Generally, the inspirations for the drawings came from a child's picture book in which the quality of the drawing was often rather crude. She studied the picture with great attention several weeks before she executed a similar drawing. However, her drawings showed many changes and embellishments from the original. She could present the subject at a new angle and any form of simple imaging or eidetic memory as an explanation for her ability was therefore regarded with caution.

The author undertook an investigation of this child. She was tested on a battery of standard assessment procedures. However, as she lacked language and her behaviour was autistic, it was extremely difficult to test her. The test results were, therefore, only an indication of her abilities. The tests revealed profound deficits with language, with both comprehension and verbal expression. She also appeared to lack many of the prerequisites for language development. She did not imitate. She could repeat monosyllables, but not two syllables. She was never seen to engage in symbolic play.

Her gross motor development was very poor. She could not hop, nor walk up stairs one step at a time. Her fine motor control was also surprisingly deficient, in view of her drawing ability. For example, she could not do up buckles or use a knife and fork together. However, on some visual matching tasks she passed items at her own age level.

Using non-standardized tests, it was discovered that although Nadia could match difficult items with the same perceptual qualities, she failed to match items in the same conceptual class. For example, she could match a picture of an object to a picture of its silhouette, but she failed to match pictures of an armchair and a deck-chair.

In searching for theories and explanations for this phenomenon, several tentative hypotheses were examined by the author. Physiological theories of the cerebral lateralization of functions were considered. The graphic replication of eidetic images was discussed; the importance of symbolization and concept formation in governing pictorial productions in normal children was briefly examined. Finally, the role of language in mediating the drawing process was investigated, but no systematic explanation was forthcoming.

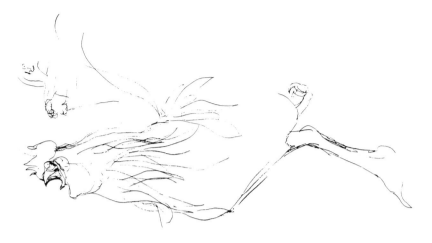

Fig. 3. Nadia's memory copy.

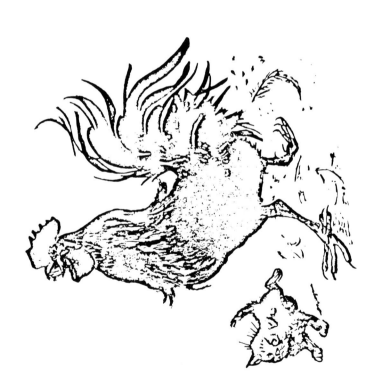

Fig. 2. Illustration from a child's picture book.

Since the publication of the case, several other psychologists and commentators have discussed its implications. Gregory (1977), reviewing the case, suggests that Nadia has "an entirely unusual cognitive development". Dinnage (1977) entertained Bettelheim's suggestion that autism is caused by an "emotional retreat" due to adverse experiences in early infancy. (The author wholly disagrees with this view of autism.) Dinnage proposes that Nadia "may have channelled her frozen intelligence into drawing". Pariser (1979) and Arnheim (1980) speculate on the possibility that Nadia's ability to represent photographic realism in her drawings was due to her inability to conceptualize the subjects which she drew. This, in essence, is close to the author's own position. There have been other speculations which have been totally misguided, Dennis (1978), for example, gives the impression that Nadia is a highly gifted genius who is an elective mute. The desire for some sort of satisfactory explanation for this phenomenon has been the sustaining interest behind this current study.

Another result of the publication of this case was that a number of parents contacted the author and the Directors of the Child Development Research Unit in Nottingham claiming that their child had exceptional graphic competence. Through close correspondence, one or two such cases were isolated as really exceptional or anomalous. It was therefore discovered that although this phenomenon of exceptional graphic competence and severe retardation is extremely rare, it was not solely confined to the case of Nadia. It was therefore decided that if a sample of such children could be identified, then stable features and characteristics of the phenomenon could be elucidated and described. Confirmation of the need for such studies was provided by Paivio (1971, p.483) in his discussion of the role of imagery and verbal processes in cognition.

> . . . Examples of more general exaggerated symbolic habits occur among calculating progidies, mnemonists and other varieties of persons possessing unusual ability for particular mental tasks, often while remaining otherwise average or even below average intellectually. Such instances are of extraordinary interest here because the manifestation of modes of thought are thrown into relief, providing an unusual opportunity for the examination of their nature and functions. Unfortunately, while much has been written about such individuals, the descriptions are often based on anecdote and uncontrolled observations and hence do not provide useful scientific information.

The first stage of the project was to identify those very rare cases of exceptional and anomalous drawing competence that it was now expected existed. Advertisements were placed in several newspapers and in educational publications. The wording of the advertisement was designed to include all children of exceptional competence, but not to exclude handicapped or retarded children whose parents may have felt that such cases would be automatically excluded. The advertisement read as follows:

> YOUNG ARTISTS—I wonder whether any of your readers could help me with some research I am undertaking. I am trying to locate children who have shown exceptional drawing ability at an early age.

So far my research suggests that there may be a group of children with remarkable ability who have also had learning difficulties and I am particularly interested in these children. However, I would be pleased to hear about any child who shows or has shown this ability. I would be grateful to receive any details of these children, preferably with one or two examples of their drawings and the child's age when these were drawn.

All letters will be acknowledged and the drawings returned in due course.

The advertisement brought forth several hundred replies together with offers from large organizations (such as the B.B.C.) to examine the art work of children in exhibitions and collections. The author has therefore had access to many thousands of drawings by children under the age of 10 years. These examples already represent a selected sample and it can reasonably be assumed that many of the drawings were chosen because of their unusually high competence. A large number of the drawings showed accelerated development of representational ability, associated with a high level of intelligence (as described by Lark Horowitz *et al.*, 1967), that is, representational drawing at a level two to three years above the child's chronological age. One or two of these gifted children showed remarkable talent, although their ability was not anomalous in terms of the portrayal of photographic realism, but showed accelerated development. In one case, which appeared to be outstanding, it was later discovered that all the child's drawings had been traced or meticulously copied from other pictures.

On the subject of giftedness, the very early, childhood drawings of the great artistic masters have only rarely survived, and when such drawings have been preserved it is probably because the drawings showed remarkable talent. Nevertheless, the childhood drawings of the great masters that have survived often do not show precocity or outstanding representational skill. Artistic talent appears to flower in the teens and even later. Picasso's adolescent drawings survive and are remarkably accomplished, but there appear to be no examples of his early childhood drawings. Berwick and Millais showed remarkable ability in childhood and their drawings survived. Giotto too is described as having remarkable facility before the age of 10 years in Vasari's "Lives of the Artists" (Bull, 1965). In these three cases it would appear that the childhood ability displayed lay in the slavish copying from life or from other drawings. Also these artists were obviously of at least average intelligence and none, as far as is known, showed the ability to draw objects from memory that Nadia had shown, at such a young age.

From all the drawings available, together with the age when the drawing was executed, the author and two independent judges were able to select a very small number of children whose drawings were truly anomalous and showed major departures from the norms of the development of representational drawing. These children exhibited a high degree of photographic realism in their drawings before the age of eight years. Representational development was defined in terms of photographic realism and included the reasonably accurate depiction of linear perspective and evidence of the use of drawing devices (proportions; dimensions; diminishing size with distance and

occlusion). Moreover, parents' confirmation that such drawings had not been traced or copied from other pictures was obtained. Four children were isolated in this manner.

Although much of the work examined was that of gifted and normal children, it was later confirmed that all the children with really exceptional pictorial competence had severe learning difficulties and, specifically, retarded language development.

Following from this initial identification and this unusual and highly suggestive finding that children with very exceptional drawing competence, in terms of the depiction of photographic realism, had severe learning and language difficulties, it was decided to attempt further measures to identify other such children.

(1) All the schools for children with learning difficulties (E.S.N.(M) and E.S.N.(S)) in one large county were approached. No further children were identified.

(2) All the hospitals for severely subnormal children in the West Midlands Area Health Authority were approached. No further children were found.

(3) All the schools and units for autistic children in the country were contacted and, apart from those children who had already been identified, several more cases were discovered.

In all, eleven children with anomalous development of graphic representational ability were identified. Most of these children were receiving special education; some in schools for the severely subnormal, but most in schools for autistic children. Two of the children in the group were in normal education, although one is diagnosed as autistic and the other child has a history of severe language retardation and of general learning difficulties and he is kept under regular review by the Schools Psychological Service in his area. The drawings of six children will be presented in this book.

The syndrome of exceptional drawing competence in association with intellectual retardation, general or specific in nature, and particularly in the area of language, has not been thoroughly investigated hitherto. In fact, apart from the author's previous study, together with a paper by Morishima and Brown (1976), exceptional drawing competence as a feature of "autistic savant" has not been investigated. Since 1977, the case of Nadia has been discussed widely but no further cases have been described. However, the author has received further confirmation that such cases do exist (personal communications — Harris and parents of a child in Australia; again, the two cases described by Harris were both autistic children and the child in Australia had had early infant meningitis and is severely intellectually retarded).

In the 1920s and 1930s a number of cases of idiot savant or autistic savant were reported in the psychological literature (these have been reviewed by the author elsewhere, Selfe, 1977). But the phenomenon of exceptional graphic competence was not described. Individuals with mathematical ability, calculating prodigies and unusual powers of memory were regularly reported. In more recent years such studies have been few and far between, with the notable exception of Luria's studies of S (1968).

Studies of unusual or unique individuals have long been in the traditions of science. Gregory (1963) undertook the study of a man whose sight was restored after an operation to remove cataracts following Senden's studies of such individuals (1932). Studies in medicine of abnormal conditions are frequent, if not regular, and add to the understanding of normal biological functioning. Studies of the abnormal give insights into the study of normal processes in human beings since abnormal process or behaviour must also be accounted for in any universal theory of cognition or human development, physical and psychological. Anomalous conditions provide clues to normal functioning; for example, the investigation into the biochemical causes of schizophrenia is making an important contribution to the understanding of normal brain chemistry. The major part of this thesis is therefore concerned with the description and discussion of the individuals with anomalous graphic competence. The implications of the existence of such individuals with such pictorial competence for theories of verbal and perceptual processes is also discussed throughout the work.

The book begins, however, with a review of the normal development of graphic competence in children and a consideration of the theoretical models proposed or assumed by other authors. The next chapter offers a theoretical approach which proposes an interactionist model of perception and representation, and which tentatively offers an account of the anomalous development of graphic representational skills.

The drawings of the children with anomalous development are characterized by the accurate portrayal of depth, space and perspective; or photographic realism, at a very early age. The following chapters are therefore concerned with the normal development of the representation of photographic realism between 5 years and 10 years of age. Since the existing literature is neither thorough nor substantial on this area, several exploratory experiments on normal development were undertaken by the author and these are described.

Finally, the development of graphic competence in a number of different child populations is briefly reviewed and the results of the investigations of the anomalous group are thoroughly described. The concluding sections attempt to synthesize some of the trains of argument pursued in earlier chapters and the implications of the study are discussed.

## 2

# A Review of Some of the Theoretical Approaches to Children's Drawings

This book is in the field of experimental and clinical psychology and will have little to say about approaches to child art other than those adopted by psychologists. There is a large corpus of work on the emotional and expressive aspects of children's drawings, particularly from psychoanalytical sources. Machover (1949), for example gives a comprehensive interpretation of pathological personality characteristics from the drawings of adults and adolescents. Kellogg (1970) traces the development of drawing in children using a psychoanalytical model, while Stokes (1972) takes a directly Freudian view of the whole field of art and artistic expression.

There are also contributions from the field of art education. Lowenfeld (1957), for example, stressed the role of the expressive arts in general development and, in particular, in the proper social and emotional adjustment of the child. (A useful review of the whole field of art education is undertaken in a collection of papers edited by Pappas, 1970.) Eisner (1977) is arguably currently the most influential writer in the field, although most present day writers in art education acknowledge their debt to Lowenfeld. Art critics and art historians such as Wollheim (1977), Gombrich (1960) and Panofsky (1955) have little to say about children's drawings or child art, but their ideas are very influential and their work is regularly quoted by psychologists. Lastly, but of crucial importance, philosophers, and particularly those concerned with aesthetics, have a vital role in guiding our conceptual perspective. Langer (1949; 1953), for example, has developed a seminal model of the arts as a symbolic expression of human experience.

Each field has a contribution to make to our understanding of the complexity and multi-dimensionality of children's drawing. Experimental psychologists obviously do not have a monopoly here and, in fact, their contribution may prove to be a minor one. They generally have little to say about the emotional, expressive and motivational aspects of children's drawings. Similarly, empirical psychology has little to offer, as yet, to teaching or therapy using drawing. Freeman (1980) makes a token attempt to draw out some practical implications of his experimental work for teaching but this is cursory in the extreme. His sole practical tip for remedial work in drawing is:

9

> it now seems a safe bet that if one is trying to teach a child to grasp a new design which involves the use of acute angles, he should be encouraged to start with one of a vertical base line if there are no compelling reasons against that. (p.352)

Most experimental psychologists in the field acknowledge that "behaviourist psychology is inadequate to treat fully the phenomenon of art" (Harris, 1963). It is clear that the emotional development of the child cannot be excluded from a discussion of intellectual development since the two are intimately related. Aspects of emotional and expressive development will, however, be discussed in connection with Langer's theories of art and symbolization. The relative importance of these aspects is therefore fully acknowledged, but the principal interest of this book on children's drawing is concerned with how their drawings relate to their conceptual and intellectual development.

In this chapter it is proposed to outline some of the major theoretical approaches to the study of children's drawing. There are a large number of studies of this area in the literature of experimental psychology. However, a small number of authors have dominated the field and it is proposed to consider theoretical approaches by reference to these major contributors. These authors are representative of theoretical approaches and the majority of researchers take their model from one (or other) of them.

## I. DRAWING AS A DEVELOPMENTAL SEQUENCE

Lark Horowitz *et al.* (1967) claim that there is a great deal of evidence that most children progress through comparable stages of development in their drawing and that this progress is sequential so that, broadly speaking, later developments can only be reached by way of earlier ones. Moreover, they claim that the child art of non-Western cultures shows characteristics essentially similar to the child art of Western cultures. They go on to assert that the course of development in drawing therefore appears to be universal (although Deregowski (1980) would certainly dispute and seek to qualify this). Nevertheless, one of the strongest and widely held assumptions about children's drawings is that there is a sequential development which reflects general intellectual and conceptual development. A broad parallelism is seen to exist between the child's drawing development and the development of his speech, his formation of concepts and, indeed, his thinking.

Descriptions of the developmental stages of children's drawing appeared to reach fruition between 1910 and 1930. Three major contributions appeared: Luquet (1913; 1927), Rouma (1913) and Burt (1921). But these descriptions were the culmination of a large number of earlier studies (Harris, 1963). There is a great deal of agreement in the descriptions of developmental stages, although terminology may vary. However, from an appraisal of subsequent literature, it would appear that Luquet's work had been the most influential and is most frequently quoted. His work is discussed in detail by Harris (1963) and Luquet described three main stages of development.

(1) The pre-schematic stage or the stage of "synthetic incapacity" from 2½–5 years approximately. This is the stage of the child's earliest scribbles and gradual attempts to draw forms that represent some object of his experience, although he fails in positioning, in co-ordinating lines and generally to synthesize elements.

(2) The schematic stage or the stage of "intellectual realism". This is the stage when the child draws "what he knows rather than what he sees" (Harris (1963) attributes this maxim to Luquet). The child draws his basic concept of an object with all its major attributes, generally without considering the fixed view point visual aspect.

(3) The stage of "visual realism" usually attained after the age of 10 years when the child can choose to draw relatively true-to-life representations of visual scenes from one fixed view point.

Luquet's description has been seminal (indeed Piaget acknowledges his debt) and has provided future researchers with a framework for study. With the exception, then, of the most explicitly Gestalt-based theories, which will be discussed later, most researchers in the field have noted the correlation between developmental stages in children's drawing and intellectual and conceptual development and have assumed some sort of causal relationship. Although these theorists have generalized from these phenomena in different terms, all, in one way or another, have found cognitive development at the core of the drawing process.

One result of this view of children's drawing was the Draw-a-Man test of intellectual maturity devised by Goodenough (1923). She used the child's gradual elaboration of the human figure in his drawings as a direct measure of the child's intelligence. Harris (1963) revised and updated this work retaining its essential character, and he too emphasizes the essential relationship between drawing and cognitive development.

In 1963 Harris produced the most thorough review of the whole field of experimental psychological studies of children's drawings up to that date. His work stands as a detailed, thorough introduction to the area, although he reflects the more traditional adherence to empiricist models current at this time, and he gives rather little room to other schools of thought. However, Harris identifies three major theoretical approaches to the study of children's drawings and he clearly favours the first. These are:

(1) The empirical approach
(2) The holistic or Gestalt approach
(3) The school that emphasizes the emotional and expressive role of drawing.

It is possible to object that a rigid and simplistic division of theoretical approaches distorts and masks the complexity of views held, just as with the notion of discrete stages in children's drawings. Inevitably, Harris is led to suggest other ways in which theoretical approaches can be dichotomized. Nativist and environmentalist approaches are described. Harris asserts that there are some writers who argue that the fact that a clear progression can be seen in the child's drawing ability is due to the fact that there are intrinsic absolute limitations in the child's concepts and in his cognitive development;

while others have seen the processes as necessary phases in the successive organization of a complex response. One stage must be mastered before the child can go on to the next. The first group stress the innate characteristics of the child's intellectual development, while the latter stress environment and learning. Traditionally, the environmental interpretation is associated with the empiricist approach, since external and observable (measurable) stimuli impinge on the organism causing predictable and measurable responses. Those who stress an innate incapacity are more likely to make use of intra-organism concepts such as mental imagery, in describing the drawing process, but they would not necessarily subscribe to holistic interpretations.

Harris says

> all scientific efforts to describe the drawing process or to develop psychological theory concerning drawing behaviour have stressed children's drawings as representative, as expressive of concepts or cognitive content. It is at the point of defining how concepts arise and how drawings reflect concepts that a sharp separation occurs.

The Piagetian, for example, will differ sharply from the learning theorist in his explanation of how concepts arise. Similarly, Gestalt theorists are likely to perceive in children's drawings the same principles that they use to describe visual perception. As the child matures, they say, the organization of the visual field incorporates more and more Gestalt elements, such as closure, symmetry etc., and expresses increasingly complex relationships among the elements. "As perceptions differentiate, drawings elaborate and become less schematic and more visually accurate" (Arnheim, 1954).

Investigators in the behaviourist tradition analyse concept formation in terms of the association of external stimuli with behavioural responses. Concepts modify in a systematic manner with increased experience and learning is seen as their source rather than innate capacities. As has been stated, Harris (1963) favours an empiricist and behaviourist interpretation of children's drawings and he therefore makes use of physiological theories to support his view. He criticizes Gestalt theory on the grounds that complex activities are explained cursorily and simplistically by Gestalt principles without an intricate description of all the behavioural contingencies. He firmly claims that these terms stand in the way of more thorough accounts.

Supplementing Harris's description of theoretical approaches to study of children's drawings, it is possible to discern four main schools of thought operating:

(1) Accounts that emphasize that drawing behaviour is mediated by intra-organism functions
(2) Empiricist and behaviourist accounts
(3) Gestalt and holistic interpretations
(4) Expressive and emotive theories of children's drawings

## A. Theories Making Use of Mentalistic Concepts to Explain Children's Drawings

Helga Eng (1952) made a longitudinal study of the development of drawing in her niece. Her discussion is interesting and unusual in two ways: first, because it is a single case study and: secondly, because she employs mentalistic concepts in her discussion. She was writing at a time when most British and American psychologists preferred a behaviourist analysis. Eng, like other European psychologists, was prepared to use mentalistic concepts in an exploration of the role of cognitive development in children's drawings.

Two important points should be noted here: (i) Eng's approach is not necessarily at variance with empiricist discussions. It is often simply that terminology differs according to the basic philosophical stance and *emphasis* varies. Eng emphasizes internal cognitive processes, whereas empiricists emphasize graphic skills and set about varying situations systematically to observe what the child does: and (ii) Eng is neutral as to whether mental operations are innate or derive from the elaboration of experience. Eng discusses the wide parallelism between the development of the child's drawing ability, the development of his speech, his formation of concepts and the complexity of his thought as revealed by language. Eng described the drawing process entirely in terms of underlying mental operations.

She pointed out that free drawing in children is almost entirely from memory. Children do not look at what they want to represent, even with a model before them, but they draw entirely "out of their heads". Eng asked "what is the nature of this mental picture?"

She claimed that children draw to a formula which she called "formalized drawing" from the age of four until nine years approximately. According to her analysis, drawing is ideomotive in its origins and early development. The child learns drawing by repeating lines and forms innumerable times.

The child's most important subjects are his own earlier drawings. The child has an image of that subject, along with the memory of where to start, the motor- movement necessary, the direction of the line and how to proceed to achieve the finished effect.

He represents objects from this store of forms. Eng thereby stressed that children drew from their own internal models. She says elsewhere:

> If children are *compelled* to draw from a model, they have first to grasp the form. They are obliged to analyse the whole mental representation that they have made, the separate parts that they have in their repertoire.

Eng's description of the pictorial process and her theoretical approach is compelling and has the appeal of both good common sense and imaginative zeal, but she fails to substantiate her claims by a thorough analysis of evidence from research studies. Eng is therefore reminiscent of one of Bacon's spiders "weaving webs out of their own substance", and a strict experimentalist might object both that her use of confirming evidence is slight and that no

attempt is made to suggest how her mentalistic analysis could be rigorously tested. Also, she apparently based most of her ideas on the general development of drawing in children on a single case.

### Piaget and Inhelder's View of the
### Development of Drawing in Children

Piaget makes use of mentalistic concepts and has a biological or genetic explanation for their development. Piaget discusses children's drawings in two major sources: "The Child's Conception of Space" (1967) and "Mental Images in the Child" (1971). Piaget has rather little to say about drawing in children on the whole. He rather uses children's drawings as evidence for his theories of the child's conception of space but no resumé of theoretical positions would be complete without a consideration of his contribution.

Piaget devotes the first chapter of "The Child's Conception of Space" to establishing the theory that internalized mental imagery depends on the child's sensory motor activity. He makes use of children's drawings as an example of how mental imagery is only developed via motor activity (pencil strokes). He says in his conclusions to the chapter:

> there can be no perception that is not incorporated in a complex of sensory motor activity. A perception linked to a particular centration is only a kind of snapshot or still cut-off from the dynamic flow of perceptual activity which reacts constantly upon the perceptions on which it is based and which it links together.

For Piaget, then, the child's drawings are a record of the limitations of his perceptual development and attest to the necessary involvement of sensory motor activity in the formation of mental imagery. Furthermore, he sees children's drawings as an account of this essentially limited understanding. He says:

> we may now go so far as to say that children are able to recognise and especially represent only those shapes that they can actually reconstruct through their own actions.

But empiricist psychologist such as Freeman (1976) might argue that drawing is also limited by performance constraints such as motor control, planning and execution problems. Piaget writes about drawing as if it were a "print-out" of the child's perceptions. The child's drawing performance is likely to be well below his visual recognition or imagery. Piaget stresses the role of sensory-motor activity but it is the case that non-ambulant children are able to draw adequately and children can draw images that they have seen in books where there has been no sensory-motor involvement.

Later in the book, Piaget describes the development of the representation of space in children. He says, for example:

it is not until after 7–8 years of age that measurement, the conceptual coordination of perspective, understanding of proportions result in the construction of a conceptual space marking a real advance on perceptual space.

What Piaget appears to be saying here is that, until the child has conceptualized features of the visual field, he is unable to understand perspective and proportion or even be aware of them at all. Piaget's rationalist and structuralist position leads him to conclude that both knowledge and understanding results from the genetic development of rational thinking in the child. The impact of the environment is minimized in this interpretation and this view leads to a dualism between the child's internal conception of the state of nature and the external world, but with Piaget the former is pre-eminent.

Again Piaget says:

the intuition of space is not a reading or the apprehension of the properties of objects but, from the very beginning, an action performed on them. It is precisely because it enriches and develops physical reality rather than merely extracting from it a set of ready made structures, that action is eventually able to transcend physical limitations and create operational schemata which can be formalised and made to function in a purely abstract and deductive fashion.

Piaget has some innovatory insights into the nature of the problems of construction in drawing at the stage of visual realism, after the age of 10 years. He maintains that the child is only able to draw in perspective when he is able to envisage a view from one vantage point.

To perceive an object according to a given perspective is identical with seeing it from a certain vantage point from which one does not need necessarily to be conscious in order to perceive accurately. To represent in a drawing the same object in the same perspective is to take notice simultaneously of the vantage point from which it is perceived and of the changes due to the intervention of that vantage point.

In Piaget's later book "The Mental Image of the Child" (1971), he is concerned with the relationship between perception, imitation and mental imagery. He says that the mechanisms involved in cognitive functions in the very young infant are perception, imitation and mental imagery. Mental imagery appears after the first two according to his theory of the biological development of cognitive processes.

In the developing child the image is supposed to arise from sensory motor activity. Piaget details the development of mental imagery. The image is not equipped to represent even the simplest geometrical movement or transformation before 7 years of age. The child's images are static and cannot be manipulated or reversed before this age, hence the postulated egocentricity of the early stages.

Although Piaget does not say so, presumably when the child is drawing from memory, he is making use of these mental images and, according to

Piaget, the child can only draw an egocentric view. This does not explain the highly symbolic and transparent drawings of 5 and 6-year-olds and according to Piaget, the experiments in angle in Nadia's drawings (Selfe, 1977) are impossible!

For Piaget, then, the young child's drawings are examples of central limitations in his thinking. The source of the image lies within internalized imitation rather than in perception. Two major criticisms are levelled against Piaget's theoretical approach. One of these criticisms is against Piaget's concept of stage. It is argued that this gives a false impression that development proceeds in a discontinuous manner rather than by gradual increments. Intellectual function at any one age has more variability than Piaget's theory suggests. Cross-cultural differences limit the usefulness of Piaget's concepts and Ausubel (1964) points out that the main problem with the concept of stage is that it implies qualitative distinctions in modes of cognitive functioning and that their appearance is an identifiable sequence in development. Moreover, that appearance has a biological foundation tied strictly to the age of the child.

Secondly, it is frequently stated that Piaget is a structuralist. He attempts to construct an enclosed system to describe the child in which all internal forces are accounted for. He talks as if the child creates the real world without either an interaction between the child and his environment, or even that environment impinging on the child to alter the course of his development. He does not elucidate the reaction of this system to the environment in which it finds itself. His system is metaphysical rather than scientific and Piaget constructs a model in which the pinnacle of development is logical deductive reasoning. Man is therefore seen as a rational being who attains and makes use of hypothetico-deductive systems by way of his innate nature rather than from observations of his environment. It is towards logical thinking that the history of his genetic development is aiming. Bruner maintains that it is the child's experiences, the demands of tasks and situations with which he is presented that will develop the child's thinking ability. Bruner points to the vital importance of the interaction between the child and its external environment. Moreover, much of Piaget's writing is pervaded by a dualism that leads to conceptual confusion. For example, in "The Child's Conception of Space", Piaget discusses perception in terms of two dependent levels: the level of reception and the level of cognition, as if there is a *central* dichotomy between the outside world of things and the inside structure of thought and imagination. The problems of dualism will be considered in some detail in the next chapter.

## B. Empiricist and Behaviourist Theories

Empiricist approaches to children's drawings have enjoyed favour with psychologists over the last fifty years in response to the behaviourist and

experimental models of human behaviour. Freeman (1972; 1977; 1980) has undertaken the most extensive research programme in this country in recent years. He says: "what psychologists have begun to do with regard to children's drawing is to conduct research which is based on the same rules of evidence as other areas of experimental psychology". His research is therefore into the production or observable output in children's drawings. Consequently, he has manipulated the conditions of drawing, presenting children with partially completed figures, etc., and analysing responses in terms of "planning strategies" rather than mental operations. However, as with so many concepts in psychology, one immediately runs into the problem that very few useful descriptions of human processes can be described only in terms of observable behaviours. Freeman prefers to describe the drawing process in young children in terms of basic psychological concepts which have their behavioural correlates. He has analysed serial order effects, the development of the representation of parts of the human body in human figure drawing, position and orientation of body parts and size scaling in the production of a drawing. Freeman is interested to understand how the child learns to solve the problems of production ordering and planning. Graphic representation is seen in terms of the analysis of task demands and problem-solving rather than in terms of complex internal cognitive processes. He says he is interested in how the child sets about solving, planning and ordering the lines that make up his drawing or, at least, how this is revealed by what he gets down on paper. And he is surely right when he says

> Experimental analysis of the development of ordering and planning is essential to any understanding of the development of representational drawing.

Freeman maintains that

> the analysis of the task demands of pictorial representation must be undertaken before we can devise appropriate units of analysis, whereby we can speculate on the role of mental imagery in determining the variant forms produced.

"Children's drawings", he asserts, "are the end result of an exacting and often exhausting productive effort." Consequently, he discusses production in terms of orientation cues or relational responding and relates early production problems to such concepts as serial order effects of human memory. All such concepts have behavioural correlates (unlike mental imagery) and Freeman does not stray too far from this path into the waters of mentalistic concepts, nor the mire of emotive or motivational aspects of the drawing process. Freeman's contribution to the field of children's drawing is the most thorough and experimental to have emerged in recent years. However, while agreeing that this is a vital area of research, there is a danger that this could possibly lead to a narrow emphasis on the task demands and production problems alone.

An inherent danger is that once development has been described in terms of the child's "strategies and plans", it is assumed that this is the *only* problem the child has in drawing; that these planning problems account fully for the nature of the drawing. It is just possible that planning problems are minor and incidental in accounting for children's drawings. To use a parallel, it is rather like saying that it is important to understand how a child achieves control over the musculature of his throat and tongue in describing the acquisition of speech and language.

Freeman (1977) himself acknowledges this:

> . . . concepts of mental imagery, aesthetic aims, projective processes and inter-
> pretation have all become entangled in a thick undergrowth. If we can define the
> level at which planning problems operate and categorise the variant forms of
> drawing that result, we then may be able to clear the way for the infinitely more
> important study of the operation of the passions.

Although the child undoubtedly has to overcome planning problems, what motivates the child to draw in the first place and what ultimately limits his production, may depend on decisions other than those about basic planning. Freeman tends to ignore both mentalistic and motivational factors. He attempts to avoid such concepts as mental imagery but substitutes concepts such as relational responding, serial-order effects of memory, which also imply "internal processes". On reflection there is little difference between some empiricist concepts like short-term memory and the much beleaguered concept of mental imagery (see Richardson, 1980, Chapter 3 for an excellent discussion of the conceptual analysis of mental imagery). However, without an adequate model to account for all aspects of the child's aims and limitations in drawing, Freeman has wisely decided to pursue those aspects more obviously open to experimental investigation.

At present, in this country the favoured approach to psychological studies of children's drawings remains experimental and empiricist. Largely for historical and philosophical reasons, psychologists prefer to see their endeavour as the "science of behaviour" rather than the art of understanding human experience. Many current studies in psychology are concerned to examine the "task demands" that drawing imposes on the child. Other commentators, such as Eng and Piaget, have used mentalistic and cognitive concepts for a description of the drawing process. All these commentators, both behaviourist and cognitive psychologists, share a particular view of the child and of the drawing process. Any theory of how children draw has within it tacit assumptions of what the child's intentions are when he draws.

In much current research, then, there are implicit assumptions that are rarely examined about the nature of the drawing process. One important assumption shared by empiricists and structuralists alike is basically a dualist

view of man. It is assumed that the child is attempting to imitate visual reality in drawing and he is more or less successful, depending on his age. Part of the attraction of viewing children's drawing *only* in terms of the progression towards photographic reality, is that the drawing can be compared and deviations measured against an external criterion. This is how Goodenough developed her test of intellectual maturity based on a child's drawing of a man. The assumption is that the child's aim is to draw a photographic image and success and intellectual maturity is gauged according to the criteria of realism. The external criterion is the photographic, true-to-life appearance of the man.

The model is essentially dualist since it is assumed that there is a fixed reality which is projected on to the retina which the child is attempting to draw. The child is believed to be engaged on learning to record the retinal image of a fixed view of the external world. The tadpole stage of drawing the human figure has been analysed by many commentators (Freeman, 1976; Bassett, 1977). In all cases, the assumption is that the child would draw a more visually accurate figure if he could. It is assumed that the child's ultimate aim is to draw a photographic image of a man. Discussion and controversy is not about whether this is an accurate or complete description, but whether the child is limited in this aim, either by an incomplete mental image or by problems with serial order effects in memory. To quote Freeman, his aim, he states, is

> . . . to explain why children's drawings of the human figure may look so queer in their slow development towards the stereotyped photographic arrangement.

Thus, for many researchers, a child's drawing indicates the level of success which the child has reached towards his final aim of portraying photographic reality. The child's drawing is supposed to indicate either what he knows of the visual appearance of the object or, at least, what the child, having grasped certain graphic rules, is able to get down on paper of the appearance of the object. This way of regarding children's drawing needs to be qualified. A full account of how this may be done will be given in the next chapter.

## C. Holistic Interpretations of Children's Drawings

The chief exponent of the holistic and symbolic view of children's drawings is Arnheim (1954, 1967, 1970). Arnheim's contribution avoids many of the dualist difficulties encountered by the first two approaches. Arnheim brings to his knowledge of Gestalt psychology, a thorough understanding of the creative arts which is a formidable and unusual combination. He has written several books on this subject and his most influential book, "Art and Visual Perception", has been revised and updated several times. In this work Arnheim distinguishes between representation and imitation. Imitation, he contends, is the process of copying the visual appearance of a two-dimensional object, such as copying basic shapes or copying letters and numbers in

learning to write. He denies that this is what the child attempts to do in free drawing of three-dimensional subjects. Arnheim argues that it is a mistake to call a child's drawing distorted or deformed if it does not accord with visual reality, because the drawing depends on the purpose the child has in mind. In any case, Arnheim points out that things are rarely viewed statically; we have constantly changing views of objects, so that when the child depicts the inside and the outside of a house, this is a perfectly correct interpretation of his visual experiences of a house. Similarly, not only are real visual experiences unlikely to be static, but the child's experience of representation is more likely to be mobile than static. Children in Western cultures probably spend much more time watching television than looking at pictures in books. It is an arbitrary convention to represent one static view and this form of representation arguably has less impact on the modern child than on earlier generations of children brought up without alternative competing pictorial representations. Again, Arnheim points out that in modern art, all realistic attempts have been dropped in favour of a multi-faceted view of an object in order to convey much more of the experience of that object than one fixed static view.

Arnheim claims that an over-simplified concept of the artistic process was based on a double application of naïve realism. According to this view, there is no difference between the physical object and its image received by the mind. The mind sees the object itself

> ... the role of the physical object was taken over on the growth of optics and the physiology of vision by its equally physical projection and the conviction prevailed that the visual experience was identical in all its properties with the picture projected onto the retina.

This theory encountered puzzling contradictions in the field of the arts. If spontaneous perception corresponded with the projected image, it was reasonable to expect that naïve pictorial representations at early stages of development would tend towards completeness and perspective distortion. The opposite, however, was found to be true.

> Representation starts with highly simplified geometrical patterns and realism is a late and laborious accomplishment.

The earlier drawing of children show neither the detail nor the deformations expected from the view of naïve realism. It was taken for granted that children do not draw what they see and a reason for the deviation had to be found. It was argued that children were technically unable to reproduce what they perceived. It is true that the drawings of young children show incomplete motor control. However, at an early age, says Arnheim, the former imprecision of the stroke gives way to an exactness that is more than sufficient to show what the child is trying to do. Arnheim concludes that none of the drawings of a child are an unskilled attempt at projective realism. Arnheim also rejects the view of drawing which supposes that, since the child is not drawing what it is assumed to see, some mental activity other than perception intervenes and is responsible for the modifications in children's drawings.

Arnheim maintains that no such conceptual or intellectual process intervenes in this manner. His theory is that perception differs in two important ways from that proposed by realists as a sort of photographic projection onto the retina. It does not register the complete set of individual details and it does not start from particulars that are secondarily processed into abstractions by the intellect, but from generalities. "Triangularity is a primary percept", Arnheim maintains. The distinction between individual triangles comes later, not earlier. Arnheim thereby expounds a Gestalt model of perception.

Arnheim asserts that the process of artistic representation requires a search for "structural equivalents". The process is basically a symbolic one in which the child discovers graphic symbols which stand for an object or part of an object. That symbol may symbolize more than the fixed view static visual properties of that object.

Arnheim says that unquestionably children see more than they draw and that representation of objects is not as differentiated as the perception of objects. The child has to invent or discovers structural equivalents that stand for objects or characterizing features of objects. Arnheim quotes Britsch (1930) who demonstrated systematically that pictorial form in drawings grow organically according to definite rules of its own: from the simplest undifferentiated form to more and more complex patterns in a process of gradual differentiation.

The author takes much the same general position as Arnheim's persuasive philosophical view, although he goes on to apply a somewhat rigid Gestalt view of the development of perception and applies these principles, such as closure, symmetry etc., to drawing structural equivalents. Other models of perception are proposed and discussed in the next chapter. However, it would be useful to summarize Arnheim's philosophical view.

Arnheim points out that, since many views of an object are possible and, indeed, is the overriding experience of perception, then many spatial relationships can be depicted in drawing. The photographic picture is only one type of spatial relationship that children and adults can attempt to portray. Moreover, Arnheim states emphatically that it would be a mistake to assume that the photographic image is the more highly evolved form of representation. He points out that in a photographic portrayal, only one face of the object is visible so that this form of representation has fundamental limitations. For the young child then, pictorial representation is not a mechanical replication of the percept (but renders the structural characteristics through the medium: paper and pencil, in drawing). Similarly, artistic representation is not based on a fixed point of view of an object at a given moment, but on the three-dimensional perceptions of a species of objects observed from many different angles under many different conditions. What determines whether depth should be depicted may be whether the child feels that this characteristic of the object is essential. His representations of transparencies, multi-faceted visions etc., have a logic of economy and utility.

Arnheim concludes that conceptual confusion and misrepresentations are inevitable if a picture is judged on the criterion of how far it replicates a fixed

view of an object, rather than a symbolic representation or structural equivalent of the object in terms of the medium. Viewed through Arnheim's approach, each stage in drawing has a functional integrity. The child invents structural equivalents for what he wants to represent of the object at that time. Arnheim has two notable followers who largely agree with his view and make use of his concepts. Golomb (1977) studied the effects of using various materials and direct instructions on children's creative productions, and she concluded that supposed developmental immaturities were dependent on the medium the child was working in: i.e. modelling, painting, drawing etc. Goodnow (1977) also uses Arnheim's concept of structural equivalence in her description of process and product in young children's drawings. Her work will be described later in detail.

To return to Arnheim's central thesis and its influence on other psychologists, Golomb demonstrates this close adherence when she says,

> so long as psychologists hold the naive view that reality could and should be copied, they will merely be concerned with replication and its deficiencies. The absence of realism or naturalism in the early drawings of children required an explanation. It was considered an imperfection to be corrected in due time. Thus, children's drawings are evaluated in the light of historically and developmentally late accomplishments, such as realism in art.

Drawing for children, as for adults, is not only about representing what the object looks like. It is perhaps more importantly to produce a satisfying symbol of aspects of experience both visual and emotive.

## C. Emotive/Expressive Theories

Drawing is a complex activity which not only reflects the child's conceptual development, but clearly also has emotional and aesthetic aspects. Drawing seen only as a cognitive activity is likely to lead to a biassed or blinkered understanding of it. Symbolic aspects of children's drawings have been neglected in British psychological research, as has been discussed. Emotive and expressive aspects have been similarly neglected recently. As far as experimental psychology is concerned, the possible exception to this is the work of Koppitz (1968). She attempts to evaluate the emotional adjustment and development of the child in much the same way as Harris and Goodenough (op. cit.), using children's drawings of the human figure. Thirty-eight indicators were identified, such as proportion, integration of parts, inclusion of details etc., and these were subdivided into categories "indicating" intelligence, adjustment etc. The difficulty with her work is that it lacks a central coherence and fails to present a satisfactory integrated model of emotional adjustment. An aggregate of "indicators" does not gel into a theory and, in any case, it is highly questionable that individual drawing features or habits arise from the emotional state of the subject alone. These

features could have been formed in many ways: through instruction, or imitation of other children, cartoons etc.

This last criticism can also be levelled at psychoanalytical interpretations of children's drawings (Machover, 1949). Unusual features of drawings are frequently ascribed to supposed emotional states which, to cognitive psychologists, may be explained in other terms, such as developmental immaturity. The problem is to bring the emotional, expressive motivation for drawing into some significance, while taking account of cognitive and developmental explanations and offering a coherent model for all aspects of human development.

The American philosopher, Susanne Langer (1949, 1953), has produced one of the most credible syntheses to date. Langer sees drawing as one of the expressions of man's unique ability to reconstruct reality for himself through conceptualization or, in her terms, symbolization. In discussing art and drawing she says:

> I think every work of art expresses more or less purely, more or less subtly, feelings and emotions which the artist knows; his insight into the nature of sentience, his picture of vital experience, physical and emotive . . .

She demonstrates that a drawing is a formulation in symbols of the artist's concepts and mental experiences. These will include, of course, his experiences of the visual world, but his expression of these experiences through symbols is not confined to the visual alone.

Langer, then, sees children's drawings as reflecting the child's total experience and response to his environment, albeit naïvely, simplistically and with developmental constraints. The experience he records is what Witkin (1974) cogently calls the growing "intelligence of feeling".

# 3

# An Alternative Approach to the Study of Children's Drawings

It is difficult to avoid some of the conceptual confusions brought about by regarding visual perception in a classical Cartesian or dualist manner, this is, as essentially divided into the physical world of objects and the internal mind of the viewer. J. J. Gibson argues in the introduction to his final book "The Ecological Approach to Visual Perception" (1979), that if we abandon the dualist way of conceiving certain questions, then "a deep theoretical mess, a genuine quagmire, will dry up". Dualism infects our thinking in many areas of psychology. Pronko *et al.* (1966), talking about traditional theories of perception, asserts that space is arbitrarily carved up into an "inside" and "outside", and perceptions are thereby supposed to have an interior location. "The result has been the erection of an elaborate but abstruse intraorganismic theatre."

It is possible to go someway to avoid the dualist dilemmas by proposing an interactionist theory. There is a recent history of enquiries into the nature of language and a number of linguistic philosophers propose interactionist models which have relevance to the problems posed by dualist models of perception. (See in particular Wittgenstein's "Philosophical Investigations", 1953.) On the whole, interactionist approaches have been more thoroughly explored and propounded in the area of language than in the field of perception, since language is a special case where the role of the general social context is particularly apparent.

In the previous chapter some objections to both empiricist and cognitive research into children's drawings were examined. It was argued that the views expressed by these approaches were essentially dualist. The empiricist view merely stresses the importance of the external environment in determining the behaviour and development of the child, while the structuralists stress internal mental processes. Arnheim *et al.* avoid many of the pitfalls of this dualism by presenting the drawing process as a symbolic one. Arnheim stresses the importance of visual perception in drawing, but he conceives of perception too as essentially a symbolic process where questions about an external world are not meaningful.

J. J. Gibson finally adopted an interactionist model and he would also seek to dispute the dualist approach. He says that the knowledge that one can have

24

of the external world comes about only as an interaction between the viewer and that world. Gibson (1979) puts forward what he regards as an ecological approach to visual perception. In one of the later chapters of his book, he writes in some detail about drawing. It would therefore be useful to examine his approach in detail since it represents a radical departure, not only from traditional dualist theories of perception and Gibson's own earlier writings, but also because it represents an exciting way of regarding graphic productions in children.

The pivot of Gibson's theory is that perception results from an interaction between the viewer and his environment. One of his key concepts is that of "invariants of structure". These are those elements of the optic array that have come to have significance for the viewer and are generally denoted by such features as edge, contour, light, shape etc. The child, he says, has a notion of "cat". He recognizes a cat from all sorts of angles, in any position so that the notion of cat is basically formless. It can have many forms in the optic array but, nonetheless, it is invariant since it is always recognized as a cat, and nothing else. Gibson rejects notions of "the visual field" or the projection of the visual field as a "retinal image" and instead, he substitutes the concept of an optic array, thereby avoiding the dualism created by the idea of a field outside the person and events inside his head. In the optic array invariants are attended to according to the relevance of the information sought, previous experience and learning. The optic array results from a visual interaction between the individual and his environment. It is constantly changing and is rarely static.

In discussing pictures and drawing, Gibson says

> the kind of vision that we get from pictures is harder to understand, not easier . . . it should be considered at the end of a treatise on perception, not at the beginning. It cannot be omitted because pictures are an essential part of human life, they are deeply puzzling and endlessly interesting.

Gibson claims that he has been attempting to formulate over his lifetime a definition of pictorial perception, but he has been forced to change his position repeatedly as his theories changed and developed. To quote Gibson,

> all along I have maintained that a picture is a surface so treated that it makes available a limited optic array of some sort from a point of observation.

In his earlier work, Gibson proposed that the optic array consists of "pencils of light"; later he proposed that the array was "visual solid angles" which became "nested solid angles". Later again, Gibson proposed that the visual array should be considered as a structure, and this finally developed into his last theory that the optic array was an arrangement of invariants of structure. Invariants are not abstracts or concepts; they are simply structures in the optic array that occur regularly and that the child attends to.

In this final work, Gibson claims that a picture makes available an optic array of arrested structures with underlying invariants of structure. But a picture can only be meaningful in the context of other non-pictorial surfaces

and since a picture is essentially two dimensional, a picture is "a surface that always specifies something other than what it is".

Gibson continues by asking, what exactly a drawing or a picture is a record of. Many writers talk about drawing as if it were a record of perception or, at least an attempt to record what the picture maker was seeing at the time he made the drawing from one point of observation. Gibson claims that a drawing can be such a record of our perceptions, as is a photograph, but drawings need not be photographic since there are many kinds of perceptual experience, such as the experiences of speed, motion and colour; and the artist or child can make a record of these just as well as a static image of a motionless array.

Similarly, the artist or the child can draw his ideas of imaginary things or regard his memories. Gibson concludes that any drawing records what its creator has noticed and considers worthwhile noticing. Gibson's views here coincide closely with those of Arnheim.

Gibson briefly describes how drawing develops in the young child. He suggests that representational drawing evolves in the infant as some of the natural invariants that appear in the ambient optic array come to be identified with the aimless motoric scribbles the infant makes on paper. Graphic invariants will thereby be established; for example, the child will identify the invariant shape of the human head as the graphic circle and, in producing the circle on paper, the child is representing this invariant structure. The child therefore discovers that movements made during drawing correspond to invariant features in his optic array, such as, straight and curved edges, angles, lines, intersects, enclosures and parallels. Gibson fails to point out that the invariants the child first draws and continues to prefer to represent are symbolic or canonical forms of objects rather than the spatial invariants of scenes.

Gibson distinguishes between copying a scene and copying another drawing or a design.

> By gradual stages human children begin to draw in the full meaning of the term. The child delineates for himself and others something he has apprehended or experienced. The traces that the child leaves on the paper are not just lines or forms, they are the distinguishing features of the environment.

In this way, Gibson rejects the notion that drawing is an attempt to copy aspects of the external physical world by projecting a mental image.

> What the craftsman beginner or expert actually does is not to replicate, print or copy, in any sense of the term, but to mark the paper in such a way as to display invariants and record an awareness.

Gibson rightly claims that it is impossible to copy "a piece of the environment"; only another drawing can be copied and he suggests that we have been misled for too long by the fallacy that a picture is similar to what it depicts or is a likeness or imitation of it. A picture only supplies some of the information for what it depicts since, as human beings, we have already selected some features

of the environment that are salient or relevant in some way and attend to those while neglecting other features.

Gibson also discusses perspective drawing. He denies that a picture drawn in linear perspective is a more realistic representation or that a picture not in perspective fails to represent reality. If a picture displays a perspective scene, it simply records some of the features of depth in a static optic array viewed from a fixed point. The term "perspective" is thereby misunderstood. Gibson would not deny that it is possible to have a view of the ambient optic array from one fixed point in the environment and, indeed, he proposes that this should be called "natural perspective". But Gibson says this is not the same as "artificial perspective". "Artificial perspective" leads to a set of prescriptions producing virtual streets and buildings, and linear interiors seen from one fixed position, whereas natural perspective leads to ecological optics.

The idea of a stationary view of a single static object is necessary to the development of Gibson's notice of invariant structures so that "natural perspective" is an essential concept for understanding Gibson's theory of an optic array. But this stationary view is exceptional. Most of the time the optic array is constantly changing as the person moves around. Gibson says that painters and some art critics tend to reject all together the prescriptions of artificial perspective, and denigrate perspective drawing and photographic realism in art. On the other hand, scientists who are impressed by classical optics and the elegance of projective geometry are tempted to scorn the efforts of modern painters. Gibson says that each is talking past the other.

> What is needed is to understand how an observer can see something from no point of observation as well as from a given point of observation, this is, from a path of observations as well as from a position.

Gibson suggests that what modern artists are attempting to do is to paint invariants.

> The separation of invariant structure from perspective structure is the heart of the problem. The invariants display a world with nobody in it, i.e. a multi-faceted world, and the perspective, displays where the observer is in that world.

Invariants of structure are symbolic forms and are perceptual schemas built up from attentional observations.

Drawing in perspective then, depends on viewing in perspective, but this only means that such drawing has required that the learner regard the optic array in a special static manner and to attend to edges, overlap and occlusion. For the very young child, these particular invariants have little significance for him. He notices and represents other invariants. But edges and occlusion, says Gibson, are the fundamental invariants to attend to in accomplishing a perspective picture. This issue is examined in more depth in the next chapter.

The young child does not usually draw in perspective because he is not interested in the edges, occlusions and contours of a scene as viewed from one fixed viewpoint in his optic array. Hence, he may draw a table with a rectangular top and four legs at the four corners of the rectangle because these are the

invariant features of the table to which he attends and which are significant to him at that time and which are acquired from many points of observation of tables. It is only much later that he comes to represent a table from the novel and unusual one fixed position view. It will be useful to consider later whether this is solely a question of interest and attention in young children or whether this amounts to a cognitive incapacity.

What is important about Gibson's general approach is that he views visual perception as both dynamic and interactive. He stresses the essential relationship between the perceiver and his environment. He also proposes basically interactive concepts in the theory of invariants of structure and the optic array. What the perceiver notices are changes or persistences in the optic array, but the individual attends to and attaches meaning and significance to certain features only of that optic array. If we have a non-dualist or inter-actionist approach to perception and graphic representation, it can be readily understood that there is no one visual reality. This is not to deny the absolute existence of the physical world, quite the reverse: individuals could not understand scientific propositions if it were not possible to bring forward evidence upon which we can all agree, for example. But human beings are selective in their attention to the physical environment and perception is not faithful, non-selective recording.

In this sense, perception is our construction of reality, what we attend to according to all the circumstances surrounding our looking. For example, an artist about to paint an interior perceives a different scene from the decorator; a gardener attends to a different array of invariants of structure than does a botanist, although they may look at the same garden.

Taking an interactionist approach, drawing too becomes a different process than that conceived by empiricists or structuralists. The child sets down, albeit clumsily at first, invariant features of the optic array, i.e. those features to which he attends and has found to be significant for him. Culture frequently dictates that such experience is similar for most of its infant members. Individuals can only observe those features which have some sort of functional significance for them. It is impossible to perceive the space between objects or "negative space" as if it had the same significance as those objects.

The idea of a "visual field" and its counterpart "the retinal image" are difficult to maintain, not because there are any doubts about the existence of the physical world, but because this separation between this environment and the viewer leads to a quagmire of difficulties and nonsense. All that human beings can talk about and perceive rests on an interaction between them and the environment in which the environment does not exist without individuals and individuals cannot exist without the environment. One of the founding fathers of social psychology, G. H. Mead, put forward a similar interactionist view as early as 1934. He said, for example:

> Symbolisation constitutes objects not constituted before, objects which would not exist except for the context of social relationships wherein symbolisation occurs. Language does not simply symbolise a situation or object which is already there in advance . . . (p.78)

These three chapters set the scene for a closer look at the development of drawing in children with particular reference to the group of children with anomalous development. The previous review, however, should alert the reader to the fact that the depiction of "visual realism" may not be the principal aim in normal children's drawing, and in any case the notion of an external reality to be drawn has within it contradictions and pitfalls. It has been argued here that it is much more useful to regard drawing as essentially a symbolic activity since a drawing is never that which it depicts.

However, the hallmark of the work of the retarded children who show anomalous ability is that their drawings are far more "photographic" than the work of normal children of the same age. They appear to have a facility in recording on a two dimensional surface, those features of an optic array that would appear from a single fixed viewpoint. As we have discussed such depiction is a special case and is not necessarily to be regarded as the universal aim in normal children's drawing. Hopefully the foregoing chapters place such drawing into a theoretical framework.

# 4

# The Development of the Representation of Depth in Children's Drawings

There was considerable interest in the study of children's drawings in the first decades of this century. However, interest in the development of the representation of depth, of photographic realism in children's drawing was more limited and is a narrower field. Comments about the child's development of the use of linear perspective are made in passing, generally. However, in the very early studies there are some notable exceptions: Clark (1897) investigated the representation of occlusion in children's drawings; Goodenough (1923) discussed the development of the representation of depth, and McCarty (1924) made an extensive study of children's drawings and evaluated the development of perspective and proportion in their pictorial work.

The interest in children's drawings appeared to wane in the 1930s and was revived at the end of this period with the work of Lark Horowitz (1939) and Barnhart (1942). A few studies on aspects of the representation of depth appeared from time to time over the next 30 years. Harris (1950) investigated the depiction of proportions in children's human figure drawing and found, that over a period of days, proportions are consistent for individual children. Malrieu (1950) attempted to assess the appearance of perspective drawing in the free drawings of children. Leroy (1951) also investigated the development of perspective drawing in children from four to fourteen years of age. Lewis (1963) studied the development of spatial representation in children's drawings and children's estimation of the relative merit of various methods of representing space in drawings, and she found an age-related trend towards producing and preferring more "naturalistic" drawings.

During the last decade there has been a revival of interest in the psychology of children's drawings culminating in three recent books on the subject (Goodnow (1977); Freeman (1980) and Gardner (1980)). Of the many studies which have appeared, some have dealt expressly with aspects of the child's representation of depth (Dubery and Willats (1972); Barrett and Light (1976); Willats (1977); Hargreaves (1978); Cox (1978); Phillips *et al.* (1978) and Freeman (1980)). Most of these studies will be discussed in detail later.

Despite the increased interest, the number of studies undertaken remains relatively small. Freeman (1980), in his chapter on "Three-dimensional Representation", comments "this chapter would have been a great deal easier

to write if just one or two other people had rigorously addressed themselves to the problem''.

In this chapter some of the recent studies of the development of children's drawings are reviewed, especially those concerned with the development of the representation of depth and linear perspective in children's drawings. It is not possible to review all of the contributions to the field, and only those which are considered to be relevant are selected.

Luquet (1927, 1929) argued that the child progressed from the symbolic representation of visual experience or "intellectual realism" (discussed by Freeman in terms of "canonical representations") to a stage of visual realism. The author prefers the term "photographic realism". Photographic realism is a more qualified aspect of visual realism and is that view of the real world that is obtained on the photographic plate of a pin-hole camera, approximating to the static image obtained on the retina of the eye from one static view of the optic array. This view corresponds to a view of "natural perspective" in Gibson's sense of the term. Also, "linear perspective" is used in the chapter in the sense used by Gibson to describe "artificial perspective".

Luquet's early work has been seminal and there has been little disagreement with his description from later authors. As has been previously discussed, one of the more recent influential authors in the field is Arnheim who conceives the drawing process in radically different terms from those of the empirical approach. Arnheim certainly would not dispute the fact that there are developmental changes in children's drawings with age. These changes he conceives as the slow differentiation and elaboration of structural equivalents. However, he may argue that all drawing productions of the infant or the adolescent are essentially symbolic, but perform different functions for the child at different ages.

Hargreaves (1978), in discussing developmental trends in graphic representation, has pointed out that although terms may differ, authors acknowledge that there is evolution and development in children's graphic productions.

As was discussed in the introduction, many psychologists adopt an empirical view of children's drawings, and they believe that the child's early graphic productions can be measured against the standard of photographic realism. Freeman (1977) considered that the main interest of psychologists in children's drawing will be to explain why children's drawings of the human figure, for example, may "look so queer in its slow development towards the stereotyped photographic arrangement".

It should be reiterated however, that the graphic representation of photographic realism is only one aim or interest among many that the young child may pursue in drawing. It could be that the child is also interested in representing his emotional experience as well as his visual experience in drawing. Therefore, he might deliberately choose a symbolic representation as more meaningful than a realistic one as do many adult artists. When the child draws ''Mummy'' with a very large head, he might know quite well that this is not how she looks, but it might be a more emotionally and symbolically

satisfying image. This issue is discussed fully by the author elsewhere (Selfe, 1980). It is important here to recognize that the child may have other preoccupations in drawing that the depiction of photographic realism. However, most researchers in psychology have been concerned with developmental trends in graphic representation, and it is undeniable that there is a gradual change towards the representation of photographic realism. This general trend can also be discerned in the drawings of children of many cultures, although Freeman (1980) admits that any rigorous model of developmental trends in the depiction of depth "may not be applicable to all cultures". I shall return to these issues later, but the author's own assumption is that there is a gradual change towards the representation of photographic realism in children's drawings. Drawing more realistically or drawing from one fixed view point certainly appears to be one of the child's aims in graphic depiction as it is in picture preference (Pickford, 1972), although it may not be the only aim.

Bearing these limitations in mind, it is useful to introduce and briefly consider some general current theoretical issues and the research orientation taken by experimental psychologists working in the field of children's drawings with particular reference to the depiction of depth.

Freeman (1980) briefly discusses the problems facing the child attempting any representation of depth in a scene and in representing linear perspective. He concludes that it would be extremely useful to analyse the order of acquisition of drawing devices and drawing systems as the child develops and to see whether these coincide with formal descriptions of the development of the understanding of space and spatial relationships. Freeman has Piaget's theories in mind here. Freeman asks how the child's understanding of the geometry of space and his performance on a range of perceptual tasks relate to his performance on drawing tasks. Of particular concern to Freeman are the planning problems facing the child in the drawing process. He gives an excellent analysis of the abilities that would be needed for the child to represent linear perspective, and his statement is quoted here in full since not only is it one of the most thoughtful observations on the subject, but also because of the contradictions it raises with regard to the performance of the group of children with anomalous ability considered in this book.

> What would a child have to know in order to draw, even crudely, in perspective? . . . Four things are essential. One is a grasp of the idea that the observer has to play an active role in construction so that the final representation is a recombination of aspects of the real objects which explains their structure and relationships. Another is some degree of abstract understanding that the best way of explaining a scene is to rescale and even to violate isolated aspects of its appearance. Thirdly, he has to have a grasp of measurement and geometry, for these are the key aspects of scaling and co-ordinating scale. Finally, he has to understand something about the structure of space, the relationships in the external frame of reference, within which he occupies but one position which is not a privileged one, but one whose consequences have to

be worked out in the context of external relationships. One can see immediately that many abilities are needed.

Apart from Freeman's chapter on three-dimensional representation, there are very few other studies that raise more general issues of the child's representations of depth and explore explanations for developmental changes. However, one such study was conducted by Phillips *et al.* (1978) who asked children to copy pictures of cubes and of similar but non-symbolic shapes. They found that children copied drawings of objects (cubes) less accurately than they copied similar designs. They discussed their findings and offered two explanations for the dominance of intellectual realism in younger children's drawings. Their discussion again points out the complexity of the "visual realistic" representation. They say that it would seem plausible that the computations necessary to translate an internal visual description into a drawing will be more complex when the internal description is of a solid object than when it is a description of two-dimensional design. There are depth cues to be resolved, for example, and the child will be reluctant to distort or omit behavioural and functional properties of the object. So the drawings of young children tend to display general functional and behavioural properties of objects when simple and obvious computations can be made on the "object data structures".

Their second explanation is offered in terms of the motor programmes for drawings that the child develops (graphic motor schema). This explanation proposes that when copying a drawing of an object, the child uses the graphic motor schema he has already learned for that object, or ones like it. "The drawing being copied serves only to select the graphic motor schema to be used and does not guide it thereafter." This view is very similar to Freeman's who proposes that the child draws canonical representations. However, Freeman gives no thorough definition of what he means by a canonical representation. Presumably a canonical form is a rule-bound, standard or acceptable form. It is that characteristic view or logos of an object which, in children's drawing, is flat and two dimensional but with defining features. What is implied by Freeman is that the representation is non-photographic or symbolic but is universally recognizable. If it is to be useful, the concept needs clarification since there can be many canonical representations of a single object partly depending on the context and on style; some more and some less symbolic and less realistic images are not necessarily less complex.

Many authors are critical in their analysis of some of the more inflexible statements of Piaget and Inhelder, but they nevertheless accept many of the basic tenets of Piagetian theory. For example, Freeman conceives of the child as a problem-solver, rather than as an expressive artist in the drawing activity, and he conceives of intellectual development and particularly pictorial representational development, as a progression in problem-solving and logical operations. More important, Freeman believes that the child proceeds in a conscious, rational and intellectualist manner: "solving problems" of three-

dimensional representation and spatial geometry. While Piaget does not deal directly with how the child acquires these abstract rule-governed systems in graphic work, he does consider the evolution of the understanding of spatial geometry in the child. He uses children's drawings rather as evidence of this evolution. This issue will be discussed further later; in the meantime, it is useful to introduce such considerations here, in view of the discussion of the difficulties to be overcome in the representation of visual realism.

Before considering drawing devices and drawing systems which relate directly to the child's representation of depth and later, to linear perspective, it may be instructive to look, briefly, at a recent group of studies of the very early graphic productions of children. This early stage of drawing has sometimes been called the pre-schematic stage, (Harris, 1963), and occurs from 2½ years to 6 years approximately. This stage has been more thoroughly investigated than any other, particularly by Goodnow (1977) and Freeman (1980).

Basically, when the infant begins to draw he is quickly presented with the problem of representing his visual experience on a two-dimensional surface. Olson (1970) was one of the first to point out the obvious fact that drawing is not just a print-out of perceptions or internal mental images, but is a problem-solving activity and a rule following process whereby techniques and rules are gradually discovered and integrated. Also, young children very rarely copy from other pictures or from models when drawing. According to Arnheim, the child invents from a small repertoire of structural equivalents a representation of some object of his experience. The child has to devise a strategy; he has to organize, in memory, a sequence of symbols and then organize these spatially on the two-dimensional surface. Goodnow (1977) says that young children's drawings, or elements of them, represent one or a series of structural equivalents. Her basic model is taken from Arnheim. She points out that infant drawings contain only some of the properties of the original. She has looked at some of the features of infant drawings; experimentally examining the rules and strategies that young children appear to adopt in drawing. These rules, she claims, appear to be universal. Problems arise for the child often as a consequence of following particular rules and his solution of these problems helps to account for the nature of his final drawing. Although Freeman's work is in greater depth, Goodnow's work is certainly more comprehensive and therefore meets the need for a brief review of the very early development of rules and drawing devices.

What then are the rules that Goodnow discerns through her experimental analysis?

(1) *Units*. Goodnow says that infants' drawings are composed of units of shapes that the child has discovered and that these units can be combined in a variety of ways. Some units are acquired many years before others. The circle is acquired much earlier than the diamond, for example.

(2) *Space*. Goodnow explains the way in which children use boundaries and separations between units and parts as a way of describing

organizational patterns. For example, in very early productions, Goodnow claims that each body part is marked off from another in drawings of the human figure. Children characteristically avoid overlapping space and units and, at this young age, seem to prefer a no-mans land between elements in their drawings. Goodnow observes that, with regard to space, young children operate with two general principles:

(a) To each its own boundary, and

(b) To each its own space.

She found that there was a definite age-related shift from using units to using an all-embracing line which traces the whole outline of the person. Her point is that this is a major intellectual shift where separate units are amalgamated. The child must have constructed not just a list of parts, but an interacting relationship between the parts when he starts to use the all-embracing line.

(3) *Sequencing.* Goodnow also examines the sequencing problems facing the child in planning a drawing. Although the mental image may be grasped in one act of recall, spontaneous and complete, a drawing of that image has to be organized sequentially. The child is therefore faced with the decisions of which unit or area to draw first and which last. Freeman (1976, 1980) has gone so far as to suggest that the tadpole figure of very young children is so restricted because of the short-term memory span of young children. Primacy and recency effects of memory operate, so that the head and the legs are respectively, the first and last items of a sequence of body parts. Goodnow found that young children almost invariably operate with a top to bottom sequence. If the child is right-handed, a left to right sequence is more usual, although this tendency is far less marked in pre-school children with less exposure to the conventions of reading and writing. The tendency to proceed from top to bottom and from left to right can also be noted in the attempts to copy numbers, letters and geometric shapes.

Another problem Goodnow discusses in connection with sequencing is that very young children frequently run out of space on their paper and fail to scale their drawing adequately. They then distort their productions to fit into the remaining space. It was also found that if the child produces one distortion early on in the sequence, the distortion will be magnified throughout the rest of the drawing so that initial lines have an enormous effect on all subsequent lines.

To sum up, Goodnow has shown us some of the ways in which the normal child proceeds in the stage of pre-schematic drawing, and she has identified certain universal principles to which the vast majority of young children adhere. She says that many features of young children's drawings may be attributed to the way in which they solve problems encountered in the course of achieving certain kinds of patterns or in solving problems created by their own previous achievements.

There has been far less research of the development of the representation of depth after the pre-schematic stage. Barnhart (1942) undertook a descriptive and comprehensive study of the development of the representation of "visual realism" in children's drawings from the age of 5 to 16 years and his account serves as a useful introduction to the area.

Barnhart described characteristics of drawings such as their spatial organization, the arrangement of units and depiction of objects done by children at the schematic stage (approximately from 5 to 10 years) and when children were older at the "stage of visual realism" (10 years approximately).

Acknowledging his debt to Luquet, Barnhart distinguishes between a "schematic stage" and a stage of "visual realism". He says, for example, that in the schematic stage,

> objects are represented by means of simplified diagrams or schemas. These are not visually realistic at all and bear but a slight resemblance to the objects for which they stand. They are flat forms with no depth or foreshortening and with no indication of the conditions of light. They are much closer to an intellectual than to a visual realism and represent more a statement of what the child knows to be the major features of the object rather than an attempt on his part to represent a visual record.

The stage of schematic symbolism, according to Barnhart's analysis, is characterized by objects or units drawn apart from one another and either disposed over the page or organized in one line along a ground line or plane. Later, several levels or planes may be employed and items are arranged in horizontal rows, but there is usually no diminution of size with distance where the bottom of the page represents the foreground and the top, the background, nor does the child attempt to overlap objects (Hidden Line Elimination — H.L.E.). Units are almost always given in their complete form, and objects are placed independently from one another. (This is a rather crude and over-generalized description, but at least it opens the way for more detailed studies.) Barnhart claims that as the child grows older, his drawings become more "visually realistic". (As previously mentioned, "photographically realistic" would be a more accurate term, and it is taken that Barnhart means this.) After the age of 11 years the child will begin to attempt to draw scenes using some of the elements of perspective. Objects will be attempted using foreshortening. According to Barnhart, the "stage of visual realism" begins with the gradual development from the avisual spatial conception of the schematic stage to the visually realistic, and there is a slow change from the aspatial disposition of units to a form of spatial organization marked by linear perspective, overlapping of forms and diminution of size with distance. Discussing the stage of visual realism, Barnhart says,

> Space is now represented more or less accurately as it would appear to the eye from one vantage point. Linear perspective is sometimes handled correctly; objects diminish with distance and overlap and the multiplanar form of spatial representation generally gives way to the implicitly planar, where the surface of the ground is drawn as retreating into the distance towards the horizon.

Barnhart's work gives a useful comprehensive introduction to some of the concepts which will be explored in more detail, particularly in the next chapter. However, his work was entirely descriptive and his sample of subjects, ranging in age from 5 years to 16 years, contained only 50 children.

Linear perspective drawing is invariably described as a notoriously difficult accomplishment. Freeman (1980) has already been quoted at some length on this point, and other studies have confirmed that an attempt to draw scenes or objects in linear perspective is a relatively late development (Harris, 1950; Malrieu, 1950; Leroy, 1951 and Lewis, 1963). Burt (1921) described the stage of visual realism in children's drawings as occurring from the age of 10 years onwards. Barnhart and Malrieu (1950) state that linear perspective drawings appear after the age of 10 and 11 years respectively. Harris (1963) reports small but increasing proportions of children attempting to draw scenes in perspective from ages 10 to 15 years. However, Leroy (1951) reports some attempts at perspective in the drawings of children of 6 to 7 years, but does not give details of how she judged perspective to be present or her criteria for perspective drawing. She used single objects such as a car, a house and a boat and asked children to draw these. Harris (1963) challenged her statements about the development of perspective drawing and states that American experience has been that attempts at perspective are infrequent before the ages of 10 and 11 years. He quotes studies to substantiate this.

Most of the early commentators describe perspective drawing as if it were an all or nothing phenomenon; either the child uses it, or it is entirely absent in his drawings. This is an inadequate description and an error that has led to much confusion. It would be more accurate to say that there are many elements or devices which are gradually incorporated in perspective drawing and add to the representation of photographic realism. For example, the child learns to use overlapping or hidden line elimination long before he uses diminishing size with distance; he also learns relatively early to represent dimensions on buildings by including sides as well as frontal elevations.

The inadequacy of early descriptions of perspective drawing also accounts for the confusion and contradictions among earlier writers for the age norms quoted for its inception. Harris disputes Leroy's findings, for example (p.213, 1963). Neither of these writers offers a precise definition of what they mean by perspective drawing. Leroy presumably means that a perspective drawing is one that contains any attempt at dimensionality since she asked children to draw single three-dimensional objects, where one of their salient features is that they have depth and interiors. Whereas, for his part, Harris possibly alludes to some demonstration of an understanding of central vanishing point linear perspective and some regularity and coherence in the use of perspective.

A series of studies which are very much more rigorous and precise in their definitions of perspective have been conducted by Willats (1977), and these will be described in detail shortly. He found that, in general, linear perspective drawing still posed problems and was not fully mastered by students of 15 to 17 years of age. In view of the foregoing, surprisingly enough, Leroy too found that only 65% of her 14-year-old subjects could depict perspective accurately.

All in all, it is generally agreed that perspective drawing is a late accomplishment in the child. One commentator (Gablik, 1976) has drawn a parallel between the development of perspective drawing and Piaget's cognitive stages, in which, by the way, the ultimate development in drawing is "a logical system which exists independent of perceptual experience", i.e. abstract art. Linear perspective is a late accomplishment historically, and some cultures have simply never attempted to represent depth in their drawings or paintings. Perspective is usually demonstrated to children in school in Western cultures. The child is usually taught the techniques of producing artificial perspective, such as how to represent depth by drawing roads that narrow into the distance. The adolescent is taught to construct a central vanishing point and radial lines and to use these to guide his drawings of scenes. The child thereby learns the techniques and conventions of perspective (Gombrich, 1960). His interest in and ability to apply these techniques is age-related, however (Freeman, 1980).

To conclude, any mastery of the ability to represent depth in two dimensions is universally acknowledged to be a difficult task which undergoes a slow development that is often not completed by late adolescence. However, there have been very few studies of this development, and fewer have defined precisely the devices and elements of perspective drawing that are gradually incorporated and contribute to a true to life representation of depth in drawing. Very few studies have produced age norms for the development of these devices or, indeed, have established clear age-related trends. There are no studies at all of the anomalous development of the representation of depth in children's drawings.

In the following pages the representation of depth in children's drawings will be analysed more closely and recent concepts and studies will be briefly reviewed. The next chapter will report how a number of drawing devices used by children in the graphic representation of depth have been isolated and studied experimentally by the author. Norms and trends will be described and implications discussed. This, of course, has direct bearing on the subsequent discussion of the anomalous development of the group of children with severe learning difficulties.

## A Review of the Studies on Drawing Techniques Associated with the Representation of Depth in Children's Drawings

Freeman (1980) has recently addressed himself to the problems facing the child in the representation of depth and he has produced the best analysis of the subject to date. He distinguishes between drawing devices and drawing systems. Drawing devices are discrete techniques or elements that the child can use for depicting an aspect of pictorial depth. Freeman restricts his discussion of drawing devices almost exclusively to the development of the depiction of occlusion or hidden line elimination. Drawing systems involve the

integration of these devices under a superordinate system in which a general projection principle is observed.

Freeman discusses the geometrical abilities that children would need to possess for pictorial construction as was quoted earlier. Most of his work, however, is concerned with the pre-schematic stage of development and here he is particularly concerned with relational responding and the external frame of reference and the co-ordination of orientation cues. In his view, there are many possible drawing devices the child can use for dealing with relationships between discrete elements, and these are progressively incorporated. He selects the strategies the child can use to represent one object placed behind another for an analysis of age-related trends. Freeman found that he could group children according to the drawing device they adopted to represent occlusion, and describes a development from the segregation of objects in a drawing to the ability to represent occlusion using hidden line elimination. There is also an intermediate stage when children represent the occlusion of one object by another by enclosure or interposition. Freeman's conclusion was that drawing devices "are not just 'tricks of the trade' but are indices of specific abilities at handling pictorial depth relations in situations when purely two-dimensional abilities fail to differentiate children". Reviewing the few studies that have been undertaken by other researchers on drawing devices, Freeman claims that there are two conclusions that can be drawn from this work at present:

(1) There is a discernible horizontal bias in the free drawing of children in the disposition of objects on the page. However, this bias can be experimentally manipulated and children can be made to produce a vertical bias in certain conditions.

(2) There is a strong tendency, in the younger child, to draw objects as segregated which gives way to hidden line elimination after the age of six years when a small number of children will attempt H.L.E., increasing to approximately 50% of children by age 9 years (Freeman, 1980, Fig. 76, p.225).

In discussing drawing systems, Freeman draws heavily on the work of Dubery and Willats (1972) and Willats (1977). Drawing systems can be described in terms of the type of projection system involved as well as the complexity of the orientation. Willats has assessed how different drawing systems are used at different ages from orthographic projections through to linear perspective. The stages that Dubery and Willats identify are:

(1) *No Projection System:* a base-line may be used (e.g. for a table).

(2) *Orthographic Projection:* in which objects are depicted as flat projections in which all lines, contours or edges of the object are given their proportions as in life. Objects therefore are drawn without reference to a spectator or a fixed viewpoint as if every part of the object was seen head-on.

(3) *Oblique Projection:* here objects are viewed from the front and the side and a compromise is achieved between elements of linear perspective and the geometrical properties of the objects depicted. For example, a table in oblique projection would be depicted with the front and rear edges in the top/bottom plane being of equal length. This, of course, transgresses the linear perspective view if the table is viewed head-on, but retains a known, geometrical relationship. Linear perspective may be used in the right-left or left-right plane, however. No one fixed viewpoint is possible with this projection.

(4) *Naïve Perspective:* where perspective is used but foreshortening is often incorrectly applied and obliques do not all converge to a central vanishing point.

(5) *Linear Perspective:* this has been described by Gombrich as "a non arbitrary method of pictorial illusion relating directly to a common visual experience and based upon certain constant characteristics". Dubery and Willats claim that it is the most abstract drawing system. This view will be discussed in more depth shortly.

Freeman claims that Dubery and Willats' description is

> a good classificatory system for finished products (drawings) according to complexity of underlying construction, whereby it becomes comprehensible how the core of say, orthographic projection can be given a more economical description than that of oblique projection.

Freeman also claims that there is a clear age-related trend in the frequency of the occurrence of the systems in the above order. But Willats found that the order represents a development in which the discovery of a new system was discontinuous rather than gradual and incremental. Freeman is particularly interested in Willats' notion of "drawing systems", pointing out that if such systems are demonstrably of a sequential nature, then it would be possible to specify a limited number of new decisions or new graphic abilities that have to be acquired in order for the child to move from one system to another.

Freeman admits that his suppositions may not hold for other cultures, and the author would be far less optimistic about whether such a regular development from one drawing system to another could be found. None of the data Freeman presents are longitudinal, and different children may arrive at the same point via different routes in the acquisition of devices and systems in drawing. Nor does he discuss the fact that development may be accelerated and some systems by-passed altogether by teaching and training in one particular projection system. Lark Horowitz (1967), for instance, argues that only a relatively small number of children can work out a realistic perspective representation on their own. "Most children need specific instruction in order to proceed." It therefore seems highly unlikely that all children make their way progressively through the five stages Dubery and Willats describe. It also seems more likely that the three middle stages represent alternative systems of approximately equal complexity and these may represent a stage between orthographic projection and linear perspective. Freeman points out an increasing feature of the supposed progression, however, as the child progresses through the stages, he is increasingly constrained towards representing one fixed view point. To paraphrase Freeman: the descriptive system moves from a general purpose view of objects that succeeds to a limited extent with everything, at the cost of depth and realism, to linear perspective which is a powerful system for representing objects from a single point of view and in depth. Finally, Freeman claims that if we could identify a sequence of the acquisition of devices and systems, we would be able to map their development and compare them with theories of perceptual development.

## Theoretical Problems of Linear Perspective

In Gibson's terms, "artificial", or linear perspective could be defined as a two-dimensional representation of some of the major characteristics of natural perspective in the optic array as it appears at a single moment, from a single point of view. In attempting to draw in linear perspective, the adolescent is

creating a two-dimensional image of some features of this natural perspective. The greater the degree to which he is successful, the closer will his drawing coincide with natural perspective and with the laws of optics and principles of light and geometry. So, when the adolescent draws in perspective he is discovering and recreating some of the properties of geometry and optics (Kemp, 1978). However, the relationship between the actual world of objects, and the space they occupy and the pictorial representation of this visual world is highly complex. (See Farber and Rosinski, 1978, and Goodman, 1976, for a useful discussion of this relationship).

Gregory and Gombrich (1973) discuss illusion effects in vision and in pictorial representation. It is well known that the brain interprets, selects and sometimes distorts the visual information received on the retina. Gombrich (1972) maintains that linear perspective is just such an illusion effect, since it creates the illusion of depth where none exists because the paper or canvas is a flat surface. In vision, a great deal of depth perception is achieved by binocular views. A flat picture therefore cannot fully mirror the two separate and disparate views received by the two retinas. We rarely view from one fixed static point since, not only do our heads and bodies move about constantly, but our eyes make small rapid movements scanning the visual field (Gregory, 1967).

The most systematic projection, however, which corresponds most closely to perceived reality and the laws of optics remains the central vanishing point linear perspective. Objects diminish in size from the viewer in a uniform and linear manner. Gombrich has pointed out these regularities and says that linear perspective "relates directly to common visual experience" and Gibson (1979) too expresses a direct relationship between "artificial" and "natural" perspective — "drawing in perspective depends on viewing in perspective". In linear perspective then, the individual fixed viewpoint is fundamental to the representation. The objects depicted are dependent on the viewer, and objects are represented only from a single view-point. Linear perspective faithfully records all occlusions and distortions of angle or light because the viewpoint is static. Some writers have claimed that this system is both limited and qualified. They see it as artificial and conceptualized and bearing little relationship to the slippery and elastic conditions of vision where the viewer moves, glances, runs his eyes over and examines objects.

The laws of linear perspective were first described in the Renaissance. The discovery is attributed to Brunelleschi and was first described by Alberti in DiPictura (1584). As we shall see, its construction is highly complex and many painters in the Renaissance and Photorealists today have to rely on aids such as pin-hole cameras or on constructing a central vanishing point and linear radials for the accurate constructions of linear perspective. A drawing in perspective is a projection of a three-dimensional scene onto a flat plane. A simple demonstration was given by Leonardo who said that perspective in drawing was like seeing through glass on which the visual world is projected:

Freeman (1980) argues that oblique projection may satisfy perceptual and cognitive expectancies better than linear perspective, and that it is closer to

canonical representation. He reports a study by Hagen and Elliott (1976) who researched with adults and asked them to select the "most natural drawing" from a series showing various projection systems of a cube seen in depth. Adults persisted in preferring representations that approximated to oblique

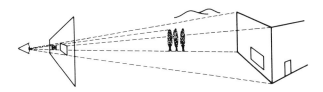

projection rather than to linear perspective. It would be reasonable to conclude that proper linear perspective does not look so "natural" to the adult viewer, and the most satisfying view is not therefore, a duplicate of a single fixed viewpoint.

Arnheim too, argues that an oblique projection unambiguously represents certain important relationships that may be the most salient features of the object. He says that obliqueness allows that such relationships are not violated in the representation, e.g. the nearer and further edges of a table are represented as being the same length; oblique projection allows for length to be treated as a constant in one orientation and therefore gives no preference to one fixed viewpoint; a range of views is suggested. Linear perspective is much more complex and involves the adolescent in drawing a view or an object, such as a table, that does not yield the common symbolic or canonical representation. Freeman maintains that the canonical representation of an object is pre-eminent, not only in drawing, but in picture preference, as described above. Where the canonical view is seriously violated then, as frequently occurs in linear perspective, even adults will choose a less photographically realistic and more canonical representation.

As we have seen, the laws of linear perspective are a relatively recent invention; moreover, there are some psychological objections to assuming that this projection system is the most advanced and satisfying. Closely allied to this, we have already noted that a drawing in linear perspective is only like our visual experience when the scene is viewed from one fixed viewpoint only. There are yet further limitations to linear perspective which arise from laws of physics and optics.

The perspective radials that can be described in linear perspectives are only approximately linear and these lines are straight only for a view at some distance from the viewer and at the centre of his visual field. The linear radials of perspective describe decelerating points and are in fact sine curves. As these radials approach the edge of the visual field of the fixed eye of the viewer, they do, in fact, appear to bend outwards. Objects very close to the fixed eye

appear larger and this is why, if a tall building is viewed close to, at one of its apexes, the receding top of the building appears to bend:

There are, then, a number of limitations and constraints to the notion that linear perspective is the system which is closest to "common visual experience".

True linear perspective is only perceived where the scene is viewed from one stationary eye; where the view is at a considerable distance from the viewer and where the angle of view is low and towards the centre of the visual field.

Goodman (1976), in discussing normal vision and linear perspective, reminds us that given these conditions what actually happens is that what we are looking at promptly disappears! He points out that experiments have shown that eye movement and scanning are essential for normal vision.

It is little wonder that the discovery of linear perspective is a late accomplishment historically; it has also been pointed out that this projection system could not have been discovered without a carpentered environment of streets and buildings. A central vanishing point and linear radials would have been an almost impossible discovery in a natural environment where the only observation one might make is that objects appear to diminish in size with distance.

To confound the matter further, humans are subject to all sorts of illusion and distortion effects. It is well known that the brain compensates for diminished size with distance for relatively important objects such as human figures, so that they do not appear as small as they are, in terms of retinal size, as they recede from view (the phenomenon known as size constancy: a useful discussion can be found in Gregory, 1967).

Finally, the relationship between the size of the object and distance from the viewer in linear perspective can be expressed mathematically and is a highly complex logarithmic function. Its graphic construction without constructional aids is, therefore, extremely difficult. Without the construction of radial lines in perspective, we must rely on approximate judgements of eye and hand which are frequently inaccurate. So, although linear perspective is a system which approximates to our actual view of the world in some limited situations, in graphic production, it has to be constructed and this involves the complex logical and intellectual activities of geometric construction and measurement.

> Perspective is the guide and the gateway; and without this nothing can be done well in the matter of drawing.

(The notebooks of Leonardo da Vinci, P. Taylor, ed. Mentor, New York)

# 5

# An Experimental Examination of the Development of the Representation of Photographic Realism in Children's Drawings

The development of the ability to represent photographic realism in children's drawings is investigated in this book because it was possible to identify a very small group of intellectually retarded children who are distinguished by using photographic realism in their drawings at a very early age (between 5 and 8 years of age while having severe learning difficulties). The author was faced with the fact that the drawings of this group showed obvious qualitative differences from the drawings of normal, average children of the same age. The first task was therefore to objectify and make specific these qualitative differences. As has been said, the main difference was that the retarded groups drawings were more photographically realistic. Further analysis showed that certain elements or aspects of photographic realism and devices for its depiction could be isolated and described. Freeman (1980) has similarly isolated aspects of depiction and has begun an analysis of how children in the schematic stage of drawing (5–10 years) depict occlusion (one object partially hidden behind another). He finds an age-related change from the segregation of objects, through one object depicted ''seen through'' another, to the ability to eliminate the hidden lines altogether. Hidden-line elimination, then, is one drawing device that the child needs to master in order to represent photographic realism.

It was possible to isolate other elements or devices the child needed to master in his drawing in order to achieve an approximation to photographic realism. Earlier literature was searched to discover which devices or aspects of the representation of depth other authors had considered, although the author's own observations had already provided clues.

In order to draw more realistically, the child should have mastered, to some extent, an ability to draw in proportion. He should also have learned the techniques or devices for representing objects with three dimensional characteristics as having depth and dimensionality. He should also have some graphically demonstrable understanding that objects and scenes can be

45

depicted on a two-dimensional flat surface so as to create an illusion of depth. The most potent method of creating this illusion is by placing nearer objects in the foreground at the bottom of the paper and farther objects at the top of the paper. Along with the realization of this organization will go the representation of diminishing size with distance (e.g. uniform objects, such as telegraph posts, become smaller towards the top of the paper; road boundaries converge etc.).

Apart from Freeman's identification of devices for representing occlusion, there are here three further elements or devices that will play a part in the representation of photographic realism:

(1) Proportion
(2) Dimensionality, i.e. representation of three dimensions in single three-dimensional objects
(3) Diminishing size with distance

The child must master and integrate all of the elements and devices (and certainly others too) into his drawing in order that he may achieve a photographically realistic representation. There are further techniques for depicting depth, of course, such as foreshortening and shading. The early Egyptian artists and calligraphers used cut off to indicate occlusion. But those techniques are generally far more sophisticated than these four devices and are generally only used at an advanced stage during adolescence. The four devices identified above are their precursors.

How do the drawings of the group of retarded children differ from those occurring in normal drawing development? Studies of the inception and development of these elements or devices in normal children were examined.

It was evident that there are rather few studies of the schematic stage of children's drawings and of the development of the representation of depth. Descriptions of the stage are given by Barnhart (1942); Lark Horowitz (1939, 1967) and Harris (1963), but descriptions have rarely been substantiated by rigorous experimental analysis or systematic data collection. It seemed necessary, therefore, to include in this research programme further studies of the representation of photographic realism in order to make direct, and therefore more meaningful comparisons between normal and abnormal drawing development. A more thorough description of the development of photographic realism in children's drawing could thus be attempted, and norms for the incorporation of elements and devices used by children to depict photographic realism be given. A scale of development could thereby be devised by which normal and abnormal drawing development could be evaluated. (This anticipated Freeman's discussion of the possibility of isolating drawing devices and drawing systems and studying their inception in children's drawings, 1980, Chapter 7).

In order to make a useful comparison between the development of the representation of depth in normal children and such a development in an abnormal group, it was necessary to consider many aspects of the representation of photographic realism. Four aspects have been chosen here for closer examination, since these are generally acknowledged features which have been

previously studied and they are all complementary aspects of the representation of depth. It was decided not to concentrate attention on one aspect alone since it was hoped to highlight more than one feature of the drawings of the abnormal group and not all the drawings of the anomalous group show all these elements. (For instance, some are drawings of single objects where diminishing size with distance is not an essential feature of the accurate photographic representation.) An advantage of including more than one element is that the overall results give a broad sweep of the development of the representation of photographic realism rather than isolating one feature for investigation. However, many interesting questions were raised by the studies about to be reported, which it was not possible to pursue. These are discussed in the Conclusions section.

The objectives of the following experiments can be summarized as follows:

(1) To isolate elements and devices in the representation of photographic realism in children's drawings.
(2) To show whether the incorporation of the devices in children's drawings showed a developmentally sensitive trend.
(3) To establish norms for the development of these elements.
(4) To demonstrate whether it is possible to promote these elements or devices in children's drawings; i.e. Can stages of representation be accelerated by simple procedures such as varying instructional content, or solving some of the basic problems of production for the child?
(5) To identify possible sex differences in the development of these elements.
(6) To combine the experimental results to provide a scale of comparison for the normal, average development of the representation of photographic realism and anomalous development.

The studies were begun in 1975 and completed in 1980.

## The Development of the Representation of Photographically Realistic Proportions in Children's Drawings

Commentators on the subject of children's drawings have noted that young children have difficulty in portraying photographically realistic proportions (McCarty, 1924). Freeman (1977), for example, comments on the young child's "immense tendency to draw the head larger than the trunk well into middle childhood".

There are two discernible cases in which the child ought to take account of proportions in order to render a reasonably photographically realistic representation in his drawings. The first is the simple case of the representation of accurate proportions within a single object. This case will shortly be considered in some detail. The second case is representing proportions between objects. This case is much more complex since the child has to consider not only the situation where the objects are placed on the same plane and at an equal distance from the viewer (i.e. their comparative objective size), but also their relative subjectively perceived size at varying distances

from each other and from the viewer. (The second case will be discussed more fully in the section on diminishing size with distance). The first case is investigated here as it is much more basic and simple to achieve in drawing where one might expect the child to first reveal a gradual awareness of the possibility of representing photographically realistic proportions.

It was similarly decided to concentrate on human figure drawing since the human figure is a preferred subject in children's drawing and more highly practised; hence one might reasonably expect that it would be one of the subjects where one might expect to detect more sophistication and realism at an earlier age.

There are surprisingly few studies of the development of photographically realistic proportions in human figure drawings. Very few of the early studies offer statistical evidence and they are often descriptive e.g. McCarty (1924). Harris (1963) reports on the very early work of Schuyten (1901) and Lobsien (1903). This work is unobtainable and no translation from the Dutch is available. In any case, Harris reports "no precise norms were established", although he goes on to say that both authors reported that "with increasing age the proportions of the different parts of the body, as drawn by children, approach more nearly the realistic standards".

Lobsien (1903) compared normal and "retarded" children and found that the use of photographically realistic proportions in the latter group was much more immature and lagged behind normal development. Another study on the child's development of photographically realistic proportions was undertaken by Wolff (1946). But the study is only indirectly relevant since he investigated the use of proportions in relation to personality and affective characteristics of children. However, his measurement of body-part ratios provides a useful method of assessing the child's use of proportions.

Although observational studies of the development of children's drawings agree that human figure body-part proportions show developmental sensitivity in the direction of more photographically realistic productions with age, there is a notable paucity of experimental work. It was therefore worthwhile to test this in a more systematic way. A subsidiary question was whether children learn to represent body proportions in a more realistic manner gradually in a continuous development, or whether a stage effect would be discernible. Sex differences could also be assessed.

Three school classes with 30 children in each class (approximately 15 boys and 15 girls) and ages 5–6 years, 7–8 years and 9–10 years were requested to draw a man. Each drawing was then scored for head/trunk ratios using 1/10 inch transparent grid. Head and trunk lengths were also measured.

The performance of the three groups were compared using an analysis of variance for factorial designs. Sex differences were not significant. Group differences (age) were highly significant ($p < 0.001$). The change of head/trunk ratios with age is expressed graphically in Fig. 1.

Head/trunk ratios were measured by means of area ratios. This method gives the best measure since both width and length are taken into account in one composite area measure. However, it could be possible that there is a

persistent bias in one direction with either head and trunk such that the area ratio could mask the possibility that true to appearance overall lengths were being produced. It was therefore decided to measure head and trunk lengths as a further check to see whether lengths, irrespective of area, showed similar

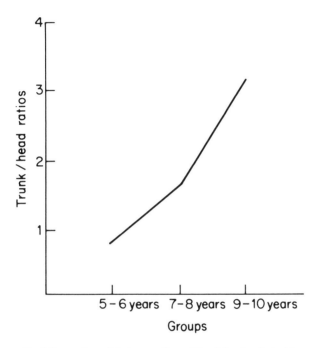

*Fig. 1* Proportions of the human figure (Trunk/head ratios) with age.

developmental trends. Means were computed and very similar trends to the head/trunk area ratios were discovered. It was therefore concluded that area ratios give the best measure of proportion and accurately reflect other, unidimensional proportions within the drawn figure across subjects.

These results provided empirical support for the general observation that children produce more photographically realistic proportions in their free human figure drawings with age. The results showed that on average, 5-6-year-old children draw the head larger than the trunk. By 7-8 years, the average child draws the trunk slightly larger than the head, and by 9-10 years the average child produces a trunk which is approximately three times larger than the head size. Taking the head/trunk ratios of a number of photographs of a standing male figure, the actual photographically realistic proportion for head to trunk is approximate 1 : 6 + . Even by the age of 10 years then, the normal child has some way to go before representing photographically realistic proportions in their human figure drawings, and the "immense tendency" to over-estimate the size of the head remains.

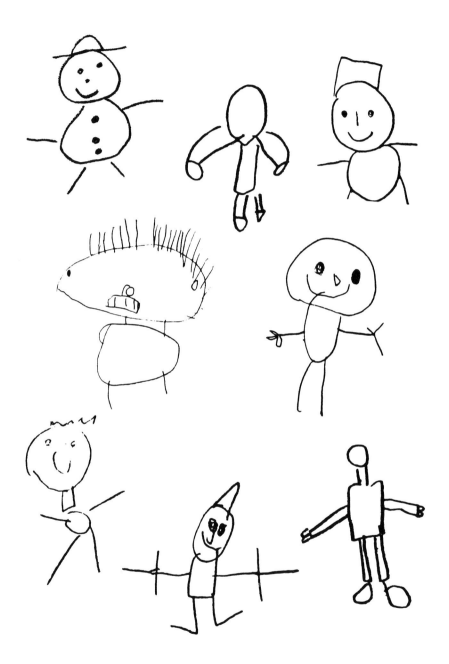

*Fig. 2.* Examples of normal children's drawings of a man (5–6 years of age).

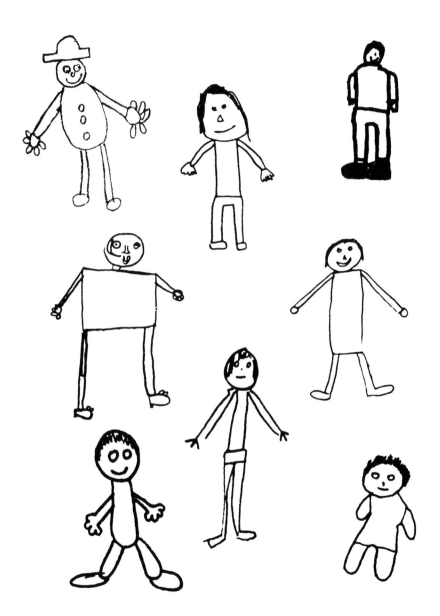

*Fig. 3.* Examples of normal children's drawings of the human figure (7–8 years of age).

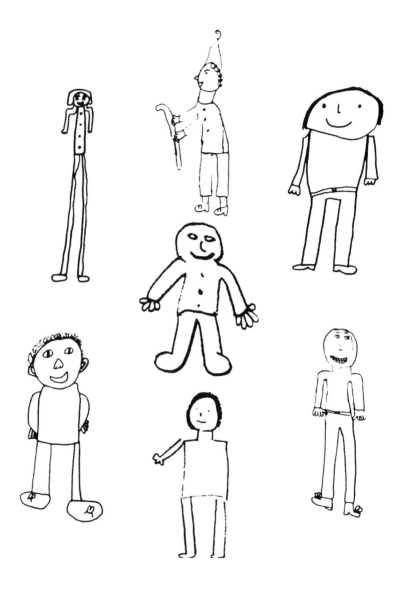

*Fig. 4.* Examples of normal children's drawings of the human figure (9–10 years of age).

*Fig. 5.* Photographically realistic drawing of a man presented to subjects in Experiment 2. (Completed by a subject aged seven years, four months).

It can be seen that the tendency to produce more photographically realistic proportions with age is not strictly linear; there appears to be an acceleration in this tendency after the age of 8 years.

Bassett (1977) reports that when children were given cardboard cut-outs of the parts of the human figure to construct a man, children of 4 years were much more successful in this task than in their drawings. Moreover, she claims that their choice of pieces for arms and legs showed an understanding of proportionality not evident in their free drawings. It was decided to investigate whether children could be promoted to produce more photographically realistic proportions in their drawings of the human figure.

The young child has many problems to solve in drawing the human figure; predominantly he has difficulties in organizing space and in remembering and representing the sequence of parts of the drawing (Freeman, 1980). It might be expected that there would be a much higher degree of accuracy in producing photographically realistic proportions if the trunk, arms and legs of the figure were pre-drawn, thereby solving problems of spatial organization and sequencing.

The child only has to draw the head of the figure, a single oval shape, of the appropriate size. The incomplete figure has been used as a technique for observing children drawing by several authors; Gesell, 1954; Terman-Merrill, 1960; Ames and Ilg, 1963 and Freeman and Hargreaves, 1977.

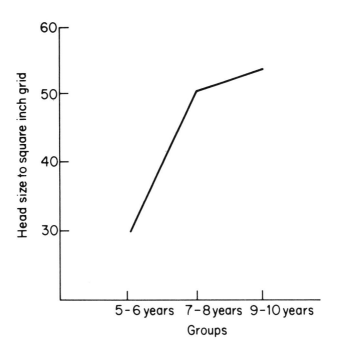

*Fig. 6.* Proportion as a measure of head size means with trunk already drawn.

Three classes of approximately 30 children of 5–6 years, 7–8 years and 9–10 years, were selected from a different primary school from the first study. All the children were given the drawing of a headless figure of a man, traced from a photograph, on A4 paper (See Illustration). Each drawing was scored for head size using a 1/10 inch square transparent grid.

The performance of the three groups was compared using an analysis of variance for factorial designs. Sex differences were not significant. Group differences were significant ($p < 0.001$). Further analysis showed that the differences between the two older groups did not reach significance. The change in head size in drawings, with age, is expressed graphically in Fig. 6.

The results of this experiment were surprising. From all previous observations and studies, one might have expected that the children would over-estimate the size of the head at all ages, as they did in the first experiment. In this second experiment the reverse tendency was discovered. All of the children under-estimated the actual photographic size of the head. This was most marked in the youngest group, this trait becoming progressively less marked with age, but even by 9–10 years, head size was still under-estimated. Also the accelerating trend towards more accurate proportions with age was reversed too. The greatest change between the groups occurred between 5–6 and 7–8 years. Thereafter the trend decelerated.

Before discussing the unexpected aspects of these results, the most relevant issues must be examined. This method failed to produce photographically realistic proportions in children's drawings of the human figure. It is obviously difficult to promote drawing with more accurate proportions even when trunk, arm and leg proportions are already drawn from the child. Even by the age of 10 years, the average child is not able to represent photographically realistic proportions, at least, not by this method.

It was possible to compare ratios in the two experiments, and to some limited extent the second study does produce a method for promoting more accurate proportions. But the overriding conclusion must be that, despite so many of the problems encountered in production being solved, children still have difficulty in representing photographically realistic proportions up to 9–10 years.

To return to the unexpected finding that head size was under-estimated rather than over-estimated in the second study, is there any possible explanation for this? It is not proposed to pursue this question too far, since it is not directly relevant to the subject at issue, except that this occurrence underlies the problem the child has in representing photographically realistic proportions.

A possible explanation could be pursued involving the differential use of frame of reference with age (Freeman, 1980). However, from the author's observations of the task another explanation is suggested. In human figure drawing, children almost invariably commence with the head. In the younger years this is drawn as an independent discrete shape (sometimes without sufficient account given to planning the space below the head). Children

usually next add the trunk with consequent problems of alignment, placement and judgement of proportions.

Quite apart from the difficulties with placing the trunk, the larger the space transcribed by the trunk, the greater the chance for motor error, and inaccuracies to be magnified.

The well known "immense tendency to over-estimate the size of the head" could just as well be a tendency in younger children to be unconfident and unadventurous in representing the true size of the trunk. The same may apply to the situation where the trunk is predrawn; the younger the child, the more hesitant and the less adventurous his line in drawing the head. Problems with alignment, placement and the possibility of magnifying errors may cause the child to adopt a parsimonious strategy and may account for both tendencies, (a) to under-estimate the size of the trunk in free drawing and, (b) to under-estimate the size of the head in this study.

In conversation with Paul Light another problem was discussed. He pointed out that the size of the figure to be completed in the second study was generally much larger than the figures produced by children in their unconstrained drawings and that the child may simply be responding by drawing in the size of head he would normally produce in his free drawing. It was decided to test this explanation. The original drawing used in the second study was reduced in size to approximately half the size and then reduced by half again so that three size versions of a headless figure were obtained. These three drawings were then presented to children of 5–6 years, 7–8 years and 9–10 years (12 children in each group) in a randomized order. It was found that head size was under-estimated by all three groups and in all three size presentations. It was also found that the head/trunk ratios at a particular age level, for the three presentations was approximately a constant. Children tended to duplicate the ratio of head/trunk size in the three versions so that head/trunk scaling appeared to be independent of the size of the figure to be completed.

## Comparison with the Anomalous Group

One of the outstanding features of the anomolous group's drawings is that they all use drawing devices associated with the final stage of drawing visual realism, at a very early age. However, all the children in the group were otherwise mentally retarded. In their drawings all demonstrate a more advanced and photographically accurate use of proportions than normal average children.

Direct comparison between the findings in these studies and the performance of the group are difficult. The studies investigated the use of proportions in human figure drawing since the figure is simple in terms of depth differentials (i.e. relatively flat), and it is also well practiced as that one might expect to see the start of the representation of more photographically realistic proportions. Only a few of the children in the anomalous group drew human figures, an unusual fact in itself, and only one child showed a regular

preference for human figure drawing. Claudia's human figure drawings from the age of 8 years show remarkably realistic proportions (Dwg. 31) (This was established using a 1/10 square inch grid). Human figures also appear in Richard's, and Nadia's work (Dwgs 39 and 52) and again, although less accurate, the proportions are generally more realistic than the production of normal children of the same age.

Quite apart from the simple case of within object proportions, a photographically realistic representation of between object proportions is essential for the realistic representation of depth. To vary these proportions accurately with depth is a complex achievement quite beyond the reach of any of the normal children studied. However, this is attained by the children in the anomalous group; this achievement will be discussed in detail later in the section on diminishing size with distance.

### Dimensionality as a Means of Representing Depth in Single Objects in Children's Drawings

Several authors report that in the early stages of drawing, children typically represent objects flatly in two dimensions (Barnhart, 1942; Harris, 1963; Lark Horowitz *et al.*, 1967). There are, however, very few empirical studies that investigate this phenonomen, and there are none that attempt to give age norms for the development of the depiction of three dimensions in single objects in children's drawings.

At the pre-schematic stage of drawing, a canonical representation of an object is confined to a simple one-sided representation of the object where characteristic and salient features are added. Either a front or side elevation is depicted, whichever is the more characteristic of the object (Freeman and Janikoun, 1972). During the schematic stage the representation is elaborated. The child will attempt to incorporate more of the salient features and these may include side and rear elevations of the object. These are usually "tacked on" to the original canonical representation. Later still, and usually not until adolescence, the child will be prepared to deform his canonical representation in favour of a single fixed view representation of the object.

It was decided to investigate the development of this phenonomen in normal children in order to compare their performance with that of the anomalous group.

Lark Horowitz (1967) reports that one of the most common subjects that the child freely chooses to draw is a house. She reports on two studies (Maitland, 1895 and Ballard, 1912), where houses were the most popular subject chosen by children only after the human figure. Houses then are a popular, and therefore well practised, subject where one might expect to see early evidence of growing sophistication in drawing. The representation of a house also presents the child with an essential puzzle. Early on, houses are represented in children's drawings as flat objects with only front elevations visible. The child is likely to be aware that the essential characteristic of a building is its depth,

space and solidity. It is plausible that it is through his knowledge of buildings that the child becomes aware of the ambiguous and unsatisfactory nature of flat representations in drawings. Since houses are a preferred and well practiced subject, and since dimensions are an essential characteristic of them and are relatively easy to depict, it was decided to investigate the development of dimensionality in children's drawings of houses.

The free drawings of houses were collected from children of 5–6 years; 7–8 years and 9–10 years. Any attempt to represent a side elevation as well as a front elevation was scored as positive. Normal children of 5–6 years of age did not attempt to represent any side other than the usual canonical rectangle plus roof. By the age of ten years the majority, but not all of the children, attempted an elaboration of the frontal view by incorporating sides. An obvious question arises from the foregoing: Can the children represent another dimension in their drawings of houses, but simply do not choose to do so? It was decided to attempt to promote the representation of a further dimension in children's drawings of a house by making the instructions explicit and by directing the child's attention to the problem of representing an oblique view of a house where front and side are visible. The situation was made concrete by using models and cut-outs. The attempt to produce a drawing of a further dimension in this manner produced mixed results. None of the 5–6-year-old children represented a further dimension. Their performance remained unchanged from the first occasion although many looked puzzled, realizing that their canonical representation was inadequate, but being unable to produce a further dimension. Significantly more children at 7–8 years and 9–10 years than on the first occasion produced further dimensions in their drawings on this second occasion. The second study showed that it is possible to promote the depiction of further dimensions in older children. Clearly, after the age of seven years, some children have a more elaborate representation of an object within their competence, but in their free drawings they do not always choose to use it. However, none of the 5–6-year-old children were able to extend their front elevation drawing of a house or, at least, the method described failed to produce a change.

A further question raised by these studies in whether the graphic representation of a further dimension represents a genuine change towards a more photographically realistic representation or whether it merely represents an elaboration of the basic schematic or canonical drawing. The elaboration of the basic form in itself must show that the child has a growing recognition that his previous drawings are not wholly satisfactory or veridical. But there is a fundamental difference between an elaborate schematic drawing and a photographically realistic drawing. For example, the latter need not be at all elaborate (see Drawing 3).

Observations of normal average children drawing and of the finished product were instructive. Freeman (1980) observes that children have persisting difficulties in representing right angles by acute angles in drawing. None of the children in these two studies represented the base line of the side of the house as an acute angle where it joins the front elevation. The side

elevation was invariably "tacked on" as another rectangle, rather than as a parallelogram. Such subjective distortions of the solid facts of angle and line are essential in representing the photographically realistic image. None of the children, up to 10 years of age, then, were able to represent photographically realistic angles in their drawings of buildings, and their drawings represent more an elaboration of the schematic stage rather than a development of a single fixed view or photographic realism.

Lastly, it was decided to attempt again to promote the representation of another dimension by presenting the child with a tangible concrete example of the problem in hand.

Three groups of children of 5–6, 7–8 and 9–10 years were selected. There were forty children in each group. Each child was presented with a rectangular box placed at an angle to the viewer so that the top and two sides were clearly visible. The child was requested to draw the box on A4 paper. He was next presented with the same box and a flat card rectangle of the same dimensions as the top of the box and requested to draw both and to show how the two objects were different in his drawing. He was given foolscap paper for this second drawing.

The drawings of the box alone were scored and any attempt at representing a further line beyond a basic rectangle was scored as positive. The drawings of the box and flat rectangle were similarly scored.

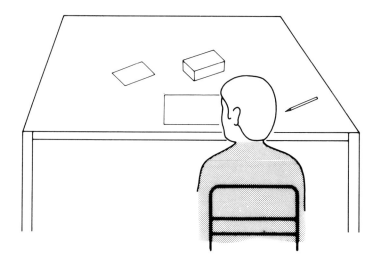

*Fig. 7.*

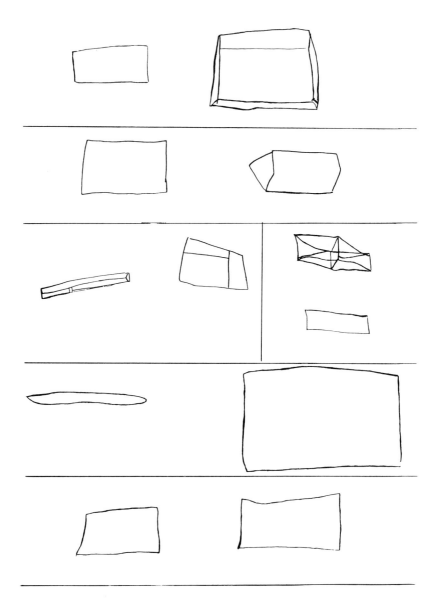

*Fig. 8.* Examples of subjects responses; subjects were presented with a rectangular box and a flat card rectangle. They were instructed to draw the two objects and to try to show how they differed. Drawings have been reduced to approximately three-eighths of the original size.

It was found that again, in both conditions there is a highly significant trend towards representing further dimensions with age. The results were very similar to those in the previous two studies and the productions of children at the three ages who succeeded in representing another dimension is similar in this experiment. However, in this study, where the child is given a three dimensional model at the outset, he draws his most elaborate production on the first occasion. Despite the representation problem being made as manifest as possible, only four out of 120 children elaborated their second drawing of the box.

It was hypothesized that by presenting children with two models which were different in the important essential of dimensionality only, that children would be forced to adopt some sort of drawing strategy that would represent the difference. The results revealed that significantly few children changed from their first representation of the box at all ages. If the child had not indicated dimensionality in his first drawing, he was unable to on the second occasion, although the problem had now been made obvious. It would seem reasonable to conclude that if the child could make some attempt to depict another side, he did so on the first occasion. Many of the children who represented both the box and the flat rectangle as a basic rectangle were puzzled and passed a remark on their failure. One child said "It's got sides. I can't" (meaning— draw them too). Children were clearly puzzled about the alignment and placement of additional sides. Again, very few of them represented side angles as acute angles. Acute angles only occurred as the final unavoidable closure of two lines. Most of the representations of the box where more than one side was included, consisted of a series of rectangles adjoining one another (see illustrations).

## Comparison with the Anomalous Group

An examination of the drawing of the anomalous group shows that there is evidence for most of the members that they were representing depth in objects by using front and side elevations from a young age; certainly from 6 years of age when all but one of the normal children failed. Not only are the anomalous group representing further dimensions in their drawings of buildings and other objects, but the angles of receding or projecting sides are drawn as acute or obtuse angles as in Dwgs 1, 4, 21 and 47. The use of dimensionality is manifestly different in the anomalous and normal groups. All the retarded children's drawings are photographically realistic, drawn as if the scene is viewed from one fixed viewpoint, rather than the elaborated schematic drawings described in these studies of normal children.

## The Representation of Diminishing Size with Distance as a Means of Depicting Depth in Drawing

The phenomenon of representing depth by drawing diminishing size has received very scant attention. The development of its use as a graphic device in children has hardly been touched upon. However, it is one of the most potent ways in which depth can be suggested in a drawing of a scene. It also relates directly to the child's development of the ability to represent a receding plane on a two dimensional flat surface. Barnhart (1942) describes this development and he claims that children at the schematic stage do not use this device coherently or consistently to depict depth. Freeman gives this matter scant attention and it is only mentioned in his earlier work (1977). He discusses size scaling (1977) but only for the drawings of single objects in relation to the size of paper offered the child. He is interested in size scaling as an example of the child's ability to plan ahead to fit and scale his production to the available paper space. However, Freeman reports one or two interesting and relevant findings by other workers. Gridley (1938, for instance, found that even 4-year-olds can scale their drawings depending on the size of paper presented. In contrast, the concern here is to investigate how children scale one object against another drawn object in their graphic representational productions to create an illusion of depth in their drawings.

The problem of the graphic representation of depth cues using interdepicted object scaling clearly presents the child with a much more difficult problem since they have to scale first to the size of the paper and then to previously drawn objects.

From an observation of free drawing of children, it was discovered that children of under 7 years generally fail to represent diminishing size with distance. It would appear that either young children fail to understand that depth can be suggested by an up-down organization where the top of the page represents a further distance from the viewer and the bottom, a nearer view, or, at least they are not concerned to represent depth in this manner at this age.

As has been said, the drawings of the anomalous group of children show the use of this drawing device from very early ages (Dwgs 4, 7, 13, 24, 30, 39, 48 and 51). This raises questions as to why the device is not used by normal average children. Is it a question of choice or does the failure represent a genuine central cognitive difficulty yet to be overcome? (Piaget, 1971).

A number of investigative studies were undertaken to try to find a situation in which children might be promoted to use size scaling to represent diminishing size with distance. It was evident that in order to examine the development of the ability to use this device, it would be necessary to find the most simple and basic situation in drawing where diminished size with distance could be used for an accurate portrayal of photographic realism. It was eventually decided that a simple straight vertical line from a fixed base represented one of the easiest prospects for size scaling that young children

could use. It was also reasoned that it would be possible to optimize children's use of size scaling if all the other problems of representing depth were solved, by presenting the child with a pre-drawn picture depicting depth. All conditions for the accurate representation of diminishing size with distance were thereby optimized. It was then possible to examine the questions:

(1) Can children represent depth by drawing diminished size with distance accurately when all conditions are optimized?

(2) What kind of production errors will be encountered, if any?

(3) Is there an age related trend in accuracy?

(4) Are there sex differences in accuracy?

The subjects comprised three groups of children of 5-6 years, 7-8 years and 9-10 years (approximately equal numbers for sex). There were approximately 30 subjects in each group. The subjects were presented with a drawing of a street in linear perspective (traced from a photograph). On one side of the drawing there was a row of five lamp-posts which diminished in size with distance according to linear perspective properties. The middle lamp-post was incomplete, only its base was drawn (see illustration). This drawing was presented in four variations which were randomised; presentations to the left and to the right and a small and larger versions of the same picture. Right and left presentations were given to see whether there would be differential responses due to hand position obscuring parts of the picture while the child was drawing. A small and large version of the picture was used in order to assess the stability of responses with the length of line to be drawn.

Each subject was instructed as follows:

> Here is a picture of a street going into the distance. Here are some lamp-posts [E indicates]. This lamp-post is missing. Can you draw it in so that it is just the right height?

The length of each attempt to represent the missing lamp-post was measured from the bottom of the base to the top of the drawn line.

The lamp-post measurements were analysed using an analysis of variance for split plot designs. The differences between the groups for age were significant ($p < .001$). Further analysis revealed that there was a large and significant difference in the performance of the 5-6-year-olds and the older groups ($p < .001$). But there was no significant difference between the performance of the two older groups. This is apparent when the mean measures for each group are plotted graphically.

These results show that in using both large and small versions of the pre-drawn pictures, the youngest group, 5-6-year-old children, substantially under-estimate the length of the lamp-post. By the age of 7-8 years, there was a dramatic change in performance; and there was a tendency to just over-estimate the length of the lamp-posts and judgements about the size of the larger version are more accurate. The error is greater with the smaller version. By the age of 9-10 years, size judgements are extremely close to the actual photographic length (it should be noted that the scaling on the graphs is very fine, i.e. 1 inch is represented by 10 inches and 5 inches respectively).

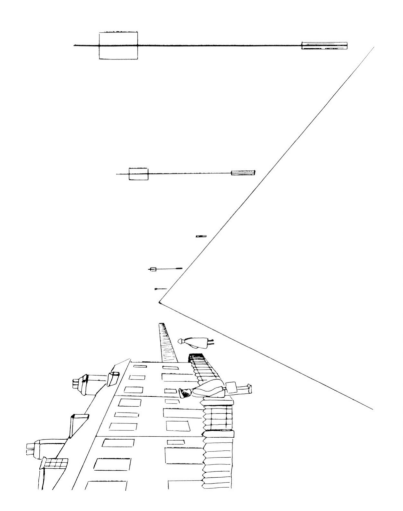

*Fig. 9.* Test picture for Experiment 6: Diminishing size with distance. (Left-hand view).

Although there appears to be little difference in the performance of the children of 7–8 years and those of 9–10 years, judging from means, the degree of accuracy was much higher in the oldest group comparing standard deviations from the mean.

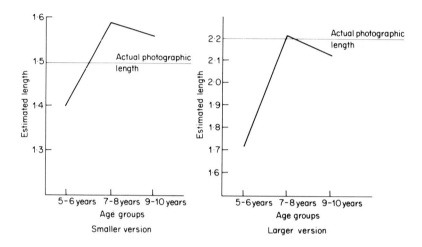

*Fig. 10.* Mean estimated length of drawn-in lamp-posts for the three age groups — smaller and larger versions.

In the analysis there was only one significant interaction effect and this was between the groups and the two size versions of the picture.

Overall, the results indicate that there is a stage effect with a discrepant and qualitatively different response from the 5–6 year-olds and the performances of the 7–8 and 9–10-year-olds. A tendency to under-estimate the size in judging diminishing size with distance changes to a tendency to over-estimate at 7–8 years.

There were no significant sex differences found in the analysis and, since there were no significant interaction effects involving the sex of the subjects, it can be concluded that the performances, in all conditions, of boys and girls were parallel.

A surprising finding emerges from the results: there was a significant difference between right and left versions of the drawing. Lamp-posts to the right of the pictures were frequently, but not invariably, drawn smaller by boys and girls, at all three ages and in large and small versions.

It would appear that young children under the age of seven years have great difficulty in judging the size of objects and executing that judgement in the graphic representation of photographically realistic diminishing size with distance. This is true even in the present experimental situation where all the conditions are optimized. The tendency at this age is also to under-estimate the size of the object in relation to other objects which have already been drawn in the depicted scene. This finding coincides with that of the previous experiment on proportion. It was suggested that young children under the age of seven tend to operate a rule of parsimony in representing proportions of the human figure where they are adding elements either to their own productions or adding to a pre-drawn incomplete figure. The same rule could be operating in this experimental situation.

Another explanation for this finding could be given in terms of relational responding (see Bryant; 1974, and Freeman, 1980, for useful discussions of this in non-drawing tasks, pp.135–142). It could be argued that in performing the present task, the children have to note the sizes of the lamp-post immediately to the left and to the right of the missing one. They must code the size of the missing one relative to these two. And they must also take account of the whole context of the task, the rest of the scene as well as the edges of the paper. They have to therefore integrate their performance relative to at least four cues (paper edge, total scene and immediately adjacent cues). All of the children were able to use the paper edge and general scene cues in as much as the lamp-posts were drawn invariably in the correct position and no lines or edges were crossed. But of much more importance and significance, virtually none of the lamp-posts, in 392 drawings, was drawn in *larger* than the adjacent large post, nor *smaller* than the adjacent small post. In this respect, all of the children could scale using both posts at once as contextual cues. Their ability to scale their graphic productions then, is not in doubt, it is the accuracy of this scaling that is under discussion. It is also evident that children as young as 5–6 years can form judgements and make a graphic response that indicates that they are able to make a relational response between two disparate cues. (Freeman, 1980, reports that 4-year-old children can respond to more than one orientation cue at once in their human figure drawings). If children of 5–6 years could only respond to one cue at a time, then it might have been expected that there would have been bimodal results: lamp-posts drawn in relation to the adjacent large post, and lamp-posts drawn in relation to the adjacent small post. No such result was obtained.

It is probable that both explanations partially explain the results; children of 5–6 years are capable of relational responding in this type of task and of integrating many contextual cues, but they also tend to under-estimate lengths, operating with a rule of parsimony.

By the age of 7–8 years this tendency to under-estimate has disappeared and it would appear that a stage effect is operating, rather than a linear incremental trend towards more photographically accurate representations. Even at 7–8 years and 9–10 years, however, there is considerable variation in the children's performance. By no means all of the children can make accurate

estimates of the length of the lamp-post even at 9–10 years and in this optimum situation. From observations of children employed in the task and from their finished productions, the task presents problems in the initial placing of the pencil and in the execution of the line. Many of the drawings showed unintentional wavering, the line was not upright, etc.

Another interesting finding was that the youngest group under-estimate the length of the line in both size presentations and all the groups tended to draw smaller lamp-posts on the right-hand presentations than the left-hand ones. Although this tendency is statistically significant, the difference is very small in terms of the overall length of the drawn lines and therefore the groups behave the same with regard to overall trends.

It could well be that this small, but consistent, difference between right and left presentations could be due to the fact that the majority of the subjects are probably right-handed (unfortunately, handedness was not recorded). The larger lamp-posts would have been partially obscured by the right hand in drawing in the lamp-posts on the right-hand side presentations. It is possible that the right-handed children were therefore responding to the relatively smaller item cues in the picture.

In drawing in the left-hand side lamp-posts, the reverse is likely to obtain. The right hand is more likely to obscure the right-hand side of the picture together with the smaller lamp-posts, and judgements may therefore be orientated towards the remaining large lamp-posts to the extreme left of the picture. This finding is only of importance here because it demonstrates how sensitive this task is to hand positioning.

To conclude, all the children studied have considerable difficulty with accurately portraying diminished size with distance in a linear perspective scene, even when the opportunity for producing accurate photographic dimension has been optimized, i.e. in drawing one straight line. Clearly, producing accurate size scaling would be considerably more difficult for most other objects where intra-object scaling has also to be considered. Also, for all the children in the three groups the judgement of the line has been discussed only in terms of overall length; most productions were inaccurate in terms of unintentional wavering and other distortions.

### Comparison with the Anomalous Group

The accurate representation of diminishing size with distance is one of the hallmarks of the productions of the autistic group of children (see Figs 7, 27, 30 and 51). This is reflected in within object proportions as well, as was discussed in the last section. It is much more difficult to achieve between object proportions especially when the issue is confounded with distance from the viewer. Yet this is precisely what is achieved by these retarded children.

It is now clearer that even in the most simple situations, children of 5–6 years have a tendency to under-estimate size in their drawings where they are adding further elements to pre-drawn figures or parts of a scene. They clearly

find it difficult to reconcile all the cues and may decide to err on the side of caution. This tendency is not noticeably present in the drawings of the retarded group. In fact, there is generally a bold and successful representation of diminishing size.

### The Development of the Ability to Represent two Objects, one partially Occluded by the other as a Device in the Representation of Photographic Realism

The development of the ability to represent two objects, one partially occluded by the other in children's drawings has been discussed generally by many authors (Piaget and Inhelder, 1956; Lewis, 1963; Barnhart, 1942).

The classical study on occlusion in children's drawings was undertaken by Clark in 1897. He asked children to draw an apple with a hat-pin extending through the middle and protruding from side to side. All his six-year-olds draw the apple as a circle and the hat-pin as a continuous line running through the circle, although in reality, most of the hat-pin had disappeared into the body of the apple. But, with increasing age, there was a growing tendency to delete the invisible part of the pin. Freeman (1977) calls this ability "Hidden Line Elimination (H.L.E.)". In 1972 Freeman and Janikoun turned their attention to a re-examination of this phenomenon. They presented children with a cylindrical mug with its handle turned away from the child so that it could not be seen. The children were simply requested to draw the cup. They found that young children, below the age of seven years, tended to draw the cup with a handle. Freeman (1980) later discusses this finding in his book and he offered four possible explanations, three of which are similar but employ different models for conceiving the issue.

(1) The error may be one basically of the child "normalizing his representation to the canonical form".

(2) The model is a representational problem such that the child has difficulty in "selecting an output to match to the model". (This is reminiscent of the explanation offered by Phillips et al. (1978) in their paper on children's drawings of a cube.)

(3) The child draws the "specific defining features" of the object, irrespective of his viewing point.

(4) The error occurs because the child draws from memory rather than from the model.

After the initial experiments using single objects with occluded defining features, Freeman continued with another series of experiments and perhaps the most comprehensive investigation to date on occlusion or hidden line elimination was conducted by Freeman et al. (1977). Since this work, interest in the phenomenon has grown. Cox (1978, 1980) and Light and MacIntosh (1980) are currently conducting research. Cox (1978) found for instance that when two objects, one partially obscuring the other, of different colours are drawn, very young children will draw two separate objects, but they will draw

the nearer object first. Light and McIntosh (1980) describe a further experiment and discuss the young child's failure to produce hidden line elimination in terms of the child's orientation to the "visual world rather than to the visual field".

Undoubtedly future experimental work will be directed to consideration of these explanatory models. However, all these subsequent studies have tended to support the basic findings of Freeman *et al.*

This influential study was mainly directed at elucidating the development of the kinds of solutions employed by children at different ages in depicting two objects, one behind the other, and thereby describing age norms. Freeman and his associates examined the way in which children from age 5 to 20 years related two simple objects in their drawings. The subjects were requested to draw two apples, drawn as circles either "beside", "behind", "above", "below" or "in front of" each other. Freeman *et al.* argue that the child has to convert a 3D relationship into a 2D representation and there should either be a discrete stage phenomenon or a gradual shift in the relative frequency of solutions that could be adopted.

Freeman *et al.* discuss seven possible graphic solutions used by children (Fig. 11).

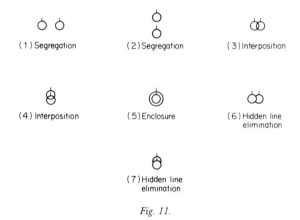

Fig. 11.

He found that all his subjects, at every age, obeyed the instructions "above" and "below" and he therefore concluded that the instructional demands did not interfere with the task demands. Freeman *et al.* report that with the "behind" condition, where the ability to use hidden line elimination would be called for, the tendency to draw the circles as separate (segregation) declined with age. Hidden line elimination increased with age, but with Freeman's subjects, this ability was not evident at all in children under the age of 7 years. Below that age the strategies children employed to depict one object behind another were either segregation or enclosure. Freeman *et al.* also found that at the age of seven, a side-by-side representation of the apples was

preferred (only verbal instructions were given). But this preference changed with age so that, by the age of 10 years, most of the subjects drew an up–down representation.

It was also reported that the methods of representing occlusion showed incremental changes with age rather than a stage shift. Freeman *et al.* say that the results support the suggestion that ''depth cues are used reliably only after the age of six''. (This remark is unqualified, although it is well known that in graphic representation, production lags far behind perceptual comprehension and recognition, and it is unclear as to what Freeman's claim amounts to here.) Freeman *et al.* conclude that hidden line elimination is only mastered by age 9 years with its precursors of interposition and enclosure occurring from 7 years onwards.

Freeman conducted further experiments on hidden line elimination which are described in his book (1980). In one experiment Freeman and Greenfield used a battery of tasks: one involved drawing apples one behind the other; another involved choosing from a set of different sized apples which one would be most appropriately placed in a three-dimensional visual array. Another of the tasks involved the child in interpreting from a picture the position of objects in a three-dimensional display. Freeman found that he could group children according to the drawing devices they had adopted, and those children who had achieved hidden line elimination in their drawings also had a better grasp of pictorial depth relations.

In another experiment Freeman compared performance on the apples test with Clark's hat-pin task in a ''split halves'' design and found that the occurrence of hidden line elimination on the apples task corresponded with its occurrence on the hat-pin task. There was a remarkable correspondence in the results on the two tasks.

In most of the experiments Freeman and his associates conducted into methods of representing occlusion in drawing, they used verbal instructions to describe the task. It was assumed that the instructional demands did not interfere with the task demands. Freeman *et al.* (1977) included an ''above'', ''below'' and ''at the side of'' instruction in order to test whether children could respond appropriately to verbal instructions. It was found that subjects at all ages could respond accurately, but it may be mistaken to conclude, as Freeman *et al.* did, that ambiguities in the ''behind'' condition related entirely to task demands and not to instructional demands. Freeman does not discuss the problems of the ambiguities of verbal instructions in the child's comprehension of the task in his papers on the subject or in his book, although this is a fiercely debated issue (Donaldson, 1978). Without further instruction or the use of models, there are ambiguities in the instruction to draw ''one apple behind another'', since the situation of the viewer relative to the apples is not specified. There are a number of possible views of ''one apple behind another'' which need not produce hidden line elimination, such as an oblique aerial view; and, indeed, enclosure and separateness could both be photographically realistic views of one apple behind another.

In order to discover whether Freeman's findings would still hold when the

ambiguities of these verbal instructions had been reduced, it was decided to repeat Freeman's paradigm but to introduce models of the objects and their relative positions to be depicted. Several means for promoting the use of hidden line elimination were therefore devised:

(1) Through verbal instructions
(2) By using a three-dimensional display
(3) By using a two-dimensional display
(4) By using a completed drawing for the child to copy

It was reasoned that the use of a three-dimensional display which restricted the viewer to one possible view, made the situation more concrete and specific and less ambiguous. Further, the two-dimensional display reduced three-dimensional information to two-dimensions while retaining a specific view. Finally, the completed drawing situation should remove all possible ambiguities for the child because he has the precise solution which he can copy.

These four methods of promoting hidden line elimination could be compared with each other and with the results of Freeman *et al.* After some pilot trials it was decided to use subjects who were much younger than the age below which Freeman claims subjects do not produce hidden line elimination in their drawings (i.e. below 7 years). The subjects were 160 children of 5–6 years of age, approximately 40 subjects in each group.

It was found that verbal instructions alone were not sufficient for all the children to grasp the basic requirements of the task unambiguously. Significantly fewer children managed to represent hidden line elimination in the verbal instruction condition. When the task was made more explicit, more children are able to produce hidden line elimination and the number of children producing H.L.E. increases the more concrete and less ambiguous the task. The data of Freeman *et al.*, then, is confounded with the ambiguities of using verbal instructions alone.

The fourth condition reduced all possible ambiguities since the child is given the solution to copy (see Fig. 12, p.72). Even with the solution presented together with the instruction to draw "two apples", "just like this", just under half of the children still failed to draw hidden line elimination. It was a dramatic experience to observe children when they had been shown the drawing and given instructions, draw two segregated apples. It would appear therefore that Freeman's *general* finding that young children have difficulty in representing hidden line elimination is robust since even given the solution to copy, many children will produce segregation, enclosure or interposition rather than hidden line elimination. However, the data differs from that of Freeman *et al.* insofar as none of their subjects between 5 and 6 years of ages produced hidden line elimination. Freeman *et al.* state that hidden line elimination was not evident until age 7 years and was not used by the majority of their subjects until age 9 years. In this study it was found that using verbal instructions in a similar situation to that described by Freeman *et al.*, one quarter of the 5–6-year-olds could produce hidden line elimination. Approximately half of the children produced H.L.E. when models were introduced.

The results of these pilot studies showed that verbal instructions alone are ambiguous and the addition of visual displays improves performance, promoting H.L.E. by making the task demands explicit. It was decided to explore why children fail to produce H.L.E. and to link this exploration with the fact that the anomalous group of children has a particularly remarkable facility with H.L.E. It was reasoned that not only do verbal instructions make a difference to the child's comprehension of the task, but the words themselves may operate to ''set'' the child to attend to certain task demands and that some features of the verbal description will be attended to more readily than others. The child is asked to draw ''two apples, one behind the other''. ''Two'' denotes the number; ''apples'' the objects, and ''behind'' their positions relative to one another and the viewer. It is possible that the ''set'' of number and object override considerations of spatial relationships, i.e.

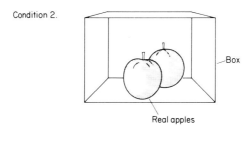

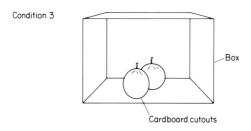

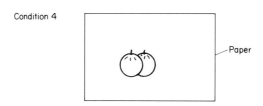

*Fig. 12*

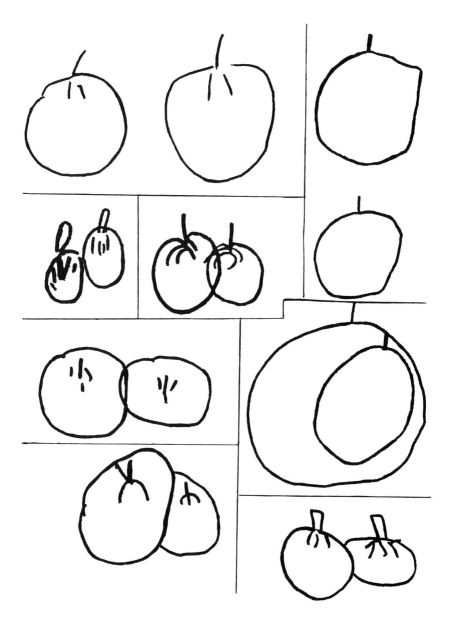

*Fig. 13.* Examples of children's responses.

"behind". Would young children have the same difficulty if they were not told to represent two objects?

Two groups of children of 5 years of age were selected. The first group was presented with a completed drawing of two apples and they were asked to draw "two apples one behind the other just like this" (see illustration). The second group were shown the same completed drawing and were requested to "draw a pattern just like this". The results for the two groups showed very similar proportions of children producing H.L.E. (approximately one fifth). It was concluded that it was not the verbal instructions alone that were operating to define the configuration as objects. When children were presented with the drawing as a "pattern" they were redefining the "pattern" as two objects. The children drawing the "pattern" condition were asked what they had just drawn when they had completed the task, most of them said they had drawn "apples" or "cherries". All these children produced segregated circles. However, six children produced H.L.E. but only one of this minority replied "apples" to the enquiry and the other five responded "It's a pattern". This bears out the supposition that most of the children were redefining the pattern as objects and there was a tendency to produce hidden line elimination when no such redefinition occurred.

In a further study of a further 60 children, two groups of 30 subjects of 5 years of age were presented with a drawing similar to the previous one but the "apples" in the completed drawing were drawn as two circles only. The stalk was omitted since this addition served to define the circles as objects. The two groups were asked to draw either "apples" or a "pattern" as in the previous study. The results in this situation showed a highly significant difference between the production of H.L.E. when subjects conceived the task as drawing a pattern rather than drawing two apples, one behind the other.

In these two studies it would appear that defining the subjects to be drawn as objects has a profound effect upon the way the child represents those subjects from memory or by copying. This is not only true at the verbal level when the objects are defined for the child but where he is copying and he is told that the subject is a pattern he will also tend to redefine that pattern for himself in terms of objects, if this is at all possible in the configuration of the design.

The results of the final study show that young children do not lack the necessary motor skill to adequately align and join a circle and half circle since this was accomplished by the majority of the children in the "pattern" condition. Lack of motor skill cannot explain the preference for segregation in the "apples" condition. (Phillips *et al.*, 1978, report the same finding from their data.) Phillips *et al.* (1978) compared the drawings of cubes, copied from pictures and the child's copies of similar but non-object designs. They were concerned to see whether the structural accuracy with which simple line drawings are copied by children depended on whether the pictures were seen as objects or not.

The principle result of the study of Phillips *et al.* was that drawings conceived as objects were copied much less accurately than those not seen as

objects. Children were able to copy drawings of designs more accurately and these designs had the same degree of complexity in terms of lines and angles as the drawings of the cubes. Phillips *et al.* concluded that "symbolic realism" does not result because the child lacks the necessary graphic skill. They offered two explanations for their findings. One, in terms of computational complexity. They argue that if a cube is seen as a three-dimensional object, this presents the child with complex computational difficulties of translation into two dimensions whereas a design is already seen as two-dimensional. The other explanation is in terms of the use of schemas that the child has in his limited repertoire for drawing classes of objects. Phillips *et al.* define schemas not in terms of canonical forms but in terms of the learned sequence of graphic motor movements required to draw the object. With a limited repertoire of such schemas the young child draws objects such as cubes from a schema for squares or rectangular objects.

In the present studies, the second explanation of the dominance of "schemas" or canonical forms appears to be more plausible since the computational complexity of "apples" and a circular pattern is reasonably constant. An apple can be realistically represented as a circle, by its exterior shape. Also "apples" are conventionally represented as a circle in drawing.

It is reasonable to conclude that the cause of the persistent preference for segregation, despite instruction, models and drawings to copy to promote H.L.E., is due to the young child's dominant representation of simple, complete, canonical forms. In these simple experimental situations, the child is given three separate items of information to be integrated in his subsequent drawing: (1) the identity of the objects, (2) the number of objects, (3) the relative position of the objects to one another and to the viewer. It would appear that in their drawings, young children do not give due weight to spatial and positioning considerations until they are older. Consideration of the completeness of the canonical form appears to override other information. There are other reasons one could advance as to why young children prefer segregation to H.L.E. The representation of the apples by H.L.E. threatens the clear and unambiguous representation of the characteristic features of apples and of these as two independent objects as specified. Also, the representation of H.L.E. transgresses those basic rules observed by Goodnow (1977) that young children prefer to represent objects with "their own space and to each its own boundary".

Since the conclusion of these studies, Maureen Cox has published a series of experiments addressing the problems of the representation of H.L.E. (1981). She too points out that the original study of Freeman *et al.*, where no models were used, was highly ambiguous. Cox decided to investigate these ambiguities in the representation of depth (what she calls the near/far dimension). As with these studies, her first idea was to re-run the Freeman experiment using a tangible real-life situation. She asked children to draw funnels (as discussed earlier this shape presents difficulties since the attempt to solve the depth problem may be confounded with difficulty in drawing a basic triangular shape alone. The triangle is only mastered by the average child of 5 years (Terman Merrill, 1960).

Cox's findings in fact were similar to those of Freeman *et al.* but she found that the order in which the funnels were drawn showed that the nearer object was drawn first. She concluded that even at 5 years there is an embryonic understanding of the near/far relationship which Freeman's study had failed to reveal.

In another experiment, Cox used two drawings of possible solutions to H.L.E.: one showed partial occlusion and the other showed two separate objects. The children were asked to select which one best illustrated one object behind another. The "separate" version was preferred by the majority of children under 6 years. Cox concluded that partial occlusion in drawing violates the young child's concern to portray an object in its entirety. In her final study, Cox attempted to devise a task in which the concept of hiding and partial occlusion would be integral. She asked children to draw a robber hiding behind a wall. Children were asked either to pretend to be a policeman or given a toy policeman placed in front of the wall and they either drew the scene or were asked to select a solution from three possible views, one being partial occlusion. In this situation, where the key concept of "hiding" was introduced, a significant shift towards the representation of partial occlusion occurred although only half of the 4-year-olds drew or selected partial occlusion as a solution. (Again, the difficulties of placement, alignment and positioning vis-à-vis head and body in relation to the height of the wall for a 4-year-old may be a confounding factor).

However, Maureen Cox's studies throw further light on the difficulties the child has with representing depth (the near/far dimension) and she too comes to the conclusion that (1) the task is highly ambiguous and sensitive to verbal concepts and (2) young children appear to be dominated by the need to represent the complete object.

### Comparisons with the Anomalous Group

It is useful to reiterate the main findings from the last group of studies of occlusion. They were conducted as pilot studies into the development of the representation of H.L.E. during the stage of symbolic realism. It would appear that Freeman's finding that children under the age of 7 years avoid hidden line elimination and prefer segregation in their representational drawings where the objects to be drawn are known to be one behind the other, is robust.

It is also hypothesized that this preference for segregation occurs because the child is dominated by canonical representation in which the most basic and defining features of the complete object are depicted. Depicting spatial relationships between objects is disregarded by young children and does not assume importance until they are older. Under the age of 7 years, symbolic or canonical considerations in the representation of objects override realism.

This is clearly not the case with the children in the anomalous group. Canonical representations are subservient to the photographically realistic

depition of line and edge. Hidden line elimination is applied with fluidity and always in the service of photographic realism. Objects, buildings, etc. are truncated if other objects intervene in the fixed field of vision. There are some startling examples of hidden line elimination in Dwgs 3, 21, 44 and 48, and some of these pictures were drawn when the subjects were 5 years of age. The subjects are clearly "untrammelled" by the need for symbolic or canonical representation (Buhler, 1930).

How do the studies just described relate to naturalistic drawings of occlusion? It should be noted that two circles (representing apples) are the simplest most basic arrangement to use to depict occlusion since the shape is perfectly symmetrical and positioning is not as much a problem as it would be with an irregularly shaped object. The basic circle shape is mastered at 2½ years well before the square or the rectangle, so that we could, with considerable justice, assume that if the child has any notion of hidden line elimination, we would expect him to be able to demonstrate it in the "apples" situation. Freeman claims that hidden line elimination does not appear until seven years. But this stage is probably generously early for the use of hidden line elimination in drawing other objects. We might expect that in naturalistic, free drawings of children, occlusion will be avoided until the child is older than seven years. The author observed the use of occlusion in free drawings and in some specially concocted constrained situations. Children were presented with partially completed drawings and were asked to draw in objects where, for any reasonably realistic solution, the object would have to be depicted partially occluded. For example, children were presented with the drawing of a brick wall which covered the lower half of the total available space on the paper and they were asked to draw a man behind it. It was found that in all such situations there was a strong age-related trend towards hidden line elimination but the results varied according to the objects being represented. It was concluded that the ability to use hidden line elimination therefore also depended on the graphic complexity of the objects being depicted as occluded. This suggests that no conclusions regarding the development of occlusion in drawing can be drawn from one experimental situation.

The further observation of the free drawings of children confirmed this finding. Children master certain well-practised occlusion problems well before they will attempt others. A partially occluded figure of a man driving a car is produced relatively early, but it is also noticeable that occlusion is avoided. As Barnhart (1942) suggested, the child during the symbolic stage of drawing prefers to depict objects as complete and separate.

# 6

# Final Comments and Conclusions
# to the Previous Studies

Before proceeding further, it would be worthwhile to reiterate the conclusions so far reached from the previous studies. The investigations were undertaken because there were few systematic studies of the development of photographic realism in children's drawings between the age of 5 and 10 years or during the stage of intellectual or symbolic realism in drawing development. Descriptions of the stage have frequently been given, but statements had rarely been substantiated by a more detailed experimental analysis or even by systematic data collection. It was therefore decided to undertake some further analysis of the development of the representation of depth in normal children in order (a) to gain understanding and insight into normal development of representational drawing and to elucidate the development of essential drawing devices in the depiction of photographic realism and (b) to make reasonably rigorous and informed comparisons between normal and abnormal development.

Drawing devices necessary for depicting photographic realism were identified and systematically studied and have been described in the previous pages. The elements or devices studied have been:

(1) The use of photographically accurate proportions between and within elements in drawing.
(2) The inclusion of further dimensions rather than flat frontal or side elevations in the portrayal of three-dimensional objects.
(3) The drawing of photographically realistic diminishing size with distance as a means of representing depth.
(4) The use of occlusion or hidden line elimination in children's drawings.

The results of the studies can now be summarized.

## (1) Proportions

It was discovered that even up to 10 years of age, and using the most well practised single object children draw, i.e. the human figure, normal children do not portray photographically realistic proportions in their human figure drawings. However, there is a clear age-related trend towards doing so. Children of between 5 and 6 years usually draw heads that are larger than the

trunk in their human figure drawings, but by 10 years, heads are usually drawn considerably smaller than the trunk, although the tendency to over-estimate the head remains.

## (2) Dimensions

From the experimental studies undertaken, it was discovered that children of 5–6 years generally do not attempt to depict other dimensions in their portrayal of three-dimensional objects other than a flat canonical representation. By 7–8 years, only one quarter of the group of normal children added additional elevations in their drawings of three-dimensional objects and by 9–10 years, over one third of the group still failed to depict anything other than a flat front elevation in drawing a house. There is therefore a clear age-related trend towards depicting further dimensions of objects, but even by the age of 10 years, not all children have incorporated this device into their drawing. It was concluded that drawing further dimensions indicated the elaboration of a canonical or symbolic representation at least up to the age of 10 years, rather than the more radical shift towards depicting a fixed viewpoint scene.

## (3) Diminishing size with distance

Again, a clear age-related trend towards the accurate depiction of photo-graphically realistic diminished size with distance was evident in the studies undertaken. However, all the children, at all ages, showed some basic understanding of size scaling. It was therefore concluded that size scaling appears at an early age, but accuracy in its manipulation is only slowly acquired. Children of 5–6 years frequently under-estimate photographically accurate size, and appear to operate a rule of caution, in adding to a drawing where some features have already been drawn. By 9–10 years by no means all normal children can scale accurately, even in the most simple drawing situation.

## (4) Occlusion

Freeman et al. (1977) found that H.L.E. was not used until after 7 years of age. In the present studies H.L.E. was evident earlier and it was found that its use could be promoted by making the instructions less ambiguous. However, Freeman's finding that there is a development with age from the depiction of separate objects to using H.L.E. was confirmed. H.L.E. is an essential device in depicting photographic realism. Further observations showed that in children's drawing the use of H.L.E. depends on the graphical complexity of the objects being depicted. If the object is asymmetrical, unpractised and complex, children will revert to the easier solution of separation.

Two further points need to be reiterated. It should be acknowledged that the studies undertaken of drawing devices, represented a brief examination of several areas in order to achieve an overall understanding of the representation of depth in children's drawing. Each drawing device discussed would warrant a much more detailed investigation.

Secondly, some drawing devices, by their very nature, are acquired in a step-like or stage transition, such as the depiction of occlusion where discrete strategies are employed: segregation, interposition, enclosure and hidden line elimination, and some devices show a gradual evolution towards more photographically realistic depiction such as proportionality. The incorporation of drawing devices for the depiction of depth therefore show development changes which are either continuous or discrete. Some attempt to describe discursively and categorize the complex and multifaceted development of drawing in children from 5 to 10 years has been made. The enterprise has not been undertaken without acknowledging underlying philosophical assumptions and without inspecting previous studies. The attempt was made in order to make precise the qualitative difference between normal drawing and the drawings of children in the anomalous group.

Using the observations made in the foregoing studies, together with the work of Barnhart (1942), Lark Horowitz *et al.* (1967), Eisner (1978) and Freeman (1980), and systematic observation of children's free drawings, it is possible to suggest a scale of the development of drawing devices used in representing photographic realism in children's drawings. Lark Horowitz *et al.* (1967) for instance reports on her study of 1800 representational drawings of children from 6 to 14 years of age where she classified the drawings according to degrees of schematic or realistic representation. Her results are given in Table I.

*Table I.* Analysis of children's drawings in terms of drawing systems.

| Age | Primitive schema | Schema | Mixed | True to Appearance | Sub totals |
|---|---|---|---|---|---|
| 6 years | 26 | 73 | 1 | 0 | 166 |
| 7 years | 8 | 90 | 1 | 0 | 186 |
| 8 years | 6 | 91 | 2 | 0 | 200 |
| 9 years | 0 | 88 | 11 | 0 | 202 |
| 10 years | 1 | 72 | 20 | 5 | 200 |
| etc. | | | | | |

(Lark Horowitz *et al.*, 1967, p.47.)

In the first place, it should be noted that these results coincide with and confirm the general findings already reported. But her method fails to identify and distinguish between elements and devices in "true-to-appearance" depiction. A scale of development incorporating these elements and reflecting far more closely the nature of the graphic development was therefore seen as a natural progression.

The scale is not assumed to be an interval measure, and since the development of some drawing devices is discrete in nature and continuous with other devices, the scale is not necessarily ordinal, although an attempt has been made to organize the scale along a developmental continuum. Such a scale could suggest non-parametric measures of the child's development of photographically realistic representation in drawing.

### Scale of the representation of photographic realism in children's drawings

(1)    Any attempt to organize objects in an up-down or (less usual) in a right-left arrangement on the paper surface, thereby demonstrating a recognition that the two-dimensional paper surface can represent the near and far (bottom–top) arrangement of natural perspective.

(2)    Any indication of a primitive planar arrangement. This would be characterized by the use of a baseline or ground line along which objects would be placed, thus dividing the paper space into two planes: ground line and distance. ("The air-gap stereotype", Hargreaves *et al.*, 1978.)

(3)    Any indication of more than two planes of arrangement. The use of levels of planes of arrangement of spatial organization entails the understanding that nearer objects in natural perspective should be placed towards the bottom of the paper or on the ground line and further objects from the viewer should be placed higher up the paper. This can culminate in the depiction of a horizon and sky plane at the top of the paper. This use of planes of organization is the prelude to the depiction of depth and artificial perspective.

(4)    The depiction of any dimensions other than flat elevations in the representation of three-dimensional objects.

(5)    Any example of the use of hidden line elimination.

(6)    Any example of the depiction of diminished size with distance. This is often incorporated with a planar arrangement.

(7)    The use of relatively realistic proportions within objects.

(8)    Any recognition of proportionality between objects within the same plane or on the same baseline.

(9)    Demonstrating the regular (but not necessarily accurate) use of proportionality with distance.

(10)    The regular use of all four drawing devices in depicting depth where planes become gradations.

(11)    Right angles portrayed intentionally as acute or obtuse angles in attempts at linear perspective.

(12)    The accurate and photographically realistic portrayal of natural perspective.

Studies concerned with the use of perspective in adolescent drawers generally confirm that children have continuing problems with the graphic depiction of space. Leroy (1950) found that only 65% of her sample of 14-year-olds were able to use perspective precisely (according to her "table of exactitude"), and Willats (1978) found that even by the age of 17 years, a proportion of students did not use linear perspective in their drawings.

*Comparison with the anomalous group*

Eight drawings of the children from the autistic group were selected; one drawing from each child, and were systematically compared with this scale of photographic realism. These and other examples of the drawings of the group are given on page 98. It can readily be seen that the performance of all members of the anomalous group is very different from the performance of normal children of the same age. The majority of the drawings of the anomalous group were executed between 6–8 years so that the correct comparison group is the 7–8-year groups.

It would be useful to consider the anomalous children's performance in terms of the items on the scale. In all cases the autistic children's use of the planar arrangements when scenes with depth are being depicted, have succeeded to the point where planes have become gradations. Proportions within elements of objects are highly realistic (see especially Dwgs 3, 13, 35, 43 and 52). However, the more difficult accomplishment of achieving realistic proportions between objects with distance is also apparent in all of the drawings of the anomalous group. One member of the group demonstrated this ability before 5 years of age (see Drawings 13, 25, 27, 30 and 48). There is a marked difference between the fluent and natural use of proportion with distance in the anomalous group and its contrived and inaccurate use by normal children. Any attempt is frequently absent altogether in the drawings of the younger groups.

The ability to depict further dimensions other than flat frontal planes is also very well developed with the retarded group. In fact, the portrayal of depth within objects and in scenes is everywhere apparent in their drawings. See, for example, Michael's light and clock fitments depicted in Dwgs 49 and 50; the garden shed, (Dwg 1) drawn by one subject under the age of six; and the car, (Dwg 43) drawn by one of the most severely handicapped of the group at the age of between 6–7 years.

None of the anomalous group shows the usual difficulty with hidden-line elimination. Objects are depicted overlapping, lines and objects are truncated, and none of the usual devices employed by young children to avoid overlapping are apparent. There is also a qualitative difference in the use of occlusion. When older children begin to incorporate occlusion into their drawings, the results are often clumsy and imprecise so that partially occluded objects often do not "sit" satisfactorily. These characteristic inaccuracies and distortions are not apparent in the drawings of the anomalous children. Their use of occlusion is usually accurate and fluent.

Finally, it has been noted that normal children have some difficulty in attaining the depiction of a right-angled solid with a receding side by an acute angle. The anomalous group clearly do not have this problem (Figs 5, 24 and 31). It seems unlikely that the anomalous group demonstrate an accelerated development in pictorial and graphic depiction. Children with above average measured intelligence can sometimes have accelerated drawing ability but the

members of the anomalous group are not highly intelligent, quite the reverse, most members are at least two standard deviations below the mean on measurements of their intelligence.

It is therefore argued that it is more likely that the group's drawing development has been anomalous. (This claim is borne out by further evidence to be presented in a later chapter.) It is suggested that the drawing development of the anomalous group is controlled by a different set of underlying cognitive functions than are normally involved in the complex activity of pictorial depiction.

In the preceding chapters it has been shown systematically that in normal children's drawings, the production of drawing devices necessary for the depiction of photographic realism show age-related trends. It is also concluded that in their graphic productions, children do, in fact, show a development towards more photographically realistic depiction or, at the very least, children differ in their interests in depiction according to their age.

All the studies undertaken confirmed the well-documented assumption that approximately from the age of 4 years until 9 years, children's representational drawings are symbolic and schematic; and that later, from the age of about 10 years, children's drawings increasingly become more photographically realistic.

Attempts were made to promote the use of certain drawing devices for depicting photographic realism, and it was generally found that it was difficult to obtain substantial changes in children's graphic productions. In any case, the basic age-related trends were unaffected; where a better performance was promoted, all age groups tended to benefit equally. It was concluded that it is difficult to enhance and accelerate younger children's graphic performance substantially, although it cannot be concluded that children do not have these abilities within their competence. All that can be said with certainty is that the methods employed to promote more realistic productions were not successful, although it is possible to err too far on the side of caution here. The only reasonable conclusion is that young children have great difficulty in accessing or organizing the drawing of devices which are necessary for photographically realistic productions, that is, if he has such devices within his repertoire at all.

Another interesting finding was that, there was some indication that boys tended to be more advanced than girls, in the acquisition of devices for depicting photographic realism. This coincides with other research findings (Ounstead and Taylor, op. cit.) that boys are better than girls at some tasks involving spatial organization, whereas girls tend to be in advance of boys in some tasks involving verbal abilities. These findings have an interesting bearing on the hypothesized explanation for the anomalous performance in representational drawing of the retarded group. It is possible to interpret these findings in a different manner and to hypothesize that it is not so much a question of boys being in advance of girls on spatial skills, as a possibility that girls rely more heavily on verbal mediation to solve spatial problems, particularly with regard to drawing. Where children have delayed or deficient verbal abilities, as in the anomalous group, they may have to rely on spatial

processes and visual abilities in solving problems of graphic representation. This tentative hypothesis will be examined in much more detail in the final chapter. Questions of definition are instantly raised by these speculations which need to be thoroughly explored, but it is useful at this point to give some directions as to the way in which the thesis is proceeding.

Although there are age-related trends in the production and accuracy of the use of drawing devices by normal children, the results of the experiments described rarely revealed an equal incremental change. Most of the results tended to show that the greatest gains in the acquisition of drawing devices occurred between 5–6 years and 7–8 years. Some of the conditions requiring the depiction of photographically realistic proportions also showed an accelerating, rather than a decelerating trend over these ages. The differences between groups says very little about individual performances. However, one main conclusion that can be drawn is that the devices studied are developmentally sensitive.

It was also confirmed that verbal instructions play a vital part in the child's production, not only because of the ambiguities that language may create in the child's understanding of instructions about spatial relationships, but, far more significantly, it was discovered that the act of labelling a pattern or design as an object or objects changes the way in which the child will draw or copy that pattern. Even when young children are given a picture to copy with a clear solution to a representational problem, the young child chooses to depict the complete object with all of its defining features and he frequently appears to ignore the fact that, in the picture he is required to copy, one object is partially occluded by another.

These, then, were the principle general findings derived from the series of experiments described.

It was very useful to conceive of the drawing of photographic realism in terms of the acquisition of necessary drawing devices. However, it should be acknowledged that there are some inherent contradictions in defining what is essentially a spatial representational activity in a discursive and descriptive manner. It has already been noted that some of the devices described show a gradual incremental and continuous development, whereas other devices change progressively but discontinuously. It is possible that by isolating certain features of the drawing process in terms of "devices", it might be possible to miss other equally significant, but more elusive features that may be being incorporated and may account for the changes in the child's productions with age. For example, the child may become gradually more aware of negative space: the space and shapes between objects. There is something odd about discursive or descriptive accounts of pictorial space. How can there be an adequate description of a painting or a child's drawing? Verbal descriptions cannot wholly penetrate the "ineluctable modality of the visible" (James Joyce).

There is overwhelming evidence of a developmental trend towards a more photographically realistic depiction in children's drawings. (What does this signify?) It would appear that the younger the child, the more limited and

inflexible is his repertoire of graphic strategies and devices. In Arnheim's terms, the structural equivalents that young children use are less differentiated and less elaborate. Harris (1963) assumes that the problem is one of basic limitations in the child's conceptual development or cognitive incapacity. It was previously argued that such a view may not constitute a complete explanation and the child's basic interest in pictorial depiction may change with age.

It is generally assumed that the young child's inaccuracies in representational drawings in terms of the depiction of photographic realism, correlates with his general intellectual development. Drawing development is seen as mirroring the development and integration of cognitive structures and drawing devices can therefore only be acquired in a certain order after the acquisition of sub-skills, such as the handgrasp of the drawing implement, the acquisition of cues, such as position and orientation and the sufficient development of short-term memory (Connolly and Elliott, 1972; Freeman, 1980).

As has been previously stated, Gibson (1979) describes drawing in terms of a child learning or selecting to attend to invariant features of the optic array. The child attempts to depict these invariants in his graphic work. Each child's view of the optic array is different; moreover, he will attend to invariant features that are uniquely significant to him. Also, different features of the optic array will have significance at different ages and stages in the child's life. An architect will attend to different features of a building than a stone mason or a carpenter or a demolition expert.

However, in the process of socialization, the child is brought to see the world in a similar manner to other members of his society. This is an essential process before communication can commence.

With regard to the anomalous children in the group and using Gibson's non-dualist approach, it can be seen that in their drawings they are representing those features of their optic array to which they attend, those features which have importance and significance for them. The drawings of normal children are a record of the conventional visual experiential features that are often important to all children in the shared culture. In Western cultures at least, and from 3 to 9 years of age, the essential features of the optic array which children choose to depict in their drawings appear to be objects and their defining characteristics. The drawing of the object is not limited to one fixed view and in this respect, coincides much more with the dynamic visual experiences of the child. He selects a symbolic form with defining features to represent this experience.

The features that the anomalous children draw, however, appear to be the lines, edges, contours and angles of a frozen, fixed viewpoint optic array. These are very different features from those attended to by normal children of the same age. Bruner et al. (1966) supposes that young children are primarily concerned with symbolizing, codifying and categorizing experience. Bruner and his colleagues regard language as the most specialized system of symbolic activity and define three modes of representation: enactive, iconic and

symbolic, where the symbolic system emerges last in development and is assumed to be more abstract and complex. Other authors have stressed symbolization as a pre-eminent cognitive attribute where the child develops internal representations of objects or events that have significance, in the first instance, for his survival and reduction of needs.

Language is essentially a symbolic activity whereby multivarious experience is organized, codified and reduced. The single word "chair", for example, can stand for all objects that are for sitting purposes, and all possible relevant visual and tactile experience is hence organized and reduced by the use of this one single verbal label.

It would be maintained that much the same symbolizing activity characterizes the drawings of the very young child. He represents those objects that have functional significance for him. The production of a characterizing and meaningful symbolic representation appears to be more important than attention to idiosyncratic detail or to a single viewpoint representation of an object. When the anomalous children represent through drawing those aspects of their optic array, such as lines, edges and occlusion, they are attending to non-symbolic aspects of their visual experience. Their drawing is far less symbolic; objects are partially occluded, truncated and represented without their defining characteristics as seen from one fixed viewpoint. Such a view is necessarily special and is autistic and asocial insofar as one fixed view is possible only to one single viewer at one fixed spot. These children also represent spatial rather than symbolic aspects of the optic array where the space between objects and their position relative to other objects is more accurately represented and is therefore given more consideration than is evident in the drawings of normal children, where the depiction of the objects themselves is paramount. The drawing is, in this sense, more detached and objective, but this is not the objectivity of mature intelligence. For most normal children, photographic realism in graphic depiction is a late accomplishment. For these anomalous children, with deviant language and deficient symbolic abilities, it is another symptom of their cognitive deficits.

It is hypothesized that in drawing, these children respond to objects in their optic array more as patterns, edges, contours and shapes, rather than as representatives of classes or categories. It is further suggested that linear perspective drawing before the age of six years is as much a symptom of retardation in these children as is their delayed language development. It is perhaps coincidental that adult laymen generally value photographic realism in drawing and this feature is the hall-mark of the drawings of the anomalous group.

The question of whether photographic realism in drawing could be promoted in children at an earlier age remains open. What is suggested here, is that symbolic representations of objects predominate in normal children and this precludes the depiction of other spatial features. The young child does not have an interest in portraying these features, not so much because he lacks the planning strategies to do so, but because he is dominated by other considerations, although this may in itself amount to an incapacity to do so.

As the child grows older he eventually comes to depict other features of his optic array. He comes to accept and require far less information in the recognition and depiction of an object. He learns to depict an object from one point of view where much less redundancy is tolerated. Also, his understanding now incorporates spatial relationships as a worthwhile feature of depiction. The retarded children in the group's drawing is truly anomalous. If they were able to depict photographic realism and to have an elaborate symbolic understanding of their world to be mediated by complex language usage, they would be very gifted. But it is much more probable that the anomalous group depict lines, occluding edges and contours in their drawings because they cannot symbolize or categorize their visual experience at anything like the level of complexity of normal children.

# 7

# *Anomalous Graphic Representational Ability*

The following section of the book is concerned with the development of graphic representational ability in a group of children, all of whom have autistic symptoms and whose drawing development is anomalous, characterized by a high standard of photographic realism produced at a very early age. To briefly reiterate, this study directly derives from an earlier study (undertaken by the author) of an autistic and severely retarded child with exceptional and anomalous drawing competence (Selfe, 1977).

The phenomenon of anomalous development of drawing competence is extremely rare, even in normal highly intelligent children. Goodenough (1923) describes such an occurrence as ''a very rare event''. In children with a degree of mental retardation or with specific learning deficits, it is assumed that drawing ability will inevitably be associated with the general mental age of the child. This widely held and well established correlation between drawing competence and general cognitive development has been reviewed by the author elsewhere (Selfe, 1977). However, a brief review is necessary and pertinent here, and the author's previous review is extended and updated.

## INTELLECTUAL DEVELOPMENT AND REPRESENTATIONAL ABILITY IN CHILDREN

The previous section of the thesis was devoted to an analysis of the development of the representation of photographic realism in the drawings of normal children. Most of the research work undertaken and previously quoted was concerned with normal children. However, there are some studies concerned with the development of drawing in intellectually retarded children or children who have specific cognitive deficits.

The most extensive review of studies of children with learning difficulties was undertaken by Harris (1963). He entitled his book ''Children's Drawings as Measures of Intellectual Maturity''. His fundamental thesis is that the development of children's drawing is strongly correlated with their conceptual development. Harris describes his own study of the Goodenough Draw-a-Man test, and his views are categorical. He says (p.79),

It is instructive to compare the drawings of mentally retarded children with those of normals . . . on almost every point on the scale mentally retarded children are slower than normals to achieve success . . . mentally retarded children are relatively more deficient on items of proportion and dimension . . . and are relatively less handicapped on the inclusion of specific body parts.

Harris also quotes Goodenough's (1923, p.194) discussion of retarded or "backward" children when she says:

they analyse a figure to some extent and by this means are able to set down some elements in a graphic fashion but the ability to combine elements into an organised whole is likely to be defective and, in some instances, seems to be almost entirely lacking. It is this inability to analyse, to form abstract ideas, to relate facts that is largely responsible for the bizarre effects so frequently found among the drawings of backward children.

Harris reviews a number of studies which confirm his thesis that retarded children's drawing ability is necessarily also deficient. Two of the most notable studies were, firstly, one undertaken by Townsend (1951) who found that graphic copying skills in children correlated highly with mental age. (Copying designs and patterns is a regularly used component of some of the major tests of intelligence, such as the Terman Merrill revision of the Stanford-Binet Scale of Mental Measurement, The Wechsler Scale of Intelligence and the British Abilities Scales.) Copying skills correlated highly with mental age rather than with chronological age.

Secondly, Stotijn-Egge (1952) found that drawing ability invariably correlated with mental age in her sample of 2000 mentally retarded subjects. She concluded that some expressive language ability was a pre-requisite for any representational drawing.

Lark Horowitz *et al.* (1967) comment on the drawings of mentally retarded children and they too assume that retarded children draw like normal children of the same mental age. They state that the rate of development of drawing ability is obviously slower and, consequently, the successive stages in drawing occur at later ages. Conversely, at the other end of the I.Q. spectrum, Lark Horowitz *et al.* state

children who draw well are *invariably* bright [my emphasis],

and, later,

the mean I.Q. of artistically talented children is higher than that of average children of the same age and these children, rather than being one sided (i.e. gifted drawers only) are in fact mentally versatile. It seems quite clear that the ability to draw is a significant one and can help for forecast the young child's potential.

They conclude that very bright and artistically talented children go through the same stages in progression in drawing as other children, but at an accelerated rate. However, they also point out that the drawings of many very bright children are unremarkable and in their survey of 1800 drawings quoted

earlier, all the sample, up to the age of 10 years, were producing schematic or symbolic drawings only, none were producing "true to appearance" representations (see p.80). This suggests that photographic realism is a very difficult accomplishment, even for very bright children (this is presuming that the sample of Lark Horowitz *et al.* was normally distributed with regard to I.Q. scores).

The assumption that children's drawing ability relates to their general intellectual development and intelligence is universal, and finds support from every area of developmental psychology; for example, drawing would be difficult without the necessary fine motor control and will, in part, be governed by the development of eye–hand co-ordination. Where subnormal subjects are used in experiments on various aspects of drawing competence, it is assumed that they will draw well below their chronological age (and will thus show the biases and anomalies produced by much younger children (Freeman, 1980)).

Paivio's (1971) statements regarding studies of autistic savants were quoted in the opening chapter; his major criticism was that such studies lacked rigorous data collection. On the other hand, he points out the importance of such studies and Gregory (1977) too believes that such cases can "sometimes tell us more than many 'normal' cases averaged".

It was therefore decided to undertake reasonably rigorous data collection. It was decided to compile full case histories together with case records and to undertake an up-to-date analysis of the cognitive functioning of each subject using standardized test procedures. From the methodological viewpoint, therefore, the study is idiographic and a natural history approach is adopted, that is, as much relevant information as possible is collected, compiled and presented in as systematic a way as the data allow.

## DATA COLLECTION

Each subject was visited at home and the parents were interviewed. In some cases the children were also visited in school. Information was gathered on each child under the following headings:
  (1) Family details and history
  (2) Prenatal and postnatal history
  (3) Physical development
  (4) Social development
  (5) Cognitive and intellectual development
  (6) Symptoms of autism not included above
  (7) Full details of the development of the child's drawing ability
Wherever possible, each subject was tested on a series of standardized procedures under the following headings:
  (1) Verbal skills — British Abilities Scale (B.A.S.) 1978
  (2) Visual/perceptual skills — B.A.S., Illinois Test of Psycholinguistic Abilities (Kirk and Kirk, 1968) — visual memory sub-test and the Benton Visual Retention Test (1955).

(3) Retrieval and Application of Knowledge (Scholastic skills — B.A.S.)

(4) Eidetic imagery (Haber, 1969)

(Medical and psychological reports were scrutinized where available)

All drawings that were available were collected and dated by reference to parents and, in fact, many were already marked with the date or child's age. A selection of these is included.

## A. The Questionnaires on the History and the General Cognitive Development of the Child (see Appendix 1)

These questionnaires were devised in two main parts:

### (1) Family History and Immediate Pre- and Postnatal History

This questionnaire asked for details of parents, e.g. occupations, siblings and a full birth history and pre- and postnatal circumstances of the subject. Where possible, the details were checked against previous reports when all parents were found to be highly reliable in the information given.

### (2) General Cognitive Development (see Appendix 2)

This questionnaire was devised to obtain retrospective information of the child's general, intellectual, social, physical and language development. The present status of his language was also elucidated, and since autism was suspected in every case (and actually previously diagnosed in four cases), a section on additional symptoms of autism was included.

Most of the questions concerned with each child's general, intellectual, social, physical and language development were based on eighteen standardized developmental tests (Wood, 1967).

Questions on the additional symptoms of autism were based on the symptomatology described by Wing (1976), Rutter and Schopler (1978) and Newson (1980).

The questions about the status of language usage of subjects were taken from the analysis of language usage given by Tough (1975, 1978). This was included to attempt to assess the areas in which the subjects might currently be experiencing difficulties with expressive language. Tough's work appeared to offer one of the best analyses of expressive language usage known to the author.

The questions in the questionnaire were designed to be open-ended and to invite elaboration. It was decided to indicate through the structure of the questionnaire and by deliberate reference, the normal age for certain features of development. The questionnaire is therefore chronologically arranged

according to normal development. As the questionnaire was retrospective, it was hoped that this arrangement would help parents to order the events of the subject's babyhood and childhood and thereby to judge more accurately whether or not their child had been able to do the task under question. The questionnaire was piloted on two mothers with adolescent children and adjustments were made to make it as comprehensive, intelligible and fluent as possible.

### B. The Questionnaire on Drawing Behaviour (see Appendix 3)

Evidence was collected from parents as to the development of drawing and representational ability in each subject. The questions were generally open-ended, and were based on features of drawing in normal children (Harris, 1963; Goodnow, 1977) and on features noted in the previous case study of Nadia (Selfe, 1977).

### C. Standardized Tests of Intellectual Functioning

All the subjects were tested on a wide range of abilities to obtain a profile of general intellectual functioning. The British Abilities Scale was selected as a comprehensive measure of intellectual functions with a recent standardization on British children. However, one child was tested on the Wechsler Intelligence Scale for Children.

Some supplementary tests were also given. The Benton Test of Visual Retention was given since the subjects were suspected to be able to perform well in visuo/spatial tasks, and this test could provide further confirmation. Similarly, the visual memory sub-test of the Illinois Test of Psycho-linguistic Abilities was employed.

Finally, Haber's (1969) procedure for testing eidetic imagery was adapted and used with the subjects.

### CASE HISTORIES

The following are brief biographies of the six subjects

### Stephen

Name: Stephen (male)      Born: 2.3.68      Age at interview: 10 years
Father's occupation: Social Class III (Registrar General's Classification)
Mother's occupation: Housewife
Siblings: (not known) S is adopted — only child

### General History

S was adopted at 15 weeks and is his adoptive parents' only child. However, the adoptive mother had full information as to the birth history. He was a full-term birth. It is not known whether his natural mother had any illnesses during her pregnancy, but it is believed that the pregnancy was quite normal. S was born after 12½ hours' labour with no complications. Birth weight: 6lb 15oz. No abnormalities were diagnosed at or just after birth, and there were no perinatal complications.

When S was 3½ months old he was adopted. His adoptive mother thought "there was something wrong from the start". He had a series of short stays in hospital: a naevus operation at 12 months, circumcision at 2 years, and in hospital for 9 weeks at 4 years with chronic constipation. He attended a playgroup at 2 years, and he was placed in a small unit for children with learning difficulties attached to the ordinary school at 5 years.

At 3½ years he was referred by his G.P. to a London teaching hospital. S was diagnosed as autistic, and since his educational problems were severe, he was given a place at a residential school for autistic children when he was nearly 8 years of age and where he has remained to the present. S is right-handed and right-eyed. The handedness of his natural parents is not known. He has had no major illnesses.

### Simon

Name: Simon (male)      Born: 25.3.60      Age at interview: 18 years
Father's occupation: Social Class I (Registrar General's Classification)
Mother's occupation: Housewife and Magistrate
Siblings: 2 sisters (both older)

### General History

S was born at full-term. Mother had a normal pregnancy, but she had severe anaemia during the last two months which necessitated iron injections. S was born after 6 hours' labour. Birth weight: 10½lb. There were no birth complications and no abnormalities diagnosed at or just after birth. S's development appeared to be normal up to 9 months–1 year, when he was not walking and none of the rudiments of language were developing. He was seen at the Children's Hospital but no specific diagnosis was made, although it was clear that his development was retarded. He received speech therapy. At 4½ years S entered a small private school but by 7 years he was evidently not able to cope with normal school and his parents were asked to remove him. S was placed on Home Tuition by the L.E.A. for a period and autism was diagnosed. At the age of 8 years S started at a school for the Physically

Handicapped where he remained until he was 14 years when he was transferred to a P.H. unit attached to a comprehensive school. He left school at 16 years and has attended an Occupational Unit for the physically handicapped since then. S is left-handed (parents and siblings are right-handed). S has had good health apart from the usual childhood diseases.

## Claudia

Name: Claudia (female)      Born: 8.1.66      Age at interview: 13 years
Father's occupation: Social Class IV (Registrar General's Classification)
Mother's occupation: Factory worker
Siblings: 1 sister (1 year younger)

### General History

C was two weeks overdue. Her mother had a normal, trouble-free pregnancy. C was born by Caesarian section and needed oxygen, but there were no further complications. Birth weight: 8lb 13oz. There were no abnormalities diagnosed at or just after birth and no perinatal complications.

C appeared to develop normally but her mother became anxious when C was not talking by age 2 years. C could not cope with a nursery so she was sent by her G.P. to a Children's Hospital for observation at 3 years. At 5 years she was placed at an E.S.N.(S) Day School. At 7 years she transferred to an I.C.A.A. Residential School specializing in language difficulties in less able children. At 9½ years she was transferred to a residential school for autistic children where she is at present. C has had the usual series of childhood diseases but apart from the original period of assessment and observation, she had not been in hospital.

## Richard

Name: Richard (male)      Born: 14.4.52      Age at interview: 26 years
Father's occupation: Social Class III (Registrar General's Classification)
Mother: deceased
Siblings: 1 brother (6 years younger)

### General History

R was two weeks overdue. Mother had a normal pregnancy but she had glandular fever at 6 weeks of pregnancy. R was born after 6 hours' labour. Birth weight: 6lb 10oz. R was jaundiced at birth, and at 3 weeks of age congenital cataracts were diagnosed. R's development was very slow; all his

milestones were very late. At 3 months he was operated on for bilateral cataracts and three further operations were necessary at 6 monthly intervals. When he was 3 years old he was seen by a paediatrician who diagnosed mental handicap. At 6 years of age R was successfully operated on for lymphosarcoma. At 6½ years he started to attend the local hospital occupation centre. At 8 years he was transferred to the Junior Occupation Centre in E and hence to the Senior Centre. He now attends the Adult Training Centre run by the Social Services Department near his home. At 18 years R developed diabetes.

R has become well known as an artist and spends most of his time drawing with oil bound crayons at the A.T.C. R is left-handed. His parents are right-handed but his brother is also left-handed.

## Michael

Name: Michael (male)      Born: 7.4.64      Age at interview: 14 years
Father's occupation: Social Class IV (Registrar General's Classification)
Mother's occupation: Housewife
Siblings: 1 brother (several years older)

### General History

M was one month premature. His mother had rubella when 10 weeks pregnant. Mother cannot remember how long she was in labour but it was an easy birth with no complications. Birth weight: 5lb 1oz. At birth, M showed a number of features associated with maternal rubella in the early weeks of pregnancy. He had a cataract on his right eye. He had a mild degree of cerebral palsy, a heart murmur, and later it was discovered that he is deaf (60db loss) in his right ear. Mental handicap was suspected from birth.

M made very slow progress, sleeping most of the time during the first year of life and all milestones were very late. Speech failed to develop, and M has remained mute with gutteral vocalizations when he's excited. M had a successful operation to remove the cataract at 12 weeks. From 18 months until he was 3 years, M attended a nursery for mentally handicapped babies. At 4½ years he was placed in an E.S.N.(S) Day School. At 7 years of age he was transferred to a residential school for E.S.N.(S) children. From 12 years to the present he has attended another local E.S.N.(S) Day School. M. is right-handed, right-footed but has a dominant left eye since his right eye was operated on. Parents are both right-handed. M has only suffered the normal childhood diseases. He has had two operations, however, to stretch his Achilles tendon. M has a major lasting obsession with hospitals. He used to ensure frequent visits to hospital by bunging up his ears with various objects that required specialist removal.

*Nadia*

Name: Nadia (female)       Born: 23.10.67       Age at interview: 12 years
Father's occupation: Social Class 3A (Registrar General's Classification)
Mother: deceased
Siblings: 1 brother, 1 sister (B — 2 years older, S — 2 years younger)

### General History

N was born at full-term after a normal pregnancy. There is no information on the labour; birth weight: 7 lb. There were no birth complications and no abnormalities diagnosed at or just after birth. N was a very quiet baby, her mother reported that she was unresponsive. All her milestones were late; she walked at 2 years; and language development was retarded. It became increasingly clear that N had severe learning difficulties particularly with social and language development. At the age of 4½ years N entered the local E.S.N.(S) day school. At the age of 5½ years she was investigated at the local hospital and referred to a London teaching hospital; autistic features were noted. When N was 6½ years she was seen at a Child Assessment Unit and the diagnosis of autism was confirmed. At 7½ years N was transferred to a day unit for autistic children where she remained for her junior education and moved to a unit for adolescent autistic children at 11 + years of age. Language development has advanced with a great deal of specialized teaching, but is very restricted and she remains socially isolated and obsessional. N is left-handed. Her parents are right-handed. One sibling is left-handed. N's health is very good. She is, however, a very large child and much overweight — 14st (196lb) at 12 years 8 months.

*Drawings*

*Drawing 1. Stephen, aged 5 years.*

*Drawing 2. Stephen, aged 5 years*

*Drawing 3. Stephen, aged 5 years.*

*Drawing 4. Stephen, aged 6 years 6 months.*

Drawing 5. Stephen, aged 7 years.

Drawing 6. Stephen, aged 7 years.

*Drawing 7. Stephen, aged 8–9 years.*

*Drawing 8. Stephen, aged 8–9 years.*

*Drawing 10. Stephen, aged 7 years.*

*Drawing 9. Stephen, aged 7 years.*

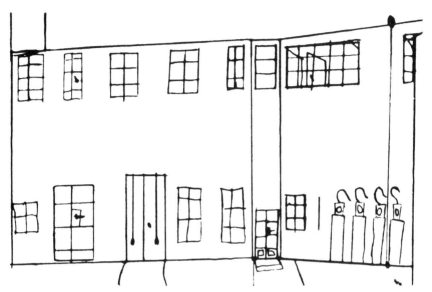

*Drawings 11–17. Scenes from Stephen's school drawn from memory. He was aged between 7–9 years at the time. Each drawing is accompanied by a photograph of the scene depicted.*

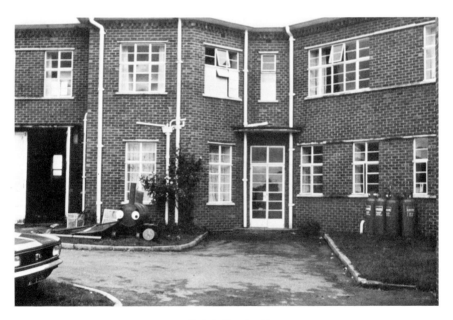

*Basis for Drawing 11*

*Drawing 12. Stephen, aged 7–9.*

*Basis for Drawing 12*

*Drawing 13.   Stephen, aged 7–9.*

*Basis for Drawing 13*

*Basis for Drawing 14*

*Drawing 14. Stephen, aged 7–9.*

*Drawing 15. Stephen, aged 7–9.*

*Basis for Drawing 15*

*Drawing 16. Stephen, aged 7–9.*

*Basis for Drawing 16*

*Basis for Drawing 17*

*Drawing 17. Stephen, aged 7–9.*

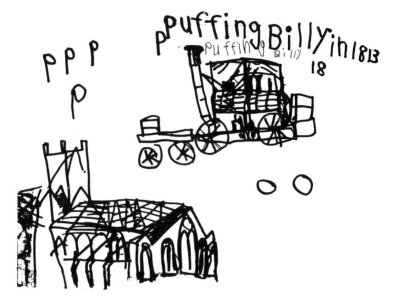

*Drawing 18. Simon, aged 6 years.*

*Drawing 19. Simon, aged 6 years.*

*Drawing 20. Simon, aged 6 years.*

*Drawing 21. Simon, aged 8–9 years.*

*Drawing 22. Simon, aged 8–9 years.*

*Drawing 23. Simon, aged 8–9 years.*

*Drawing 24. Simon, aged 8–9 years.*

*Drawing 25. Simon, aged 8–9 years.*

_Drawing 26a. Simon, aged 9–10 years._

_Drawing 26b. Simon, aged 9–10 years._

The 15th century
building in Chestergate

Three Shires Restaurant

*Drawing 27b. Simon, aged 10–11 years.*

Littleunderbank

*Drawing 27a. Simon, aged 10–11 years.*

*Drawing 28. Simon, aged 10–11 years.*

*Drawing 29. Simon, aged 11 years 8 months.*

Drawing 31. Claudia, aged 9–10 years.

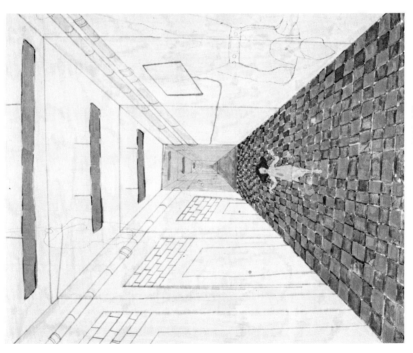

Drawing 30. Claudia, aged 8½–9½ years.

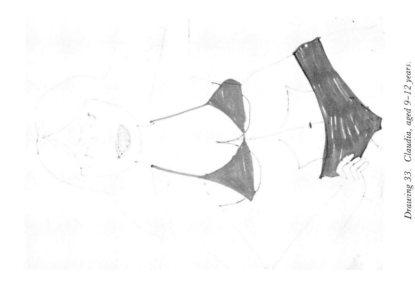

*Drawing 33. Claudia, aged 9–12 years.*

*Drawing 32. Claudia, aged 9–12 years.*

Drawing 35. Claudia, aged 9–12 years.

Drawing 34. Claudia, aged 9–12 years.

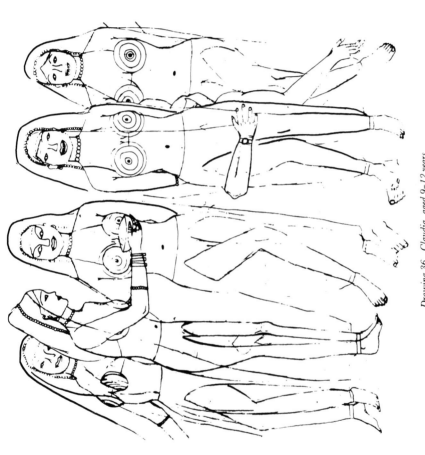

*Drawing 36. Claudia, aged 9–12 years.*

*Drawing 37. Claudia, aged 11–12 years.*

*Drawing 38. Richard, aged 6–10 years.*

*Drawing 39. Richard, aged 6–10 years.*

*Drawing 40. Richard, aged 6–10 years.*

*Drawing 41. Richard, aged 6–10 years.*

*Drawing 42. Richard, aged 6–10 years.*

*Drawing 43. Richard, aged 6–10 years.*

*Drawing 44. Richard, aged 6–10 years.*

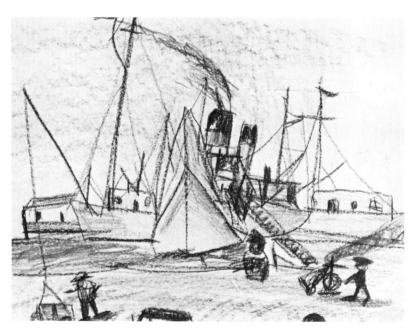

*Drawing 45. Richard, aged 6–10 years.*

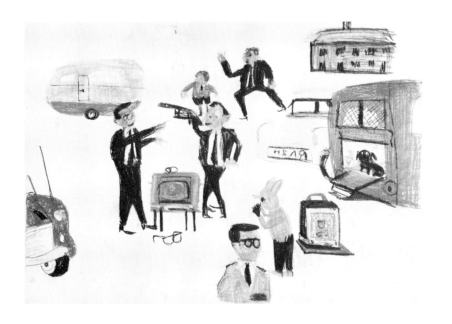

*Drawing 46. Richard, aged 6–10 years.*

*Drawing 47. Michael, aged 8–11 years.*

*Drawing 48. Michael, aged 8–11 years.*

*Drawing 49. Michael, aged 8–11 years.*

*Drawing 50. Michael, aged 8–11 years.*

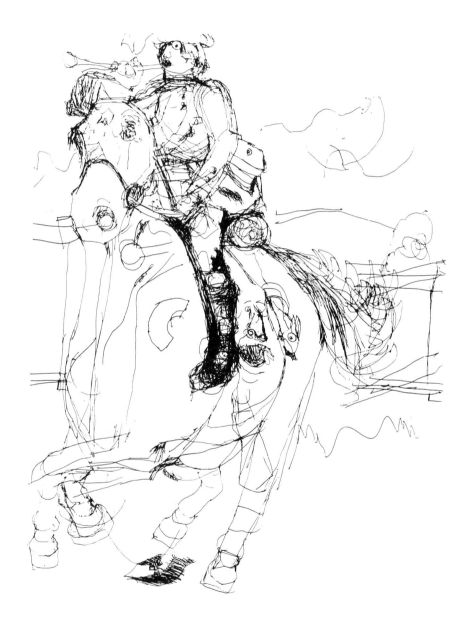

*Drawing 51. Nadia, aged 5½ years.*

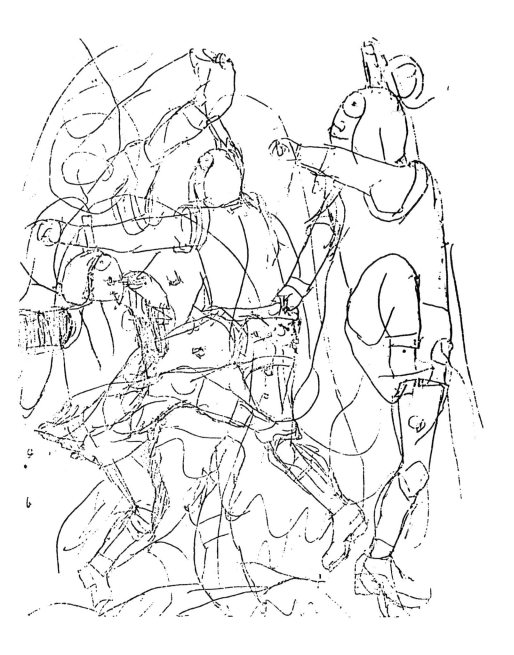

*Drawing 52. Nadia, aged 5 years.*

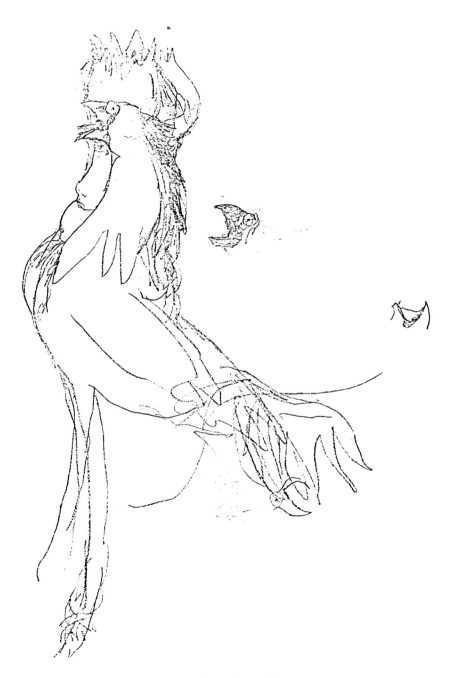

*Drawing 53. Nadia, aged 6⅓ years.*

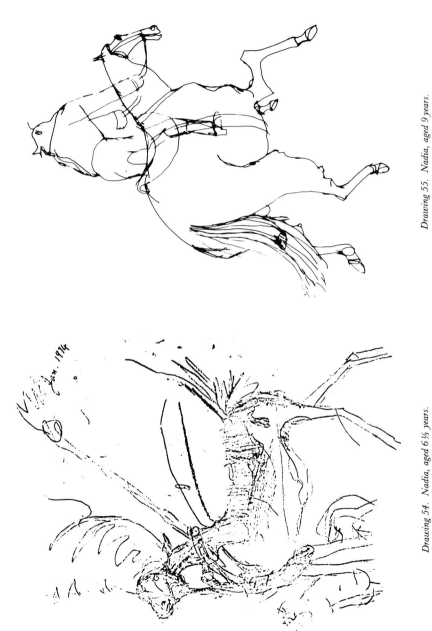

Drawing 55. Nadia, aged 9 years.

Drawing 54. Nadia, aged 6⅓ years.

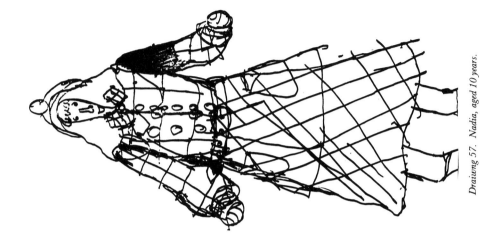

Draiwng 57. Nadia, aged 10 years.

Drawing 56. Nadia, aged 10 years.

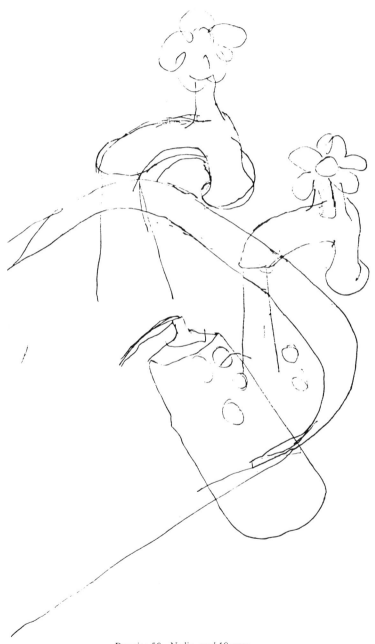

*Drawing 58. Nadia, aged 10 years.*

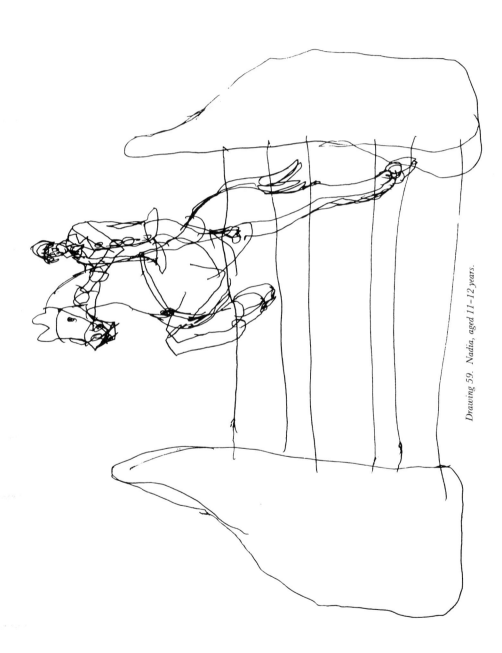

*Drawing 59. Nadia, aged 11–12 years.*

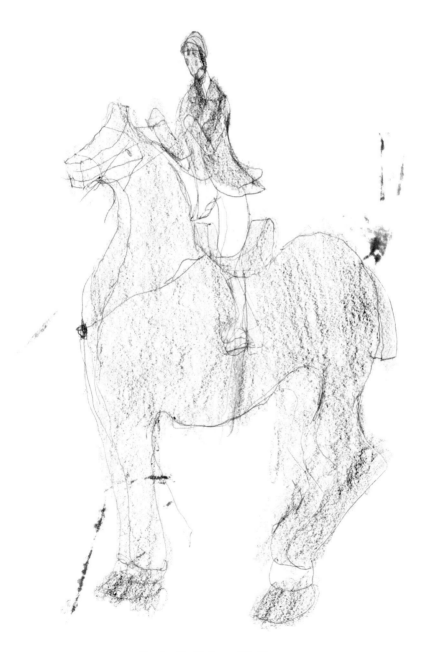

*Drawing 60. Nadia, aged 11–12 years.*

*Drawing 61. Nadia, aged 11–12 years.*

# 8

# *General Results of the Questionnaire on Cognitive Development*

When the questionnaire had been completed on each subject, the questions were divided into areas of cognitive functioning for the purpose of data analysis. In order to simplify and organize the data, the questions and responses were divided into mutually exclusive categories. Where some of the questions could have fitted into a number of categories, the most suitable category was selected. The categories considered were:

(1) Case history: family details
birth history
handedness (see previous chapter)
(2) General development
(3) Gross and fine motor development
(4) Visual abilities
(5) Social development
(6) Language development and analysis of language usage
(7) Other symptoms of autism

Since the subjects vary in age and in general intellectual functioning, the data are best understood idiographically. However, in order to attempt to elucidate significant features which may relate to and offer pointers to an explanation of the drawing ability, this section is an attempt to appraise the general development of the group as a whole. (The questionnaire is given in full in the Appendices.)

## I. RESULTS

### A. Family Details

There is no distinguishing characteristic that would mark out the subjects from the general population with regard to family history, position in the family, or the economic status of the parents. The results show a wide variety of family characteristics.

## (1) Birth History

Again, no significant factor pertaining to all the subjects and substantially different from the general population emerges regarding pre- and postnatal history. Two of the children were born with severe congenital defects: cataracts and deafness in both cases. Maternal rubella was diagnosed in one of these cases. But the other four subjects had normal and uneventful prenatal and birth histories. Three of the subjects were several weeks overdue at birth but two were premature. No significant factors therefore emerge, although the incidence of birth abnormality is high for the group as a whole.

## (2) Handedness

Three out of the six subjects are left-handed (parents in these cases are all right-handed). In addition, two more of the subjects have a dominant left eye. Although this proportion is higher than for the general population (only approximately 12% of normal people are left-handed), it is unlikely to have any major significance for the group as a talented sample of autistic children, since three of the subjects are right-handed (i.e. no simple model of left hemisphere damage can be postulated). Newson (1979) reports that 65% of autistic children are left-handed.

## B. General Development

The responses coded under General Development were chiefly those of a general nature and where no clear motor, social or language component could be discerned.

## (1) Parents' Responses to the Questionnaires

Only one parent reported that her baby responded normally to a loud noise, and five of the parents felt that there was something unusual about their baby right from the start. In two cases abnormalities had been diagnosed and were evident. But three of the parents had seemingly normal babies but still report that they had had doubts.

There were generally few problems reported with breast feeding: two had problems sucking. Sleep patterns were reasonably normal under six months; in fact, most of the subjects were reported to be good babies who were passive and slept a lot.

Four parents reported some difficulties with play activities at 6 months and at 1 year, although a normal interest was also reported. Stacking and lining objects up were mentioned at both ages and by three of the parents. In five

cases parents said that their child had not shown a normal interest in toys, and symbolic play with toys was absent or very delayed in all cases.

Reports on feeding habits after a year old were very variable, although using a spoon and starting to chew were generally reported as occurring later than normal. Toilet training was invariably delayed (according to norms), sometimes by a matter of 6 months only, but in most cases, by at least a year or more.

Results on verbal and scholastic abilities just before school age (rising five years) are also very variable. Two of the subjects could name four colours on request. Two of the subjects could recite numbers up to ten, but only one could count out ten objects correctly, although many normal five-year-olds would also fail to do this. Results here probably reflect I.Q. differences.

Despite the fact that all of the subjects have learning difficulties, particularly related to verbal ability, four of the subjects have mastered the basic skills of reading and can read at a seven-year level at least. Their ability to read is better than could be expected from their other learning difficulties. Simon who is very retarded in many areas of cognitive development, can read fluently and with a comprehension level he cannot match in ordinary conversation. Reading is therefore another ''islet'' of ability for at least two of the subjects.

The subjects who can read generally prefer reading aloud and need to mouth the words. Only one can read silently without mouthing. In all cases learning to read was delayed, and the age of reading skill acquisition would appear to relate more definitely to general levels of intelligence. However, only one subject could read a book with more story than pictures, and in all cases information books are preferred to story books. Similarly, all but two of the subjects could write a few letters and numbers before school age, and could copy sentences between 5 and 10 years. All of the subjects can write down their own name, but in all cases, creative writing is either non-existent or is very very limited.

Two subjects have learned to tell the time but some do so in a limited fashion and mechanically, without understanding; again, the significant ability here would appear to relate to general intelligence, i.e. the most retarded have the greatest problems. In most subjects the understanding of time seems to be normal, i.e. the subjects understand when you say ''later'' or ''in a little while'' and generally they do not forget a promise that has been made to them.

None of the subjects can be trusted to go out on their own. Simon's mother said

> Well, he used to take short walks but he always had to go on the same route and he got distraught when the council cut off a path through the park . . . But his level of public behaviour is always uncertain and he's really at risk.

All the parents said that their child could not be trusted to go out to the corner shop and this is evident from observation of the subject's social behaviour.

### (2) Summary

Those factors can now be identified where most of the subjects have shown behaviours that have differed from what would have been expected from the normal population. These are:
  (a) an abnormal indifference to a loud noise as a baby
  (b) delayed or absent symbolic play
  (c) problems with establishing eating and chewing habits
  (d) delayed toilet training
  (e) problems with independent movement within the local community
N.B. Reading was found to be an "islet" of ability for some subjects.

### C. Gross and Fine Motor Development

Mother's responses to questions on motor development milestones during the first year of life for the subjects show a great deal of variation. Some of the subjects show normal progress from lifting the head, sitting up with support, to standing and walking, but the majority of the subjects show a delayed development. Only two of the subjects were able to walk a few steps at the normal average age of 12 months, and crawling was absent or delayed in all cases.

Four parents reported that their child felt unusual when he was being held: either stiff or floppy muscle tone, and four parents reported that their child was very quiet and passive.

All but one of the parents reported that their child was neat fingered by the age of 1 year. Fine prehension of finger and thumb is well developed by this age in normal children, but a number of the parents commented that this was a particular skill that was well developed. Simon's mother said "Yes, food was very difficult, you see, he always wanted to eat with his fingers . . . so he developed very good finger control". Stephen's mother said "There was a time, between one and two [years] when he loved to pick up specks of dust. He was very delicate with his fingers". Claudia's mother said "Yes, she'd pick up the tiniest thing on the carpet". The majority of the parents reported that their child had also been a neat and tidy eater with no undue dribbling or spitting. Michael was born with cerebral palsy so that his motor control developed slowly, but with all the other children, although they may have had problems feeding themselves, dribbling was not a problem.

The questionnaire next surveyed motor development from the toddler to 5-year stage. An unusual pattern emerges of normal average ability and some striking deficits on certain skills.

The majority of the children (including Michael) could build a tower with blocks at the normal average level; they could thread beads, they were all especially able at jigsaw puzzles. Michael, for example, started doing 6-piece puzzles at 3 years and can now (age 14 years) do an adult 200-piece jigsaw in 2

to 3 hours. All the group enjoyed construction toys. Most of the children could eat with a spoon by 2½ years, but most of them had persisting problems eating with a knife and fork. Four had sufficient fine motor control to use a scissors before going to school and could copy a few letters.

However, with fine motor control, all the children had great difficulty with lacing and especially tying shoe laces where problems persisted into teens in two cases. Also, doing up buttons of a coat was not accomplished until well past the normal age in all six of the children.

Why do these particular skills present difficulties for this group of children and other fine motor skills, such as jigsaw puzzles, *Lego*, etc. do not? A possible explanation is that lacing, tying knots and bows, doing up buttons and using a knife and fork require two factors. in the first place, the motor movements of *both* hands must be co-ordinated. Secondly, a temporarily organized sequence of movements, each movement contingent upon the last, is needed for success.

However, this is not very convincing since three parents did not feel that co-ordinating two hands was a special problem and some skills, such as completing jigsaws are well developed, although each piece that is placed is contingent on previous actions.

With gross motor movement a similar distribution of average ability and deficits is noticed. Only one of the subjects were described by their parents as "agile by five years of age", and all of the subjects' general motor control was described as odd in some way. Michael's mother said, "He looked like a fairy, very dainty, always tripping everywhere". Some parents felt that their child's balance was not good by the age of 5 years and all parents reported that there were problems with climbing trees and nursery apparatus. One mother said, for instance, "Yes, he would go on it but he couldn't work out how to get off it again and we would have to come to his rescue and lift him". Although most of the children could walk upstairs normally by the age of 5 years (3–3 ½ years is average), five of the parents felt that their child had taken longer than average to learn to do this. Five out of six parents reported that their child could not dress himself without assistance by the age of five. Only one parent felt that their child could throw and catch a ball normally at 5 years.

There were mixed responses to "Could he unwrap a biscuit before 5 years?" and "Was he better on using skills using one hand rather than two hands?", and "Did he get into difficulties as a young child?", "climbing too far" etc. However, all the children had difficulties with learning to pedal a trike; only one of them has learned to ride a bike and he would not be allowed out on the roads.

Three of the subjects were in their teens and one is an adult; four parents feel that their offspring is still clumsy on his or her feet, but all but one felt that the subjects are dextrous and skilful with their hands. There is no simple direct relationship between reported skill with hands and well-co-ordinated walking and running.

## (1) Summary

It can be seen that there is very little absolute consistency between the reports on the subjects' motor development, although a general picture emerges. Fine co-ordination is good on the whole; the subjects are often neat fingered and of average ability, possibly where one hand only is required and where no temporal contingent ordering is necessary.

With gross motor co-ordination, the general view creates the impression that the group are clumsy and poorly co-ordinated on their feet. As we have already seen, early milestones were late for most of the children; walking was often delayed until the second year, and we see this delay continue up to at least 5 years of age.

There are a number of items where all or five of the subjects lagged significantly behind normal average development. These were:

(a) Delayed or absent ability to crawl
(b) Continuing problems with mastering: i) lacing toys; ii) buttons on coats; iii) shoe laces
(c) Parents reported that their child was clumsy at age 5 years
(d) Problems climbing playground apparatus and trees
(e) Problems with dressing without assistance
(f) All failed to learn to pedal a tricycle, and only one subject can ride a bicycle
(g) Problems with throwing and catching a ball

## D. Visual Abilities

This section was included because the questions related more directly to visual abilities rather than being related to motor skills. It also might be possible to discover whether the group, as a whole, had any visual problems.

The responses to the questions about toys disappearing from sight (object constancy) were equivocal across the group but consistent for each subject. Some subjects would look for a toy that had dropped out of sight or rolled away; others would not.

However, only one mother felt that there was no problem in her child understanding pointing. Sheridan says that a child can point at an object he wants from 12 months. In some cases, understanding pointing was still a problem at 3 years and even at 6–7 years. Stephen's mother said ''I had to hold his head and swivel it around to make him see what I was pointing at''. However, most of the group were showing a normal interest in pictures as babies although the interest was a little late in developing in one or two subjects.

Two of the children had congenital cataracts which were operated on shortly after birth. Another of the children had a developmental squint; he was seen by an opthalmologist at the local hospital and a further mother reported that

her child had no eye problems "except that in photos, you could see that his eyes were not straight". There are therefore eye problems reported in four out of the six subjects. It is all the more remarkable, then, that these children should show such talent in the graphic representations of the visual field.

## E. Social Development

The responses on social development during the first six months of life are not altogether consistent across subjects, although a strong picture of developmental delay and abnormal development emerges. Five out of six sets of parents report that their child's face did not brighten when he heard his mother's voice under 3 months, and only two of the subjects followed with their eyes when mother was moving about the room, although this would be expected at 2 months with normal babies. Only one parent reported that she could have a little game cooing and gurgling and get a response back at about 2 months. Only one mother (not the same mother as in the previous question) reported that her baby noticably increased his activity when she approached him to pick him up at 3 months.

All the subjects eventually smiled, of course, but even at this young stage, one parent reported that smiling was absent or very rare, and that later this subject learned to grimace as a smile.

Two of the subjects gave problems with sucking during breast or bottle feeding, and the parents of four subjects reported that they felt that there was something unusual about the subject from very early on. In two cases, of course, abnormalities had been diagnosed. This was an ambiguous question, requiring parents to trust that the answer would not be misconstrued to mean that there own attitude had affected their child's development. The fact that the remaining two sets of parents were prepared to admit that they had felt tht there was something wrong attests to the degree of handicap present from the start.

In all cases it was not felt that as a very young baby the subjects were irritable. As has been said already, in the main, most of the subjects were exceptionally good and exceptionally quiet. The responses to whether the mother could tell when the subject was frustrated were equivocal. In the main, the subjects cried rarely, but two mothers mentioned that when the subject did cry, he was inconsolable, and two other mothers commented that the crying tone was odd; Claudia's mother said that she cried "like a cat".

From 6 months to 1 year the subjects continued to show considerable deviations from normal social development generally. Only one mother thought that her child was aware of strangers before his first birthday, for example. Three parents said that their child would respond to games like "pat-a-cake" and "walk-around-the-garden", and most of the subjects seemed to have enjoyed "peekaboo". However, all of the parents said that you could not have a simple game of give-and-take with a toy at around 1-year-old, and only one parent said that her child would come to her for

comfort when he was hurt or upset. It would appear that these children prefer ritualized games when they are not brought into a face-to-face situation with another person, and have to engage in a type of verbal or pre-verbal interaction (personal communication, Dr E. Newson).

Similarly, few of the subjects responded to their mother's mood or would offer comfort if she was upset. Stephen's mother commenting about whether he would come for comfort when hurt, said,

> Oh no, he wouldn't. He used to run off. He would wrench himself away and scream and rush for the door—he'd pull away and bite his hand. He couldn't understand what had happened.

Responses about whether the subjects were affectionate were equivocal. Clearly this is an ambiguous and subjective question. It could be objected that none of these subjects could have shown affection in a well integrated, sophisticated and social sense, but parents nevertheless perceived feelings of affection: perhaps dependence and warmth from their child. Responses were also mixed to the question of whether the child was given to inconsolable temper tantrums. Simon's mother said "Yes, oh yes, a thousand times yes!", but another mother emphasized how placid her child had been. Where temper tantrums were reported, they appear to have been about frustration, pain or fright, and they were unusually long and drawn out.

The questions on friendships with other children showed considerable deviations from normal social behaviour for all of the subjects. In most cases the subjects did not play with other children, and when parents said that play was attempted, it was commented that this was "difficult" or "limited".

All the parents said that their child did not have ordinary friendships or a "best friend". This is particularly telling. Relationships in family are reinforced by nurturant activities such as the satisfaction of hunger, thirst and the alleviation of pain and discomfort. Friendships with other children are based solely on affiliations, the need and enjoyment of social interaction in the broadest terms. The absence of this normal, necessary impulse is therefore highlighted.

### (1) Summary

All the subjects studied have shown delayed or absent features of social development, beginning from birth. However, it was rare that *all* subjects deviated from normal on any one item. This section revealed a large number of deviant responses, suggesting that impairing social development is a significant factor with the group as a whole.

The questions that showed most clearly a uniform deviant response for all or five subjects were:

i. Absence of cooing games or general increase in activity at a social approach as a baby

ii. Generally passive babyhood with little crying

iii. Failure to recognize a stranger before first birthday
iv. Failure to engage in games of verbal and preverbal give and take
v. Failure to make friendships with other children

## F. Language Development

Within the spectrum of learning difficulties for which the children were partially selected, language development has proved to be the area where all the subjects show considerable deviations from normal development. Although within the group there is a considerable range of language ability, one child, Michael, has no expressive language at all. Nadia had very few single-word utterances until she was about 8 years of age, when holophrases started to appear. Her present language is best described as a stream of free association and echolalia, although she can, fleetingly, answer simple questions with one or two words. Simon, Stephen, Claudia and Richard have better language ability. Comprehension is well below average for their ages, but with all four, a limited conversation is possible, although echolalia and regression to free association or "verbal salad" is a possibility with all four.

Beginning from birth to 3 months, all of the parents felt that very early incipient "conversations" where mother and child had a finely timed interchange of verbal activity were either absent or delayed. One of the mothers thought that this early conversation may have taken place but it would have been very limited.

Only one parent heard any babbling or "scribble talk" when the child was alone in his cot or his pram (Illingworth reports that this should occur from 3 months on). Only one parent reported hearing babbling using different sounds, and this mother reported that her baby practised one sound at a time in an obsessive manner excluding other sounds. This is not a usual description of normal babbling.

All of the parents report the absence of the imitation of one syllable sounds made by one or other of the parents. Similarly, all parents report that it was difficult to get the child's attention by calling his name. All the parents report that they were anxious about their child's speech development from about 18 months on, when normal speech had failed to develop.

Speech development from 9 months to one year has been described in detail by Mittler (1970). Parents' responses on the development of verbal comprehension at this time are equivocal. Most parents reported that their child understood "No!", and some felt that their child was beginning to understand things that were said to him, but all of the parents said that their child failed to understand something as basic as "Time for bye byes!" at bedtime (or the equivalent expression used in the home).

Two of the more severely intellectually handicapped children had one or two single word utterances at this time, but single words came much later with all the members of the group. Again, scribble talk at this time was absent with all of the group.

None of the children in the group was said to have an early sense of rhythm. All of the children had difficulty with clapping in time and matching their own voice to rhythmical banging of a spoon. Where imitation did occur, it was often of unusual non-vocal sounds. Stephen's mother said that Stephen used to lie in his cot over 1-year-old, and make noises like the birds outside in the garden.

All of the subjects in the group showed a late or absent interest and enjoyment of nursery rhymes and all the children were late in joining in nursery rhymes.

Parents usually remember their child's first word: Simon said "No!" at 4 years. Stephen said "No!" at 3 years. Claudia said "Dada" at 2 years. Richard said "Mum" at 4–5 years. Michael has never uttered a single word. Nadia said "Mama" at about 1 year. In all but one case single word utterances are delayed, and Nadia, who gained some words at around 1 year, made very little further progress with language acquisition for 6 years! All the children, in fact, are marked by a very long plateau between this first word and the acquisition of further single words. Claudia and Stephen only really started to gain more single words after the age of 3½ years. This is in marked contrast to normal language development, where there is a slowly accelerating acquisition to an average of 200 single words by age 2 years (Mittler, 1970). Most of the subjects did not have a hundred single word utterances until 4 years. However, when single words were acquired, they were generally always used appropriately.

The two-word utterances or the holophrastic stage, usually occurs at 18 months–2 years. All the subjects showed delayed development.
Simon, Claudia and Richard acquired holophrases after 4 years, Nadia at 7 years, and Michael not at all. In all the children who had acquired speech (all but Michael), sentences became longer and language slowly developed, although most of the subjects needed speech therapy. Pointing remained a problem too in all but one case, although two parents reported that their child appeared to understand other gestures more easily, although this was not adequately probed by the questions.

Immaturities of language development, such as getting words in the wrong order, and using telegraphese persisted much longer than normal with all the children. In fact, some of these immaturities still exist in some of the subjects who are now in their teens, and Richard's adult conversation is entirely in telegraphese.

The responses to questions on the early development of verbal comprehension were not so clear in revealing deficits. Three of the parents felt that their child had an understanding of simple requests like "Stop that" and "Come here" by about 2 years which indicates average comprehension. But the questions on a more complex comprehension of verbal instructions: "Go and get the biscuits; they're in the kitchen cupboard", and "Go and get the biscuits; they're in the sewing box", revealed that none of the group could have acted on these instructions at the average age for normal children.

All of the parents reported that their child had moments of understanding

what was said when they hadn't expected their child to understand. One mother said ''Oh yes, he had moments of great clarity''.

Parents were asked if they felt that they could have had a normal conversation with their child when he was a toddler. All parents answered ''No'', and they also felt that strangers could not have had a normal conversation. By the time the subjects went to school all the parents reported that speech development was different from most other children's. When the subjects entered school, parents' comments were that speech was: ''very different''; ''still echolalic''; ''he wasn't chatting or using it [language] spontaneously''; ''very retarded''. Two children were not using speech at all.

All parents reported that there was a time when they thought their child was deaf, and, at a later stage, all the parents said that there were times when their child behaved as if he were deaf, although they knew he wasn't. Stephen's mother said ''He'd ignore the dog barking, but he'd always hear us whispering''. And Simon's mother said ''Oh yes, he'd just shut off when it suited him''.

The general picture of expressive language development pertaining to all the subjects was of gradual improvement with long plateaux apart from Michael, who has never developed even single word utterances.

### Items based on Tough's analysis
### of language usage (1976, 1978)

It was decided to attempt to analyse each subject's current language usage using Tough's classification of the uses of language. The classification is set out below:

A. SELF-MAINTAINING

STRATEGIES

(i) Referring to physical and psychological needs and wants
(ii) Protecting the self and self interests
(iii) Justifying behaviour or claims
(iv) Criticizing others
(v) Threatening others

B. DIRECTING

STRATEGIES

(i) Monitoring own actions
(ii) Directing the actions of the self
(iii) Directing the actions of others
(iv) Collaborating in action with others

C. REPORTING ON PRESENT AND PAST EXPERIENCES

STRATEGIES

(i)     Labelling the components of the scene
(ii)    Referring to detail (e.g. size, colour and other attributes)
(iii)   Referring to incidents
(iv)    Referring to the sequence of events
(v)     Making comparisons
(vi)    Recognizing related aspects
(vii)   Making an analysis using several of the features above
(viii)  Extracting or recognizing the central meaning
(ix)    Reflecting on the meaning of experiences, including own feelings

D. TOWARDS LOGICAL REASONING*

STRATEGIES

(i)     Explaining a process
(ii)    Recognizing causal and dependent relationships
(iii)   Recognizing problems and their solutions
(iv)    Justifying judgements and actions
(v)     Reflecting on events and drawing conclusions
(vi)    Recognizing principles

E. PREDICTING*

STRATEGIES

(i)     Anticipating and forecasting events
(ii)    Anticipating the detail of events
(iii)   Anticipating a sequence of events
(iv)    Anticipating problems and possible solutions
(v)     Anticipating and recognizing alternative courses of action
(vi)    Predicting the consequences of actions or events

F. PROJECTING*

STRATEGIES

(i)     Projecting into the experiences of others
(ii)    Projecting into the feelings of others
(iii)   Projecting into the reactions of others
(iv)    Projecting into situations never experienced

G. IMAGINING*

STRATEGIES

(i)     Developing an imaginary situation based on real life
(ii)    Developing an imaginary situation based on fantasy
(iii)   Developing an original story

*Strategies which serve directing, reporting and reasoning may serve these uses also.

This classification gives a very useful guide to the range of activities that expressive language can be put to. Questions were prepared on most of the items listed. It was reasoned that it may be possible to highlight areas of deficiency and ability in the group and thereby gain further insight into the nature of their language difficulties and general cognitive functioning. It must be remembered that one child has no expressive language and another has very limited speech.

### (a) Results

#### i. Self-maintaining

All the children, except Michael, can let you know what their basic needs are; all, except Michael, can use speech to protect their own interests at a basic level. Similarly, all but Michael can make threats to warn off through some form of verbal aggression, but only three of the subjects could criticize another person with any real meaning. However, on the whole and apart from Michael, the group can use language, albeit at a very basic level for most of Tough's suggested strategies for self-maintaining.

#### ii. Directing

Again, most of the subjects can use spoken language to monitor their own actions and to direct and collaborate in actions with others but, from the author's observations, in many of the subjects directing and collaborating with others through language would occur very infrequently and would be at a very basic level. For example, Nadia says "Tanya biscuit", meaning "Will you get me a biscuit Tanya" (her sister). So she manages to direct another through the most basic and limited use of language.

#### iii. Reporting on Present and Past Experiences

In this section some of the more linguistically handicapped members of the group start to fail items regularly. Nadia and Simon, for example, clearly are restricted in their reports on present and past experiences. Michael, of course, fails all the items. All of the subjects, except Michael, can label the

components of a scene in a picture book. But Nadia would have difficulty in listing objects which are out of sight. Four of the subjects would have problems in describing an unusual object, such as a traction engine.

Most of the subjects would be able to say something, however basic and rudimentary, about something they have done when their parent was not with them. Reports about something someone else did brought comments that the subjects would just not be interested. Again, most of the subjects could report on another child getting into trouble in school, but Stephen's mother said, "Yes, but he would not volunteer information; we would have to pump him". Five subjects were felt to have difficulty in sequencing events in a reasonable order and all of the members would have difficulties in conveying the most important events and ideas in relating a story.

### iv. Logical Reasoning

It might be expected that if the members of the group are intellectually impaired, then logical reasoning might present them with most problems. But no such uniform deficit emerges. Two of the group could give an explanation of how a simple object like a pencil sharpener works, for example, and two of the group could suggest a suitable solution to a simple problem. However, when it is a question of explaining why the subject has done something or why he is going to do something, more subjects would have difficulty. It was felt that in all cases except Nadia and Michael, the children could use speech to make excuses for themselves, but the excuses might not be credible.

### v. Predicting

Predicting events often involves logical reasoning, recognizing causal relationships and drawing conclusions, although it may be argued that with intellectually impaired individuals, the kind of prediction that they make will be based on the habitual association of two events. If the child anticipates the arrival of the postman, this may well be due to his habitual appearance after breakfast. Intelligent and logical action is best seen in the child's reaction to the unexpected. Simon's mother, for example, described Simon's panic when the water would not run out of the sink one bitter winter's morning because it was blocked by ice. He left the taps running, went to fetch his mother and flooded the room.

Most of the subjects in the group can predict and anticipate future events and describe this in speech and most of the group can go on to anticipate problems and offer simple solutions. Few of the group can explain the anticipated events in a fluent order. Simon's mother said, "Yes, he can explain events in order, but it sounds all wrong; it's pedantic and stilted. He gets quite het up explaining".

### vi. Projecting

It was felt that one of the simple ways of projecting into the feelings of others is through the telling and enjoyment of stories and this especially could be demonstrated by the child's understanding of jokes. In all cases, the subjects were reported to find difficulty with jokes, both with understanding them and with telling jokes successfully. Two of the subjects could repeat a story that they had heard, although this would be a very simple story. Only one of the subjects could make up a story, according to her mother, I would suspect that the story would be very simple, concrete and idiosyncratic.

### vii. Imagining

All the subjects show considerable imagination in their drawings. But, as may be expected, imagination expressed through verbal means is far less powerful or well organized. All parents felt their child was restricted in this capacity and one mother said, "That's just not meaningful. He has an imagination; it's just not what we mean by imagination", and Stephen's mother said, "Yes, he can tell stories, spin yarns . . . but they're all to do with his current obsession. He'll maintain endless lies if they're necessary for maintaining his obsession". So where imagination is indicated, it is often used in a distorted or obsessive manner. Two of the children could express sympathy for someone else, however.

Despite the fact that answers to whether the subjects could use Tough's strategies were often in the affirmative, none of the parents felt that it was possible to have a normal conversation with their child.

There were very few questions on Tough's Analysis where all or five of the subjects failed or exhibited difficulties, these few being:

(1) Explaining and giving reasons why he has done something
(2) Sequencing events in a reasonable order (occurred regularly in various forms in the analysis)
(3) Telling a story and getting the main events in the right order
(4) Understanding and telling a joke other than obvious visual slapstick
(5) Imagination

It would appear that the subjects have problems on the more subtle and complex uses of language often involving social relationships (it is interesting to remember that they all prefer information books to story books). It may also be possible to deduce that the sequencing and ordering of events, especially those involved in social interchange rather than in inanimate causal relationships, are difficult.

In all other respects, Tough's analysis yields equivocal results. It is very surprising to find that despite very obviously restricted language use with all of the subjects, even the more handicapped linguistically (with the exception of Michael), most can use language for the strategies Tough describes.

Tough does not analyse the *fluency* and *flexibility* of language usage and if her analysis does anything in connection with this group, it points out that the

language that they have can be used appropriately and for a wide range of intelligent strategies, but it is not used fluently: syntactical structure is often restricted so that shortened sentences and telegraphese are frequent. Also, it is not used flexibly, with a ready natural flow.

Simon's mother expressed this cogently, "With me, my thoughts bubble to the surface as language, in a constant stream; with Simon, it's as if he has the thought and then has to search for the words to fit".

## G. Symptoms of Autism

Since some of the members of the group had been diagnosed as autistic, it was decided to see to what extent all the subjects had autistic symptoms. The symptoms of autism were taken from Wing (1976), Rutter (1978) and Newson (1979).

The first group of questions were concerned with the problems of language distinctly associated with autism. Questions relating to symptoms of retarded and impaired language development are considered under the section on language development, although these too can be regarded as relating to the symptomatology of autism.

### (1) Results

#### (a) Language Impairment

The results for this section overwhelmingly indicate that all the subjects had or have many features of autistic language, both verbal and non-verbal.

All the parents felt that their child's facial expressions were unusual. Four of the parents said that facial expressions were notable by their absence, the child was impassive and unresponsive or "just blank", as Stephen's mother put it.

The results on whether the child had refused to use certain words were equivocal. Where language usage was very restricted, it was impossible to know whether the child was also deliberately choosing not to use certain words. All but one parents said that their child had his own private rules about the way he said things. Stephen's mother said, "His speech was stereotyped, monotonous in tone. He somehow couldn't get the intonation right, and he made up pet words: "pool spiral" for play school, and "Ahpool" for radiator." All but one parent said that their child had also used an odd tone of voice.

All the parents felt that their child had had problems in asking questions and in answering questions. Simon's mother said, "Yes, he always asked questions as statements. 'Daddy home' meant 'Is Daddy home?' He couldn't use interrogative reversals, such as 'Can I have a biscuit?'; it was always 'Want biscuit'."

All the parents similarly said that the subjects had had difficulty in using

"yes" or "no" when they were asked a question and preferred to repeat part of the question as a reply, e.g. "Do you want a sweet?" [Reply] — "Want a sweet".

All but one parent of the children who had some expressive language said that their child had asked the same questions over and over again. Stephen's mother said, "Yes, he drove us crazy — "Why have tigers got claws?" — you just couldn't switch him off."

Four out of the six subjects were echolalic. (Michael has no speech at all) and in the remaining child, the parent answered in the affirmative to the next question that he echoed part of a question for an answer so that some features of echolalia were present with all the subjects, apart from Michael.

All the speaking children showed pronominal reversal and other difficulties with pronouns. One mother said, "He would say, 'Do you want a ride?' when he meant 'I want a ride' and he progressed to saying 'Do I want a ride?' meaning 'I want a ride'".

Similarly, most of the subjects would come out with a sentence which he had heard somewhere else and was not connected with present situation (delayed echolalia).

All the parents felt that there were difficulties with comprehension and with getting their child's attention. It was generally felt that attention was the main difficulty in communication, but parents demonstrated feelings of confusion, unsure whether comprehension or attention was the principal problem. All the parents reported that their child would fail to respond to a loud noise, but notice a very quiet rustle. Again, as previously stated, many of the parents said that there were occasions when the subjects behaved as if they were deaf, although parents knew they were not.

### (b) Impairment of Social Relationships

Again, this is investigated more fully in the section on Social Development and conforms closely to the autistic criteria. However, some additional factors are considered in this section. The results were equivocal on the question "Has he ever seemed not to recognize a familiar object or person?", and on the question of whether the subject has ever walked straight past a person without apparently noticing them. Eye contact is difficult for parents to assess since this is more noticeable to strangers on initial contact. Not all the subjects avoided eye contact with the author on the first occasion she met them, although in all cases, social interaction was abnormal, either because of lack of eye contact or because of poor or eccentric verbal communication.

All but one of the parents said that they often needed to wave or call to attract attention and all of the children had unusual habits that worried the parents. (This question provoked lists of bizarre behaviours, many of which will be considered again.) But it is interesting to quote some of the mother's replies here. Stephen's mother said, "Yes, social ones . . . not knowing when to whisper and when to shout. He could be so rude; it was so embarrassing; he got very interested in fat people and he'd shout out 'That lady's fat'".

Simon's mother said, "Yes, head-waving, sand-eating, flapping — this is still with us . . . nose rubbing and face pummelling . . . spinning incessantly".

### (c) Mannerisms

The next questions concerned mannerisms, often associated with autism (and a primitive form of ritualistic behaviour). All the children had had unusual mannerisms and unusual movements. Most had had periods when they had liked to spin round and round on the spot persistently. Most had run up and down without purpose and jumped up and down on the spot. Several other gross motor movement habits were volunteered such as stuttering with feet, rocking incessantly, head banging, etc.

All of the children flapped their hands, although variations of this were described. All held their hands in the air. Stephen flaps still, but he used to use quick finger movements in front of his eyes. Claudia flicks her hands from her wrists. Michael picks his fingers, holding his hands up — in an obsessional rather than constructive way. Nadia used to shake her hands with excitement, but this feature is far less pronounced with her. Simon flapped his hands at the side of his head and by his ears. His mother thought that this was connected with tension rather than stimulation. And Richard used to flap and finger point and swivel one finger at the corner of his eye. Similarly, a number of the group used to twiddle their fingers or objects in the corner of their eyes and spinning objects was mentioned by a number of parents.

### (d) Obsessions

All the children were thought to have had real obsessions. The question is perhaps subjective, but the quality of the responses left one in no doubt that the obsessional behaviour was severe and extreme.

Richard's home tutor said, "Yes, he was always spinning objects: pennies, screws and he was obsessed with cutlery, pans out of the cupboard and banging one note on the piano".

Simon's mother said, "Oh yes, his worst obsession is a terror of mashed potato. If he sees any he can scream 'Danger!' It's been with him for as long as we can remember. Tidiness too — everything has to be the same". Regularly mentioned items included; lights, calendars, lifts, escalators, tube trains, laundrettes, record players and digital clocks.

All the children have had an exaggerated liking for some particular kind of object. Stephen loved feet, also doors, train signals and road signs, and his mother had to take him every day for a year or two to see one particular railway signal.

All the children carried their obsession to excess and to a level that made life difficult. Stephen had an obsessive fear of lavatories with difficult consequences. At one stage he had to be hospitalized with severe constipation. Michael had an obsession with hospitals. He learned that if he blocked up his nose or ears with nail parings, he could be admitted to casualty and he tried

this regularly. Simon's mother had to go through a pile of 92 picture postcards every morning before Simon went to school. These obsessions could also involve strangers.

All the subjects except Claudia would become unduly upset if there were changes in the day-to-day routine of their homes. Stephen's mother said, "He had to go the same way home from school and once, when I changed his routine, because I had to go to the shops, he had a terrible tantrum — clawing and unrooting plants in a garden . . ."

Similarly, most of the children showed a disproportional terror of some objects or of lights or noise. Claudia could not understand the noise of water circulating in the radiators in her home and regularly screamed in terror.

Most of the parents reported that their child had been excessively confused or frightened by busy streets or a large store. All the subjects showed symptoms of autism at a very early age, i.e. before 30 months.

### (2) Summary

It is obvious from the data analysis that all the children in the group have shown a number of the well-known symptoms of autism. All have shown marked language delay and abnormalities of spoken language. In the majority, language ability remains restricted and abnormal. All the subjects have also shown impaired social relationships. All have shown marked obsessional and ritualistic behaviour and, in all cases, many of these symptoms showed a very early onset. In all cases the subject has shown the four major criteria that Rutter (1978) suggests should be used in the diagnosis of autism (these will be discussed shortly).

## II. SUMMARY AND CONCLUSIONS

The major significant factors which all or five of the subjects share and which also distinguish them from normal development can now be summarized and discussed.

Since so many of these factors relate to the diagnosis of autism, it would be useful to first consider Newson's modification of Rutter's (1971) criteria in the diagnosis of autism (Newson, 1977).

(1) Impairment of language and all modes of communication, including gesture, facial expression and other body language, and the timing of these.
(2) Impairment of social relationships, in particular a failure of social empathy.
(3) Evidence of rigidity and inflexibility of thought processes (as instanced by obsessional and ritualistic behaviours (Newson, 1980).
(4) Onset before 30 months.

The foregoing provides a framework for considering the significant factors to emerge from the questionnaire.

## A. Impaired Language Development

All the subjects showed delayed and deviant language development and problems with all modes of communication. *All* of the subjects shared the following features:

    (a) A failure to imitate sounds, especially single syllables produced by the parents.

    (b) Problems with getting the subject's attention and fear that the subject was deaf.

    (c) Failure to comprehend simple requests before 1 year.

    (d) Delayed or absent babbling and failure to engage in pre-verbal "conversations".

    (e) Lack of understanding of rhythm before 1 year.

    (f) Delayed participation in nursery rhymes.

    (g) Holophrastic stage of language development delayed.

    (h) All subjects showed moments of understanding when it was not expected.

    (i) Problems with understanding some gestures.

    (j) By school age, language development was still felt to be deviant.

    (k) Unusual facial expressions.

    (l) Problems with asking and answering questions.

    (m) Echolalia or delayed echolalia.

Further factors revealed by Tough's analysis occurring in five or more of the subjects:

    (a) Problems with self justification and reasoning.

    (b) Problems with sequencing events.

    (c) Problems with telling a story.

    (d) Problems with understanding verbal jokes.

    (e) Lack of imagination in the normal sense.

## B. Impaired Social Development

    (a) Lack of normal "social" response as a baby.

    (b) Failure to recognize strangers before first birthday.

    (c) Failure to engage in games of give and take.

    (d) Failure to make friendships.

    (e) Problems with attracting subject's attention.

## C. Obsessional and Ritualistic Behaviours

Questions about these features of behaviour were included in the section on autistic features and those features occurring in the majority of the subjects were:

(a) All parents felt their child had obsessions.
(b) All had shown an exaggerated liking for objects, actions and people, and this was carried to a degree that made life difficult for the parents and even involved strangers.
(c) An insistence on sameness.
(d) All displayed unusual habits and mannerisms: they flapped their hands, ran up and down without purpose and were unnecessarily terrified of some noises.

## D. Onset

All of the subjects showed an onset of these symptoms before 30 months.

## E. Other Significant Features emerging from the Analysis not Classified above

(1) An abnormal indifference to a loud noise as a baby.
(2) Delayed or absent symbolic play.
(3) Problems with establishing eating and chewing habits
(4) Delayed toilet training.
(5) Problems with independent movement within the local community.
Motor ability:
(6) Delayed or absent ability to crawl.
(7) Problems with lacing, tying, buttons, throwing, catching, climbing, dressing oneself, pedalling a tricycle and riding a bicycle.
(8) Parents reported that their child was clumsy at least up to 5 years of age.
It should be noted that all these additional items are also symptomatic of autism.

From the foregoing it is evident that all the subjects in the group show sufficient symptoms of autism for such a diagnosis to be made and, indeed, some of the group have already been diagnosed as such. It would be useful to give a very brief summary of the current description of autism (Rutter and Schopler, 1978), since autism is shared by all members of the group and is therefore the principal stable characteristic. It is beyond the scope of this book to review and consider the numerous theories of autism (these have been summarized by Prior, 1979), or even less, to offer any sort of explanation for the phenomenon. But it is possible that there is a relationship between the cognitive deficits associated with autism and these subjects' unusual drawing ability and some theories which appear to relate the two are mentioned here and considered more fully in the final conclusions.

Kanner (1943) defined a previously unrecognized syndrome which he called autism characterized by lack of affective contact and resistance to change shown by repetitive stereotyped activities. He further defined the following features of the syndrome: an inability to develop relationships with people; the

non-communicative use of speech after it develops; delayed speech acquisition, echolalia and delayed echolalia; pronominal reversal; repetitive and stereotyped play activities; an obsessive insistence on the maintenance of sameness; a lack of imagination; a good rote memory and normal physical appearance.

There has been a great deal of research since Kanner's original classification so that a distinct symptomalogy for autism has been confirmed and some progress has been made in understanding the phenomenon, although confusion still exists since this is a baffling and complex condition.

Rutter (1978) has reviewed the diagnosis and definitions of autism. He claims to have identified four principal criteria in autism based on our growing understanding of the condition. His four criteria are:

(1) an onset before the age of 30 months;

(2) impaired social development that has a number of special characteristics and which is out of keeping with the child's intellectual level;

(3) delayed and deviant language development that also has certain defined features and which is out of keeping with the child's intellectual level; and

(4) an insistence on sameness as shown by stereotyped play patterns, abnormal preoccupations or resistance to change.

Newson (1977) offers a similar, more qualified description.

Rutter claims that the syndrome as defined by his four criteria, has been shown to be valid and meaningful in that it differs markedly from other clinical syndromes associated with specific cognitive deficits. Unlike other subnormal or retarded subjects, autistic children have a particular cognitive deficit that appears to involve language abilities and central coding processes. Rutter says that the results of several studies leave no doubt as to a differentiation between autism and mental retardation. But autism can and often does appear in association with mental retardation in which it appears to be one of several impairments. Rutter (1978) reports that only approximately 25% of autistic children score in the normal average range on standard I.Q. tests (other authors put the figure much lower). Rutter also points out that autism is known to occur in association with other disease conditions which cause global damage to the central nervous system, such as maternal rubella and tuberous sclerosis.

It would appear that there is general agreement among recent writers that autism is a specific and discrete neurological impairment bringing about behavioural dysfunctions. The cause of the impairment, whether through disease, injury or metabolic dysfunction, is not known, neither is the site or location of damage known. Where the damage is specific the cognitive impairment is more specific. The child may retain other cognitive functions and may show average or above average ability and intelligence in these areas. However, damage to the hypothesized specific locations involved in autism may occur along with more global damage to other areas of the brain so that other intellectual functions are impaired and general retardation occurs. So far, there is insufficient evidence for justifying placing the abnormal focus in

any particular area of the brain and Rutter points out that the fact of the plasticity of function in the infant's brain makes it very likely that a bilateral lesion or foci would be required to account for the deficits seen in autism.

It cannot be concluded that language areas alone are affected, for example, since it is argued that the language disability stems from a more widespread cognitive deficit which affects other skills as well as language ability. A thorough and coherent explanation in terms of the autistic baby's failure to code information in social interactions has been offered by Newson (1980).

It should also be noted that the pattern of cognitive deficits is somewhat different in very low intelligence autistic children and in autistic children with an average I.Q. (Hermelin and O'Connor, 1970). In general, the severely mentally retarded autistic child shows a wider cognitive deficit involving general difficulties in sequencing and feature extraction, whereas in the normally intelligent autistic child, the deficits mainly affect verbal and social skills.

The differential prognosis for autistic children with high and low I.Q. is both worse and different for retarded autistic children (Rutter, 1978). Retarded autistic children are much less likely to gain speech and far fewer acquire skills in reading, writing and arithmetic, whereas half of those with normal intelligence in Rutter's group went on to higher education. Epilepsy is a complication for 32% of retarded autistic children but rare in those of normal intelligence (Rutter, 1978).

There are many theories of autism. Psychogenic theories suggesting that the cause of autism lies in a faulty relationship with the parents have largely been discounted and most commentators agree that a specific cognitive deficit exists. Psychological theories revolve around the nature and mechanisms of such a deficit. Churchill (1978) and Menyuk (1978) emphasize the central role of language in autism. Other commentators have emphasized motor and perceptual deficits. Current research has centred on the role of pragmatics in autism. These theories have been reviewed by Prior (1979). One particular cognitive theory stands out as having some explanatory power in connection with the drawing ability of this group of autistic children.

Hermelin (1978) reports on a series of experiments she undertook with O'Connor which investigated normal, autistic, blind and deaf children's use of verbal and spatial modes of cognitive organization. They found that when autistic children were offered the choice between a verbal, sequential mode or a spatial mode of presentation in a memory task involving letter recognition, autistic children tended to code information in a spatial manner. They found that although autistic children could respond appropriately to the complete range of sensory information coded in particular modes; auditory, tactile, visual and spatial, nevertheless, they tended to respond only in the mode presented to them. Hermelin and O'Connor found a lack of mental mobility in handling information and in transforming one type of coding into another type. Normal children can readily memorize a list of objects in terms of words and in mental images with a ready transposition between both modes, but autistic children do not have flexible coding and transformation.

Hermelin (1978) suggests that this lack of mental mobility or rigidity in using modes can make the autistic child operationally blind or deaf, or even both. It is possible that such a rigidity may also account for the fact that this group of autistic children are able to represent spatial and perspective characteristics in their drawings. This hypothesis will be examined in the final conclusions.

# 9

# Results of the Questionnaire on Drawing Behaviour

The questionnaire on drawing behaviour was designed to gain as much information on the drawing behaviour and drawing development of the autistic group as possible. The questionnaire was also given to eight parents with normal average children in order to establish comparisons and to discover where substantial differences between the autistic group and normal children occurred.

Since the number of subjects in the autistic group is small, the responses to the questionnaire are analysed descriptively and qualitatively, and the data can be viewed in conjunction with the other questionnaires as providing idiographic information. Most of the responses to the questionnaire are discussed and enumerated in the chapter to provide a descriptive and qualitative account of drawing behaviour.

The questionnaire was designed to lead respondents through a chronological sequence from their child's earliest drawings to later and recent years thereby promoting easy and more accurate recall. The responses required retrospective information and the questions therefore had to be reasonably general and flexible. The questionnaire was given some pilot trials and amended where difficulties were encountered. In all of the questionnaires employed in the study there is a necessary compromise between the accuracy of a retrospective report and the precision of the questions asked. Also, inevitably, since the questionnaire has few precursors and the questions rested on what the author believed to be important and relevant at the time it was compiled, with hindsight there are some changes that the author would now make (see Appendix III).

## RESULTS

### Pre-representational Drawing

According to Harris (1963), in his Draw-a-Man Test, the average child of three years of age scores 7–8 points on the test, i.e. he can draw a tadpole figure, head plus legs plus some major facial features. All parents of the

normal children reported that their child began to draw between 1½ and 3½ years of age. All these parents also reported that their child commenced by scribbling. Children normally have a period of scribbling before they can draw anything recognizable (Harris, 1963; Lark Horowitz, 1967). Representations gradually emerge out of the scribbling activity. The children in the autistic group all began to draw later than normal children: between 2½ and 4 years, and in all cases the very first attempt at drawing produced a recognizable object. All the parents of the autistic group reported that there had been no preliminary scribbling stage. Some of the parents were definite and emphatic that this stage had been omitted. This is remarkable since Elliott and Connolly (1974) have investigated the development of hand and motor control in children using a paintbrush and showed an age-related increase in skill. Scribbling is often described as a stage in the mastery of manual function (Arnheim, 1954). However, scribbling and representational drawing involve the operation of one hand in a sequence of movement where spatial mastery may govern production rather than manual dexterity.

## Earliest Representations

The normal sample of children were reported to have produced their first representational drawings around 3 years of age. This corresponds with Harris's norms. The autistic group first drew at a somewhat later age, after 3½ years. Again, most of the parents of the autistic children reported that their child did not scribble at all even after he had commenced representational drawing. None of the group has ever doodled; their drawing has invariably been intentional and representational. The subjects which children draw have been classified and described by Lark Horowitz et al. (1967). All of the normal sample of children first drew conventional subjects, people and houses, noted by Lark Horowitz et al. as the overwhelming preference of most young children. The autistic group, however, showed a wide range of unconventional subjects as their first subjects. Human figures were only mentioned by two parents as first subjects. Other subjects included a church, a yacht, houses, windows, horses, flowers and cars. It is unclear precisely why human figures are the first subject of most normal children'. Convention and social conditioning must play an important part and autistic children are cut off from the effects of both.

A wide range of both implements for drawing and surfaces were used by both the autistic group and the normal sample of children, although, as might be expected, the autistic sample showed some obsession and rigidity in their use of these media. For example, one mother reported that her son drew obsessively on any surface available, including walls and the ceiling of his bedroom which he reached by climbing on furniture. Five of the parents of the autistic group also reported that their child had appeared to draw much more skilfully with one particular implement than with any other. Nigel's mother said that Nigel was "extremely rigid and he was totally opposed to using

anything other than a fine biro''. Nadia too preferred ballpoint pen and she drew in a very immature manner when offered other drawing materials.

Most of the parents of the normal children reported that their child went through a progression of ways of holding the pencil in the hand for drawing. This corresponds to Connolly and Elliott's (1972) findings where hand grasps are gradually acquired and the repertoire expanded. However, four children in the autistic sample began drawing with a standard adult grasp. But it should be remembered that drawing commenced at a later age than normal with four subjects. Nevertheless, in view of retardation in other areas of cognitive functioning and the absence of the expected development of motor control, this occurrence is not easily explained. As was discussed in the previous questionnaire, it would appear that these autistic children are at least average in manual manipulation in tasks involving one hand only. Some of the autistic children showed an obsessional retention of an inappropriate hand grasp which persisted for many years.

### Early Representational Drawing

The time spent in drawing for each individual in both the autistic and normal groups varied considerably. However, five children in the autistic group were said to draw on most days, whereas the normal group drew less often.

None of the children in the autistic group named or described their drawings, whereas the normal children almost invariably discussed and named their drawings and actively sought out parents' comments and approval. The refusal or inability to engage in social and verbal communication among the autistic group is clear, and this extends to their attitude to drawing. They appeared to draw to please themselves only. They did not seek approval for their drawings or seem to be interested in their parents' reactions. They all chose their own drawing subjects and were generally resistant to suggestions.

As with the very earliest representational drawings, the autistic group continued to draw an unconventional and unusual range of subjects. Most showed a wide scope of subjects. Buildings, trains, the London Underground, roads and road signs were regularly mentioned and were drawn by a number of the subjects. The subjects were also often the objects of obsessional interest to the children: Nadia has retained a passion for horses, Stephen drew toilets and Michael drew hospitals (he made models of hospital equipment and he engineered trips to hospitals whenever possible).

The normal sample of children drew far more orthodox subjects. In fact, it is notable that normal children are not adventurous or experimental in their drawing. They tend to be conservative and cautious, apparently preferring to reiterate or improve on old conventional themes, rather than risking subjects beyond their repertoire.

With the autistic group, the parents suggested a wide range of theories to account for the original inspiration for the subjects. In many cases the subjects were from real life. Stephen's mother produced a number of drawings which

Stephen had completed at home and which were clearly drawings of the interior of his school. (The author photographed these interior views and the drawings and photographs are included on pages 103–109). Although the drawings are recognizably of the photographed view, it is also clear that the drawing is not an eidetic image. This will be discussed in detail in the conclusions.

Books and magazine pictures also provided the inspiration for later drawing in the autistic group. But, in all cases, the parents of the autistic group of children emphasized that their child had not copied his drawings, but had drawn entirely from memory. The inspiration for the subjects in the normal group was different in nature since their drawings were symbolic rather than realistic so that any particular subject tended to be represented by a universal symbolic form. Some drawing was deliberately copied: particularly cartoons, usually copied from picture books where the child made an obvious direct attempt, often employing tracing or measuring.

Further questions were given on the topic of copying, and the parents of the autistic group maintained that direct copying occurred extremely rarely, if ever, and that the drawings were almost invariably produced from memory.

The autistic group of children started writing letters and numerals later than normal children. The autistic group often incorporated letters and numerals in the form of clocks, calendars, road signs and signposts in their drawings and this appeared to be a recurring obsession with many of the subjects. This is unusual, and parents of the normal sample reported that their children did not do this.

Questions about the child's general level of excitement and arousal while drawing proved to be highly subjective, and responses for the autistic and normal groups provided no consistent data. However, all the parents of the autistic group reported that they felt that their child's skill in drawing was very different from skill shown in other activities. The child's drawing ability was felt to be well above average, although many other abilities were acknowledged to be retarded. All the parents of the autistic group believed that their child had an early understanding of drawing perspective and proportion, whereas the parents of the normal children responded to these questions with a negative. Questions about other aspects of representational skill, such as the ability to convey humour, caricature etc., produced mixed responses. Five sets of parents of the autistic group said that their child was able to draw people and objects in different positions (an aspect of photographic realism).

Responses to questions about the use of colour in drawing produced mixed replies. From observations of the drawings of the autistic group, colour is not an important feature; many of the children draw entirely in black and white. However, the parents commented that their child would colour if colour was available, but frequently it was not, and presumably it is not very actively sought. Colours were used appropriately. In this respect, the autistic subjects did not differ from normal children, except perhaps in their refusal or inability to ask for colouring materials. On the question of decorating drawing, the

responses for the autistic group were unanimously that the children did not decorate or show any interest in this. In this respect, they differed markedly from normal children who used pattern and decoration frequently.

## Recent Drawing Behaviour

It is frequently stated that drawing as an activity wanes in the early adolescence and except in those few talented individuals who are capable of making a career in the art world, interest in drawing disappears altogether in most people (Harris, 1963). With the autistic group, four of the subjects have passed through adolescence. Interest in drawing has waned with two, but with Simon and Richard, the oldest members of the group, their enthusiasm for drawing has steadily grown and both of them now draw daily. Richard has had a number of one-man exhibitions, and has acquired an international reputation.

The social aspects of the drawing behaviour has not changed substantially with time, although with age the subjects have become more sociable. Two of the parents of the autistic group reported that, with age, their child would very occasionally draw on request, and Richard's father said that Richard now actively seeks praise for his work from others. But generally, parents reported that the activity remains something that is undertaken alone, at the subject's own choosing and apparently for its own intrinsic rewards. Subjects have never been self-conscious about drawing as many normal children are, but feelings of dissatisfaction and self-criticism have become evident in some members as they have grown older.

There is a notable difference in the amount of time the subject is prepared to spend in producing a drawing between the normal and autistic group, although this is clearly a function of the degree of interest in drawing. The younger children in the autistic group generally complete their drawings in a matter of minutes, working very swiftly, and, from personal observation, their production is much faster than that of normal children. However, the older autistic children (Michael, Richard and Simon) are now painstaking and spend several hours completing one picture.

There is also a difference between the normal and autistic group in the involvement of language and communication in drawing. Most of the autistic group do not attempt verbal explanations of their work, and drawing is the primary or initial communicative medium; whereas, for the normal children, drawing is often a secondary means of communication used to illustrate an event or story which they have already described or written down. It is debatable whether the autistic group intend their drawings to be communicative. The drawings are rarely offered to other individuals, although examples of the drawings being done directly to communicate an idea that could not be expressed verbally were occasionally given. Stephen's mother explained that Stephen's very first drawing (of a treehouse) had been undertaken by Stephen in excited exasperation in order to convey to his mother the idea of something he had seen.

The parents of the normal sample of children all reported the well-known fact that children will distort the outline of an object in order that it fit onto the paper. Realism is sacrificed to completeness. Every member of the autistic group would not sacrifice realism to completeness. This is evident in the drawings where lines and objects are truncated at the edge of the paper without any attempt to distort the shape or "squash" it into the available space. Also, most of the autistic children show idiosyncratic methods of planning drawings. It would appear that these subjects have a strong idea of the finished product. Two methods of planning are described by their parents: (1) the space is divided into sections or into some sort of grid system, and (2) small detail is completed it sections and connecting lines of the larger space added later. Both methods suggest that a strong notion of the finished product is known in advance. The normal subjects generally have a quite different approach to planning. They complete objects in a sequence of structural equivalents, as wholes, rather than considering the whole space. Planning is dictated by the objects to be drawn rather than their spatial configuration.

Parents were asked whether their child had always had an understanding of perspective and proportion in drawing. All the autistic group had had such an understanding from an early age. Both features had presented considerable problems to the normal sample of children.

### Other Art Materials and Performance on Closely Allied Activities

All the parents of the autistic group said that their child's skill at drawing was markedly different from his skill at other activities. Only two parents felt that their child was skilful with his hands generally, although the autistic group show some skill with some perceptual tasks, such as Block Design (see next section). The question as to whether the subjects were interested or showed skill with patterns brought a mixed response, but the majority of answers were negative. The autistic group were not obsessively interested in abstract pattern, although some members showed skill with some toys, such as Lego and spirographs; however, all members of the group were reported to show an obsessive interest in pictures, particularly those connected with their current obsession. Questions about diagrams and maps met with mixed responses. Similarly, there was no consistent data with regard to questions about musical and numerical ability, although three of the group showed an unusual facility with calendar calculations.

All members of the autistic group have shown some interest in other art materials: plasticine, modelling, collage. Some have shown some talent with modelling, but no consistent pattern of interest or ability emerges.

## Conclusions

The major significant factors which the autistic subjects share and which also distinguishes them from normal drawing development can now be summarized:

(1) Absence of pre-representational scribbling
(2) Unconventional choice of subjects for drawing
(3) Inflexibility and obsessional drawing habits
(4) Asocial attitudes to praise, encouragement or direction
(5) Parents' recognition that skill at drawing differed from the child's level at other tasks
(6) Drawings inspired by pictures or real life; never copied but done from memory some time later
(7) An early understanding of perspective
(8) An early understanding of proportion
(9) Idiosyncratic planning where spatial considerations appear to predominate and images are not distorted to fit into the available space
(10) Lack of interest in decoration and pattern in drawing but use of letters and numerals in drawings
(11) Drawing a primary expression rather than illustrative
(12) Lack of doodling

# 10

# *Standardized Tests of Intellectual Functioning*

All the individuals in the group were tested on a number of standardized tests of intellectual abilities as previously described. Before giving a description of test behaviour and details of the results, some general points need to be made.

In the first place, undertaking standardized test procedures with autistic, abnormal and frequently unco-operative individuals is fraught with problems of management and interpretation. Nevertheless, some sort of objective and comparative assessment of intellectual abilities was necessary. There were frequent occasions when test items were refused, either because they did not engage the interest of the subject or due to a more general problem of lack of ability or level of co-operation. In all cases the testing was spread over several sessions and was only attempted with the subject was reasonably co-operative. Many sessions had to be abandoned and test items had to be repeated on one or two occasions. In all cases the test performance was discussed with either the teachers or with the subject's parents after testing and the ability level was generally confirmed. Where there was a discrepancy between the author's findings and the parents' or teachers' subjective impressions, the test item was repeated at a later date. This occurred surprisingly infrequently and there was usually agreement between subjective understanding and the author's findings. The results on all the test items have therefore been confirmed by teachers' and parents' intimate but subjective knowledge of the subjects.

Since a great deal of time and patience was expended in the test sessions and the data was confirmed by others, the results are likely to be reliable but the data is not complete. Some of the subjects refused certain items repeatedly. This was often because they failed to understand the instructions despite several attempts to re-phrase or demonstrate the task. Items where timing was essential were particularly problematic; where the need for speed was understood the subjects became agitated and frequently refused. More often, no heed was given to the request to undertake the task as quickly as possible. Fortunately timing was only essential in one or two of the sub-tests. All the subjects took much longer than is usual over all of the sub-tests and no attempt was made by the tester to speed up performances. In most cases the test scores were achieved under optimum conditions. On occasions some test conditions were infringed in the interests of obtaining an accurate record of the subject's

abilities since there were problems of attention and distractibility. For example, instructions had to be repeated several times, several demonstrations were necessary before interest was engaged, and sub-tests had to be abandoned and returned to later. In view of this, the data will be discussed only in terms of major discrepancies in performance; in general rather than in specific terms; and with regard to intra-subject variability in cognitive abilities and cognitive profiles rather than generalized test scores.

## TEST BEHAVIOUR OF INDIVIDUAL MEMBERS OF THE GROUP
### (Observations made by the author during the test sessions)

### Simon

Simon was tested at home on two occasions. It was intended that Simon would be given further tests, but he started to object violently that he was being singled out in his household and he became suspicious and ill-at-ease when further testing was discussed. Despite the author's very best endeavours to make the testing enjoyable, Simon clearly found the situation threatening and disagreeable. In discussion with Simon's parents, it was decided not to pursue testing any further. As it was, a complete and major assessment had been accomplished. During the sessions Simon was somewhat tense and suspicious and he was upset by any failures despite all attempts to reassure him. The author discussed the test items with Simon's mother who confirmed that a reasonably realistic view of Simon's abilities had been obtained.

### Stephen

Stephen was visited in his residential school and testing was accomplished over four sessions. Much of his behaviour is now quite normal. But two features of activity appear bizarre and remain highly suggestive of autism; he still tends to run on his toes and he incessantly flaps his hands from his wrists as he walks. Although Stephen has reasonably developed language abilities, although well below average, it is very difficult to converse with him. He lacks fluency and flexibility in his speech; he answers questions but he does not initiate conversation. When he is stressed or when too many demands are made on his conversational abilities, he lapses into bizarre associative speech. Stephen co-operated reasonably well during testing. All the test items were discussed with his teacher who confirmed that the results corresponded with her experience of Stephen's abilities.

### Claudia

Claudia was tested at school. Co-operation was difficult to achieve, and it required four separate occasions to complete the testing. Claudia still has

considerable problems with language. Her language usage was very variable. It was difficult to maintain a normal conversation with her. She lapses into associative language and echolalia when stressed. Her behaviour too is unpredictable and erratic. She can swing from reasonably normal, socially acceptable behaviour to suspicious, aggressive, asocial and bizarre behaviour. Her test results were discussed with her teacher who confirmed that the results were a reliable measure of her abilities.

### Richard

The author spent two days with Richard at the Adult Training Centre in his home town. Richard has very limited verbal expression tied to very short sentences of basic concrete content. His verbal comprehension is probably a little better but also very limited. Richard is now well adjusted and well integrated within the bounds of his limited world. He needs the constant support and supervision of his father. Richard related well with the tester and he co-operated well, enjoying the individual attention of another adult. He showed persistence and pleasure with some tasks but he said ''No'' firmly when the task was too difficult. It was concluded that the results gave a realistic view of his abilities and his performance was discussed with his father and with the supervisors at the A.T.C.

### Michael

Testing Michael was very difficult since he has no expressive language and his verbal comprehension appears to be limited. Testing therefore had to be restricted to those items that could be easily demonstrated by gesture and simple example. The ideas for Block Design, for example, could be demonstrated by pointing and clearly placing the blocks together to produce the pattern shown in the booklet, but such simple visual instructions were impossible with many of the test items. Michael was co-operative and compliant generally. He was evidently pleased when he was able to understand what was required. He tired easily, however, and testing was protracted over six sessions. When Michael failed to understand or became tired he would lapse into passive indifference and turn his head away and refuse eye contact. Michael is the most severely handicapped of the group. His parents confirmed the general reliability of the test item results.

### Nadia

Nadia was tested in her school in two sessions in one afternoon. A full description of Nadia as a younger child has been given elsewhere (Selfe, 1977). Nadia has now developed some expressive language but conversation is

very limited and she lapses frequently into free association. Concentration was variable although Nadia's teacher confirmed that the test results were a reliable reflection of her classroom abilities.

## TEST RESULTS

### Simon

Tested: August 1978
Wechsler Intelligence Scale for Children (Revised)

|  | Raw score | Scaled score (at 16.11) |
|---|---|---|
| Verbal Tests: | | |
| Information | 12 | 4 |
| Similarities | 5 | <1 |
| Arithmetic | 2 | <1 |
| Vocabulary | 23 | 3 |
| Comprehension | 3 | <1 |
| Digit Span | 12 | 7 |
| Performance Tests: | | |
| Picture completion | 8 | <1 |
| Picture arrangement | 6 | <1 |
| Block design | 44 | 10 |
| Object assembly | 25 | 9 |
| Coding | 8 | 1 |
| N.B. Scaled score 10 is approximately an average score | | |

I.T.P.A. Visual memory Raw score = 9 (4 symbols)
Benton Test — All correct — Above average category
Eidetic memory — would not co-operate

### Stephen

Tested: October 1979
British Abilities Scale

|  | Ability | Centile |
|---|---|---|
| Speed: | | |
| Speed of information processing | <10 | <1 |
| Reasoning: | | |
| Matrices | 59 | 1 |
| Similarities | 47 | 3 |
| Spatial Imagery: | | |
| Block design (Level) | 67 | 29 |
| Block design (Power) | 21 | 11 |

## Stephen (continued)

| | Ability | Centile |
|---|---|---|
| Rotation of letter-like forms | 18 | 29 |
| Visualization of cubes | 28 | 4 |
| Perceptual Matching: | | |
| Copying | No difficulties, but norms only | |
| Matching letter-like forms | go up to age 8.0 | |
| Short-term memory: | | |
| Immediate visual recall | 43 | 17 |
| Delayed visual recall | 32 | 8 |
| Recall of designs | 62 | 62 |
| Recall of digits | 147 | 73 |
| Visual recognition | 67 | Average 4 year old |
| Retrieval and application of knowledge: | | |
| Basic arithmetic | <10 | <1 |
| Word definitions | 32 | 6 |
| Word reading | 85 | 2 |

I.T.P.A. Visual memory Raw score = 8 (4 symbols)
Benton Test — 5 correct, 5 errors — Low average category
Eidetic memory — very good (see example)

## Claudia

Tested: October 1979
British Abilities Scale

| | Ability | Centile |
|---|---|---|
| Speed: | | |
| Speed of information processing | <10 | <1 |
| Reasoning: | | |
| Matrices | 64 | <1 |
| Similarities | 51 | 2 |
| Spatial imagery: | | |
| Block design (Level) | 98 | 63 |
| Block design (Power) | 76 | 68 |
| Rotation of letter-like forms | 10 | 9 |
| Visualization of cubes | 50 | 52 |
| Short-term memory: | | |
| Immediate visual recall | 32 | 7 |
| Delayed visual recall | 53 | 66 |
| Recall of designs | 58 | 35 |
| Recall of digits | 137 | 38 |
| Retrieval and application of knowledge: | | |
| Basic arithmetic | 49 | 3 |
| Word definitions | 18 | <1 |
| Word reading | 151 | 11 (9.6 years) |

I.T.P.A. Visual memory Râw score = 9 (4 symbols)
Benton Test — All correct — Above average category
Eidetic memory — very good (see example)

## Richard

Tested: November 1979
British Abilities Scale

|  | Ability | Centile (at age 17.5 years) |
|---|---|---|
| Speed: | | |
|   Speed of information processing | 34 | <1 |
| Reasoning: | | |
|   Matrices | 48 | <1 |
|   Similarities | 26 | <1 |
| Spatial imagery: | | |
|   Block design (Level) | 90 | 13 |
|   Block design (Power) | 67 | 12 |
|   Rotation of letter-like forms | <10 | <1 |
|   Visualization of cubes | <30 | <1 |
| Short-term memory: | | |
|   Immediate visual recall | 43 | 7 |
|   Delayed visual recall | 47 | 54 |
|   Recall of designs | 49 | 4 |
|   Recall of digits | 101 | <1 |
| Retrieval and application of knowledge: | | |
|   Basic arithmetic | Attempted | <1 |
|   Work definitions | but | <1 |
|   Word reading | abandoned | <1 |

I.T.P.A. Visual memory Raw score = 8 (4 symbols)
Benton Test — Average category
Eidetic memory — very good (see example)

## Michael

Tested: December 1979
Michael is the most profoundly handicapped of the group. He has no expressive language so testing was very restricted. Comprehension of language is limited to visual demonstration.
British Abilities Scale

|  | Ability | Centile |
|---|---|---|
| Reasoning: | | |
|   Matrices | <10 | <1 |
| Spatial imagery: | | |
|   Block design (Level) | 94 | 36 |
|   Block design (Power) | 44 | 9 |
| Perceptual matching: | | |
|   Copying | Michael could do both of these | |
|   Matching letter-like forms | well, but norms are only provided up to age 8.0 years | |

## Michael (continued)

|  | Ability | Centile |
|---|---|---|
| Short-term memory: |  |  |
| Recall of designs | 65 | 41 |
| Visual recognition | Norms up to 8.0 years — average for 8.0 years |  |

N.B. Michael was unable to do any other tests on the B.A.S. Michael knows Makaton — 200 word signing system

I.T.P.A. Visual memory Raw Score = 10 (4 symbols)
Benton Test — All correct (2 errors, counting dots) — above average category
Eidetic memory — very good (see example)

## Nadia

Tested: June 1980 Aged:
British Abilities Scale

|  | Ability | Centile |
|---|---|---|
| Speed: |  |  |
| Speed of information processing | Could not co-operate or failed to understand instructions |  |
| Reasoning: |  |  |
| Matrices | 48 | <1 |
| Similarities | 10 | <1 |
| Spatial imagery: |  |  |
| Block design (Level) | 60 | 9 |
| Block Design (Power) | 29 | 12 |
| Rotation of letter-like forms | Difficulties understanding | |
| Visualization of cubes | instructions | |
| Perceptual matching: |  |  |
| Copying | 85 | Average at age 8 years |
| Matching letter-like forms | 10 | <1 |
| Short-term memory: |  |  |
| Immediate visual recall | 23 | <1 |
| Delayed visual recall | 10 | <1 |
| Recall of designs | 49 | 24 |
| Recall of digits | 62 | <1 |
| Visual recognition | 56 | <1 |
| Retrieval and application of knowledge: |  |  |
| Basic arithmetic | 0 | <1 |
| Early number skills | 58 | 4 at age 8 |
| Naming vocabulary | 66 | 3 at age 8 |

*Nadia (continued)*

|  | Ability | Centile |
|---|---|---|
| Verbal comprehension | 64 | <1 |
| Word definitions | 0 | <1 |
| Word reading | 18 | <1 |

I.T.P.A. Visual memory — would not co-operate
Benton Test — all correct — above average category
Eidetic memory — would not co-operate
Reynell Language Development Scale (19.1.79): Comprehension: 2 years 11 months
Expression: 2.8 years

## CONCLUSIONS

### A. The British Abilities Scales and Wechsler Intelligence Scale

With regard to overall ability the group are not homogeneous. All of the group, however, are clearly well below average in most of the skills tested, and they would fall in the lowest 2% of children with respect to intelligence quotients (i.e. the range of scores indicating severe or moderate learning difficulties (E.S.N.(M) and (S)).

The whole group are alike in a number of ways. In the first place all show a very wide variation in scores on individual tests. The British Abilities test profiles show a range of scores from average ability to below the lowest 1% of children of the same age. Secondly, although scores on individual items vary between members, the actual deficits and peaks in cognitive skills are strikingly similar. It is useful to look at this assertion using B.A.S. categories. Most of the children would not co-operate with the Speed of Information Processing test. Those members who did manage to co-operate showed well below average ability. Reasoning skills were similarly usually well below average. In all cases Spatial Imagery and particularly Block Design, represents a peak performance in each individual's profile.

All the children had difficulties with either immediate or delayed visual recall or both of these items (presumably they had failed to code the item verbally, see Hermelin (1978)). In one or two cases delayed visual recall showed an improved performance over immediate recall.

All of the children showed particular skill in recall of designs. This is a drawing task and one might expect outstanding ability. However, two of the very retarded children do not reach an even average performance here, suggesting that their drawing skill has not generalized to all drawing from memory situations.

Rutter (1978) notes that many autistic children have a good short-term auditory memory; three of the children showed exceptional performance in this area compared with their other abilities. But three members showed no special ability here and, in fact, scored below 1% of the population of children

of their age. These three members were those who are most retarded in language skills (Richard, Nadia and Michael).

All of the children whom it was possible to test on visual recognition showed a poor performance. This was interesting because all of the children who completed the I.T.P.A. visual memory item showed a particular facility with this task. In fact, three and four separate items were memorized, whereas on the B.A.S. sub-test subjects frequently failed to memorize more than one item. The difference between the two tests is that the B.A.S. uses pictures of everyday objects, while the I.T.P.A. uses abstract symbols. It is possible that the members of the group attempted to use verbal coding to remember the items and failed to do this efficiently, thus verbal coding may have actually interfered with performance. Where verbal coding was not possible, as with the I.T.P.A. test and when purely abstract visual symbols were used, retrieval was enhanced.

All of the subjects scored well below average on all of the sub-tests in the Retrieval and Application of Knowledge section. It is likely that the failure to engage in normal social interaction has affected learning on these more conventional scholastic sub-tests.

### B. I.T.P.A. Sub-test

All of the subjects showed an at least average ability to retain and reproduce abstract visual information. This is especially notable in the severely retarded subjects.

### C. Benton Visual Retention Test C (1955)

Again, results on this test showed that most of the subjects had at least average ability to remember and reproduce an abstract visual design. (N.B. The standardization of this test is out of date and categorization was based on adult performances.) It was included to provide additional information on visual retention abilities. The subjects who scored in the low average category were the youngest members, and clearly their developmental age affected their score. It is safe to conclude that none of the subjects, despite deficits in other cognitive areas, have difficulties with visual organization and retention. Furthermore, it would seem reasonable to conclude that this skill is relatively independent of other cognitive processes.

### D. Eidetic Memory Test

Research on the phenomenon of eidetic memory has been reviewed and discussed by Gray and Gummerman (1975). They quote two definitions of eidetic imagery. Eidetic imagery is

the ability to retain an accurate detailed visual image of a complex scene or pattern, sometimes popularly known as photographic memory

and

the ability possessed by a minority of people to see an image that is an exact copy of the original sensory experience.

It is possible that the autistic group achieve their level of skill by drawing or tracing around a particularly strong mental image that is "projected" onto the paper surface. This explanation has some initial plausibility; however, the value and implications of such an explanation will be evaluated in more depth in the final conclusions to the study.

Tests for eidetic imagery have been described by Haber (1969). The most simple and principally used tests consist of showing subjects pictures, letters or matrices and requiring that details of the stimulus be recalled sometime after presentation. More elaborate tests have been devised; some involve the superimposition of two pictures in eidetic memory, thereby forming a composite picture which reveals a new and unexpected image. If the subject has eidetic imagery, such a fusion can take place and subjects can describe the resulting unexpected image. Another technique has involved the presentation of two separate images independently and simultaneously to the two eyes of the subject.

The procedure chosen as appropriate for the autistic subjects in this study had to be relatively simple and uncomplicated and the strategy employed was basically that described by Haber (1969). The subjects were presented with a picture for 30 seconds. However, since language and description were problematic for many of the subjects, it was felt that it would be more appropriate to ask the subjects to draw the stimulus picture when it had been removed.

Four of the subjects in the autistic group co-operated with the test. Two subjects refused and simply showed no interest in the picture and no inclination to oblige the tester. The subjects who co-operated glanced at the picture. None of them surveyed the stimulus for the full 30 seconds. Four of the subjects produced veridical drawings (see illustrations). These subjects seemed interested and excited by the activity and worked carefully for at least fifteen minutes to complete their drawings.

A qualitative perusal shows that the drawings of the autistic group are accurate in terms of spatial qualities. Any direct comparisons were impossible in view of the subjects ages; however, normal children tend to produce a "list" of canonical items, when asked to do this task, where spatial characteristics of orientation, size and position are often disregarded. The autistic children noticed and recorded incidental and idiosyncratic details of objects rather than drawing their canonical representation. Moreover, their productions differ particularly in the faithful reproduction of spatial qualities, such as the orientation of depicted objects, their relative size and proportions and their positions relative to other depicted features.

Most of the autistic children in the group are known to reproduce from memory illustrations from books, fashion magazines and travel journals, etc.

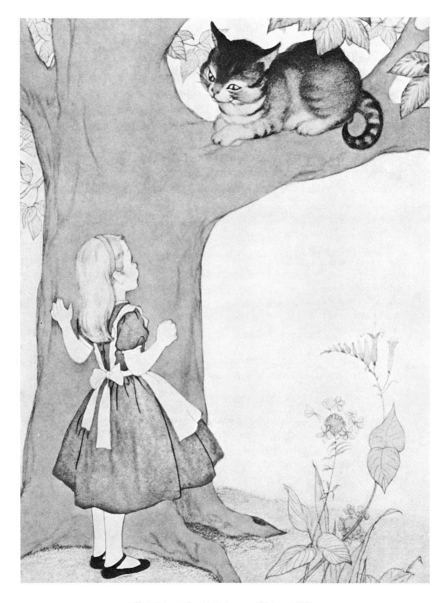

*Test picture 1 for eidetic imagery (Haber, 1969).*

*Test picture 2.*

*Eidetic imagery test result: Richard.*

*Eidetic imagery test result: Michael*

*Eidetic imagery test result: Stephen.*

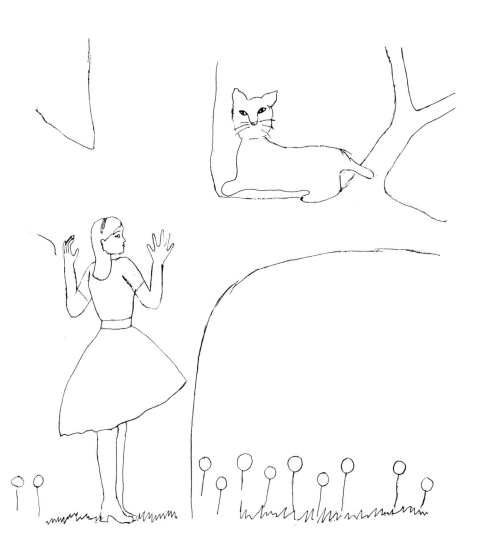

*Eidetic imagery test result: Claudia.*

as well as drawing from life. Generally these originals have been lost (but see page 4 for an example of Nadia's ability to remember and reproduce a pictorial image). The author was also able to photograph some of the scenes that Stephen was drawing from memory. Examining these drawings and the original photographed scenes is very instructive (see illustrations, Dwgs 12–16). Although the drawn scenes are easily recognizable, principle features and unusual details, such as light switches, fire alarm systems and wiring, are recorded, the drawings also show that a good deal of imaginative and intelligent reconstruction has taken place. For example, there are two windows in the wall in Dwg 2 while only one exists in reality (basis for Dwg 12).

Theories of eidetic imagery have been critically examined by Gray and Gummerman (1975). It is useful to note two of their main conclusions. In the first place, they suggest that the data on eidetic imagery does not convincingly demonstrate the existence of an imagery different in kind from those possessed by the majority of the population and, furthermore, they argue against the special status of eidetic imagery as opposed to visual imagery in general, and they state the case for an active, constructive view of visual perception. They outline two theoretical positions with regard to visual perception; one being the passive notion that the perceiver's experience is a direct and relatively passive consequence of vision, and a constructive view that utilizes the role of

> both the information provided by the stimulus and information possessed by the perceiver prior to viewing the stimulus.

The author has already argued against the former conception of perception in discussing Gibson's views (1979). Using Gibson's theoretical constructs, it is possible to offer a reinterpretation of the data presented here. It would appear that subjects in the autistic group attend to the spatial characteristics of a picture and represent these graphically. They differ from normal children in this respect. Moreover, they attend to odd, incidental and idiosyncratic detail. It could be claimed that Stephen's drawings tend to show that the so-called "eidetic image" is misleadingly represented as "photographic". The imagery involved might be better described as an intelligent and dynamic reconstruction of those features of the optic array which he considers to be significant and to which he has attended.

Gibson's analysis dissolves any distinction between visual and eidetic imagery since perception is viewed as necessarily constructive and dynamic. The child and the adult selects and attends to certain features of his environment. He cannot attend to or reconstruct the whole of the possible affordances of the optic array just as a drawing of the environment is not the real environment. The eidetic image is a selection of meaningful affordances but any form of visual imagery or visual memory involves the recall of a selection of visual features.

Selection and attention may vary in visual and eidetic imagery but the nature of both forms of imagery is the same and the concept of an eidetic image as a passive "photograph" of a scene is misconceived.

*Summary of Conclusions from Test Results*

(1) I.Q. varied between the subjects. However, all have severe learning difficulties.
(2) All the subjects showed unusual peaks and troughs in cognitive abilities.
(3) All subjects showed above their general ability level in the following general areas:
    (a) Perceptual matching
    (b) Spatial imagery
    (c) Some memory tasks, either visual or auditory
    (d) Visual memory for abstract symbols
(4) Generally subjects showed deficits in the following areas:
    (a) Speed of information processing
    (b) Reasoning tasks
    (c) Some memory tasks
    (d) Retrieval and application of knowledge (formal and scholastic abilities)
(5) When subjects co-operated, they revealed an unusual ability to retain and reproduce a visual image through the medium of drawing.

# 11
# *Conclusions*

In this chapter the major conclusions of the study are brought together and a hypothetical model which accounts for some of the results of the study is briefly proposed. This explanatory model is then examined in greater detail and its limitations are discussed. Next, the study as a whole is reviewed and critically examined and some suggestions as to further areas of research are given. Finally, some brief remarks are made relating this study to the wider field of the expressive arts.

### *Resumé of the Study and a Brief Description of a Working Hypothesis*

In earlier chapters a number of drawing devices for the graphic depiction of photographic realism were proposed and investigated. It was shown that children between the age of 5 and 10 years have major difficulties in portraying aspects of photographic realism. Generally, devices for representing photographic realism in children's drawing were seen to be only gradually acquired. Normal children of between 5 and 10 years are best described as drawing symbolic or canonical representations of objects. The transition from early symbolic forms to the eventual depiction of photographic realism, although punctuated by stage and one-trial learning effects, is accurately described as a gradual development. Children with high intelligence quotients can sometimes show an accelerated development with regard to this continuum and many writers have noted a correlation between children's drawings and their intellectual maturity (Harris, 1963).

However, this study identified a small group of children who showed outstanding photographically realist representational ability in their drawings from a very young age but also had severe intellectual deficits. The specific differences between the drawing ability of these children and normal children were isolated. These differences were found to be: the use of photographically realistic proportions; the depiction of the third dimension in three-dimensional objects; the depiction of diminishing size with distance and the depiction of occlusion or overlap.

A further investigation of the children with exceptional drawing competence was undertaken using cognitive ability tests and retrospective questionnaires

on each individual's early general development. All the subjects were found to have substantial cognitive deficits, and all showed the major symptoms of autism and, indeed, five of the subjects had been diagnosed as such. An examination of the current research literature on autism showed a general consensus that autism results from a central cognitive deficit, probably with a physiological origin, which involves retarded and/or abnormal language development, but which is thought not to be confined to a language deficit alone since motor, perceptual and social functions are also affected.

O'Connor and Hermelin's work (1978) suggests that autistic children have difficulty transposing coded information between internal representational modalities. They appear to be inflexible in transposing between modalities in a range of tasks where auditory or spatial stimuli were presented but responses had to be given in an alternative mode.

It has frequently been stated that in drawing, normal young children are dominated by the need to set down their conceptual understanding of an object (Goodenough, 1923; Harris, 1963). This has been referred to as a symbolic activity (Luquet, 1927) or canonical representation (Freeman, 1980). The child represents the characteristic rather than the idiosyncratic features of an object. It was earlier argued that this "conceptual domination" evident in young children's drawings is partly a response to normal socialization but arises mainly from the central activity of generalization and categorization in thinking processes (Bruner, 1964). This theoretical model finds echoes in the work of Piaget and Vygotsky, but is specifically related to Bruner's (1964) description of early childhood development. Language is seen as pre-eminently a categorizing and symbolizing activity whereby the welter of perceptual and sensory experience is ordered and reduced.

In this book it is argued that young children's drawings reflect these dominant cognitive and developmental processes. Bruner suggests that after the age of 2 years or so, an iconic stage of development is superseded by a symbolic stage and therefore normal children's drawings are symbolic or canonical where the defining characteristics of objects are represented rather than an idiosyncratic single fixed view. Photographically realistic and spatial considerations in drawing are secondary to the representation of concepts.

The act of drawing is sequential and discursive in nature and in this respect, resembles verbal processes rather than spatial processes, although the result of drawing is a two-dimensional spatial representation. Also normal young children's drawings have the properties of ideograms or hieroglyphics rather than photographic properties. Young children's drawings have more in common with ideographic writing than with photographic realism. However, it would appear that the autistic children in the group described here are better able or are more concerned to record single view-point, static spatial configurations, and it is argued that this is due to the fact that their symbolic and discursive abilities are retarded and because transpositions between cognitive modalities are restricted in these individuals. This difficulty involves transpositions between verbal/temporal and spatial/imaginal modes (Paivio, 1971). It is conjectured that these autistic children have reasonably well-developed

imaginal thought processes involving visual imagery, but that their verbal and discursive thought processes are defective. Their results on the cognitive tests support this conjecture. Since normal drawing development results from the normal integration of both forms of thinking and verbal and discursive processes influence the nature of early drawing, it could be reasoned that autism and its attributed cognitive deficits account for the special spatial characteristics of the drawings of these children. They are able to draw static, spatial, photographically realistic configurations, not because of an accelerated development or the attainment of adult representational abilities in drawing, but because they are unable to draw the normal symbolic or canonical forms which are essentially conceptual. It would not be overstating the case to postulate that the drawings of this particular group of autistic children are a symptom of their autism and of an underlying pathological condition taken in conjunction with their deficits in other areas of functioning. It should be noted that photographic realism in drawing is not a necessary symptom of autism and is rare, even among autistic children. This will be discussed further later in this chapter.

Finally, it has been proposed and restated throughout this thesis that Gibson's theory of perception provides a richer and more cogent framework for examining this area, since it is both interactionist, avoiding dualist dilemma of a dichotomy between external reality and internal mental states, and constructivist construing all perceiving as necessarily selective. Using this model, it is proposed that the autistic individuals be viewed as attending to spatial relationships and representing these, whereas normal children attend to objects as representatives of classes, i.e. to their conceptual or symbolic qualities.

## A Closer Examination of the Hypothetical Model

Paivio (1971) suggested that there were two distinct modes of internal representations in thinking processes: imaginal and verbal. Much of the foregoing theoretical framework rests on the assumption that such a distinction is valid. Hermelin and O'Connor (1978, 1978) clearly also make this assumption, but it is now necessary to examine the proposed dichotomy in closer detail.

## Imagery and Verbal Processes: the "Dual Coding Hypothesis"

The early behaviourists concluded that since we cannot verify the existence of images (images are accessible only to the person experiencing them), and there was no evidence that images had any functional significance, that is, that they affected our behaviour, the concept of mental imagery was unacceptably subjective. Consequently, the subject of imagery was disregarded along with other mentalistic concepts that the introspectionist schools had produced. The

emphasis in most subsequent studies of thinking processes has been on verbal processes, since verbal reports are externally observable events. Even up to the present, without necessarily denying either their reality or their importance, contemporary psychologists find the concept of mental imagery difficult to handle in empirical studies, since images are "private internal phenomena".

In the last decade, however, there has been a gradually increasing interest in the subject of imagery. In 1971, for example, Paivio produced a book entitled "Imagery and Verbal Processes". This book is not only important in helping to resurrect interest in an important aspect of mental life, but it also proposes two independent, functionally separate modes of thinking. These are verbal processes and mental imagery. Paivio's own definition of these processes is as follows:

> Images and verbal processes are viewed as alternative coding systems or modes of symbolic representation which are developmentally linked to experiences with concrete objects and events as well as with language. In a given situation they may be directly aroused in the sense that an object or an event is represented in memory either as an image or as a word, or they may be associatively aroused in the sense that an object elicits its verbal label or a word arouses implicitly verbal associates or images of objects.

Paivio thereby suggests that we have two distinct modes of thinking and, according to his theory, imagery is regarded primarily as a parallel processing system; images present themselves simultaneously and are characterized by their spatial arrangement, whereas the verbal system is specialized for sequential processing; for processing over time. It is interesting to note that Paivio's theory has its counterpart in current physiological research into the lateralization of certain behavioural functions in the brain. The left hemisphere appears to control language functions, while it is claimed that the right hemisphere is dominant in controlling spatial functions. This research was reviewed by the author elsewhere (Selfe, 1977). At the current stage of physiological research nothing is conclusive. The evidence is contradictory and there are philosophical objections to any naïve reduction from a psychological to a physiological level of explanation. Nevertheless, the dual coding hypothesis has clearly impressed physiologists.

Paivio's theory is not a new one and it has its roots in philosophy. Langer (1949) similarly hypothesized two different and distinct forms of thinking. Her work is mainly concerned with establishing the symbolic nature of thinking and how the various forms of artistic expression are symbols of aspects of human experience. She distinguishes between two forms of thinking which parallel Paivio's description. She describes these as discursive and presentational forms. She suggests that language has the form that requires speakers to string out ideas, even though their referrants may not be so sequentially arranged. The ideas that are conveyed in language are often "embedded" but the form of a sentence is sequential. This property of verbal symbolism is known as discursiveness. According to Langer, by reason of this property, only thoughts that can be arranged in a sequential order can be spoken. Any

idea which does not lend itself to temporal ordering is not fully communicable by means of words. Langer maintains that there is another kind of symbolism which is equally important and can also convey ideas and complex thinking, but in another form. These are images and imaginal thought which she calls "presentational forms". She says, for example,

> the abstractions made by the ears, eyes, touch, taste and smell; the forms of direct perception are also instruments of intelligence, and such sensory experiences have their internal symbolic representations.

There is therefore an alternative means to reconstructing and understanding experience. She gives the example of visual images: a class which includes lines, edges, colours, proportions and depth. These images are "just as capable of articulation or complex combination as are words". But the laws that govern this sort of imaging are different from the laws of syntax and grammar governing language production. The most radical difference is that "presentational forms" are not discursive. They do not present their constituents successively but simultaneously, so, she claims, the relations governing a visual structure are grasped in one image. This statement is a comparative rather than an absolute one, since images too can be scanned over time. Langer goes on to say that images, as non-discursive symbolism, are particularly well suited to the expression of ideas that defy linguistic projection. For example, our understanding of space which we gain through the interaction of sight, touch and kinesthesia could not be developed in all its detail, complexity and subtlety by a discursive knowledge of geometry. Similarly, all the gradations of light, shade and hue in a visual scene defy discursive or enumerative description. Presentational forms cannot be "Cut" into discrete chunks or sequentially arranged without abstraction which necessarily leads to distortion.

Imagery in thinking processes is so fundamental and ubiquitous that it can be denigrated. Paivio assumes that imagery is a more "concrete form of thinking". Arnheim (1970) disputes this view. He contests the notion that language is the more sophisticated mode of thinking than imaginal thought. It is frequently claimed that language is better suited for abstract and deductive reasoning. Arnheim says that no one would seek to deny this property of language, but what needs to be questioned is whether language operates substantially by properties inherent in the verbal medium itself, or whether it performs indirectly by pointing to the referants of words and propositions. Arnheim maintains that language is a special kind of thinking that operates in a certain restricted form. He acknowledges his debt to Susanne Langer when he says that it is imagery that gives linguistic statements their force and meaning.

> What makes language valuable is not thinking in words but the help words lend to thinking while it operates in a more appropriate medium such as visual imagery.

Arnheim claims that words operate to fix and anchor our thinking and to order and direct our attention to the presenting images that are evoked. The

foregoing formulation is attractive, but it is clear that there is a great deal of conceptual confusion and a lack of clarity in this model. There is no adequate formulation of imaginal thinking. Are "images" at an experiential or neural level of description? Also, language is used interchangeably to mean inner language and spoken utterances and there may be an essential difference in the nature of these.

Despite the unsatisfactory nature of these formulations of imagery, the notion of imagery in thinking processes has been gaining a hold as a concept having meaning and veracity. More recent formulations bear this out. Richardson (1980) gives an excellent review of the whole field. Kosslyn (1978) concluded that the experimental analysis of imagery had progressed so that it can be claimed that imagery is amenable to systematic study. Using various memory and search strategies, Kosslyn showed that spatial, "quasi-pictorial" images that are regularly experienced can be shown to be used in cognitive processing and have behavioural correlates in measures such as reaction time and speed of information processing.

Kosslyn goes on to claim that images are spatial representations, and he offers evidence that they are "quasi-pictorial" in so far as they can be "scanned"; their size can be internally manipulated according to directions given to subjects. Similarly, the speed of reaction can be demonstrated to depend on the physical distance between two stimulus objects that have to be recalled as images. Kosslyn concludes that imagery and visual perception intuitively have much in common and possibly share the same "processing mechanisms". However, Kosslyn also admits that the accounts of experimental data on imagery offer no comprehensive or precise definitions and that no consistent explanatory model exists and at present, the data provides only inferential evidence for the existence and importance of imagery in cognitive processes.

Similarly, Sheehan (1978) also claims that the theoretical basis for the relationship between the ability to image and memory and perceptual functions is compelling. He quotes evidence from a number of sources and he discusses the purported pictorial or perceptual nature of imagery. One of the most radical proposals in this regard was made by Neisser (1976) who, according to Sheehan, argued that mental images should be regarded as perceptual anticipations. According to this account, the description of the visual image is an account of what the person is set to see; images are conceptualized as "plans for obtaining information about potential environments". Neisser says that imaging and seeing are quite distinct. Imaging obviously is constructive. Sheehan concludes, however, that

> the field of imagery research abounds with highly sophisticated and elegant methodological paradigms and many ingenious experiments have been conducted, but the data do not collectively sum or gel together.

The status of the concept of imagery has been analysed and heavily criticized by Pylyshyn (1973). He raises both philosophical and methodological objections to the concept of imagery, particularly to "quasi-

pictorial'' or perceptual formulations of it. In the first place, he points out that the account of imagery given above is replete with conceptual difficulties and internal contradictions. He says that

> because we know that we use certain mnemonic strategies or that we say certain things to ourselves or that we see certain objects in our ''mind's eye'' . . . we cannot assume that the contents of such subjective knowledge can be identified with the kind of perceptual or information processing procedures that are offered as explanatory theory.

Pylyshyn says that the very language that we use to describe imagery leads to conceptual confusion. There are at least two senses of cognitive words such as ''see'', ''hear'' or ''imagine''. They refer to both the information itself, received through the sensory systems, and to the conscious experience accompanying such functions. The area is infected with dualist problems of this type. Pylyshyn also challenges the ''dual code hypothesis'' proposed by Paivio. He says that the partition between two modes of thought has its roots in the seemingly persuasive idea that the only way in which we experience memory of events is through imagery. A number of theorists, particularly those working in the information processing tradition, have offered a very different analysis of the form in which such information is represented or subjectively experienced. For example, many models of attention and memory require that representations differing from both sensory pattern and their verbal description be available at some stage in the process. Models of memory (long-term and short-term storage, ''recognition buffer memory'' etc.) differ radically from our subjective experience of remembering.

Pylyshyn continues by suggesting that a more basic form of internal representation for both words and images could be postulated, and he puts forward the view that this process is the coding and retrieval of propositional knowledge. Pylyshyn says, for example, that one does not have to equate a proposition with a string of words.

> A proposition is what a string of words may assert; a proposition is either true or false; a string of words is neither; a proposition may be asserted by any number of strings of words, in any language and in any modality. Furthermore . . . it may involve no words of any kind . . . knowledge of the world is not a montage of sticks, stones, colour patches and noises but a system of propositions.

Pylyshyn does not deny the experience of imagery in thinking but only asserts that if images have a role to play in cognition, the nature of such a role has not been elucidated and images may prove to be epiphenomenal. We cannot talk about images without, in fact, talking about the propositional content of their appearances.

Pylyshyn further shows that the vocabulary employed in describing imagery makes wide use of perceptual and pictorial constructs. He argues that this sort of metaphor may be inappropriate and even harmful in discouraging a closer examination of the concept. He says

one misleading implication in using imagery vocabulary is that what we retrieve from memory, or what we image, like what we receive from our sensory systems, is some sort of undifferentiated signal or pattern, a major part of which is simultaneously available.

The implicit assumption is that imagery is equivalent to a mental photograph album where memories are stored and retrieved and from which we can read the relevant information. This is sometimes called ''the imagery retrieval before perception'' view. This notion runs into difficulties, mainly in assuming that all visual, auditory and sensory reception is stored in memory only to be retrieved at a later date in an uninterpreted form. This places a great burden on the storage capacity of the brain. Another objection is that the notion is strongly dualist. As was argued in the opening chapters of this thesis, the dualist idea of an internal ''mind's eye'' and an external physical reality leads to all sorts of unnecessary confusions and there can be no perception that is not interpretive, selective and interactive. It was argued that interpretation takes place in the very act of perceiving. Any information that is stored must therefore already have been subject to selection and interpretation.

Pylyshyn comes to the same conclusion but offers other arguments. He points out that imagery processes take the same time in terms of reaction time as do perceptual processes which he claims rules out the possibility of an exhaustive interpretive search. Also, he contends that if the ''quasi-pictorial'' view of imagery were correct, we might expect that areas that had failed to be stored in memory would correspond to the images' spatial character, whereas, in fact, when memories are vague, it is always in the sense that attributes are uncertain. We do not fail to remember the lower half of our mental image, but the ''colour of a coat''. Pylyshyn suggests, therefore, that images are symbolic systems of propositions rather than internal pictures.

In conclusion, it can be seen that the concept of two functionally independent processes in thinking or the ''dual coding hypothesis'' has been seriously regarded by many psychologists, but that the concept is beset with conceptual confusions and is as yet poorly defined. The author suspects that these confusions are basic and are philosophical and conceptual in nature rather than resulting from the paucity of experimental data. Pylyshyn's criticisms of the concept must at least add further complications for the model proposed in this thesis if they do not actually throw doubt on it. The dual coding hypothesis, however, does have a fundamental appeal to subjective experience, an appeal with Pylyshyn recognizes, and it also offers some sort of explanatory framework for the evidence presented in this thesis in the absence of any other obvious explanation.

## Eidetic Imagery

In the context of a consideration of visual imagery, it would be useful to reconsider some of the theories of eidetic imagery, since historical notions of

eidetic imagery presented the phenomenon as a special kind of "quasi-pictorial" imagery.

Gray and Gummermann (1975) argue that the cognitive processes responsible for eidetic imagery are no different from those involved in ordinary visual imagery in perception. They made a careful analysis of the evidence that is sometimes presented for the existence of eidetic imagery and they argue that the evidence is inconclusive. For example, they quote Haber's study (1969) and his strange conclusion that there was no correlation between the accuracy of recall of a pictorial image and other indicators of eidetic imagery. Also, they discuss the fact that despite three further independent research studies, there has been no support for Siipola and Hayden's (1965) finding that brain-damaged retarded subjects have a higher incidence of eidetic imagery than non-brain-damaged retarded subjects. They examine Jaensch's evidence for eidetic imagery (1930), and they conclude that there is no substantial evidence that eidetic imagery is different in terms of underlying processes from ordinary visual imagery.

However, Gray and Gummermann review theories of eidetic imagery and if their major argument that there is no difference between eidetic and visual imagery is borne in mind, these earlier theories of eidetic imagery shed some light on theories of visual imagery generally.

For example, Jaensch (1930) believed that eidetic imagery was a manifestation of a basic early phase of perceptual and mental organization. If ordinary visual imagery is substituted, then the resulting theory parallels Bruner's suggestion of an early mode of iconic representation which is essentially visual in character. Siipola and Hayden (1965) extend this theory by suggesting that eidetic imagery is a more concrete mode of storing experiences which is usually replaced by abstract codes through the development of abstract thought and language. Leask *et al.* (1969) have a similar theory. They say, for example,

> perhaps initially in the life of the child all translations from stimulation to reports may be through eidetic images and not until later are the elaborate encoding and rehearsal processes necessary.

They suggested further that eidetic imagery and verbal encoding of stimuli are opposing processes. They observed that when the "eidetiker" named or rehearsed items in the stimulus scene during the inspection interval, the eidetic image did not form.

If Gray and Gummermann are correct, then these statements may equally apply to ordinary visual imagery, and these explanations have some attraction for the proposed hypothesis. The autistic children in the sample are known to have delayed language development; many drew their first drawings at a pre-linguistic stage, presumably when visual imagery was a much more predominant mode in their thinking processes. It is possible that such a visual imagery, in the absence of discursive verbal development, continued to develop and to be the dominant underlying cognitive process informing the child's representational drawing. However, such drawings are the result of a

pathological development. Early forms of visual or iconic imagery are usually superseded by symbolic and linguistic activities in the normal child's cognitive development (Bruner, 1962).

Another obvious basic assumption which is being made here is that visual imagery and representational drawing are highly correlated and the supposed strength and duration of imagery directly affects drawing competence. This requires a much closer examination and this will be considered shortly, but it is necessary first to conclude the critical appraisal of the ''dual coding hypothesis'' with particular reference to autism.

O'Connor and Hermelin (1978) relate a version of the dual coding hypothesis directly to experimental results on the performance of autistic children on a series of cognitive tasks.

O'Connor and Hermelin would support Paivio's (1971) theory of different coding systems in thinking, but they conceive of these in terms of sensory modalities; in particular, hearing, vision and kinesthesia. They related these modalities to temporal and spatial dimensions of information reception. O'Connor and Hermelin conducted a series of experiments investigating whether the sensory modalities would be selectively used for processing temporal or spatial aspects of perception. They argued that vision is more directly organized for the perception of spatial information and hearing for temporal information. They hypothesized that if spatial or temporal information was presented in one modality, visual or auditory, it could, however, be recoded into another form and into a form better suited to handle that data. For example, if nonsense syllables were presented visually, in a temporal order and subjects were required to recall them, then subjects are likely to recode the input into an auditory/temporal sequence. O'Connor and Hermelin looked at the performances of blind, deaf, cognitively impaired and normal children on a series of modality coding tasks and they found that when such children were offered the choice in mixed modal presentations, e.g. digits read together with spatial displays of numbers, the subjects selected to code and respond in the mode most suited to their handicap, i.e. blind children used auditory/temporal cues and deaf children tended to use spatial information. They argued that if theirs was a valid model of information handling, children who were restricted in their range of sensory experiences and consequently deprived of certain sensorily derived codes would be handicapped in drawing on appropriate internal representational modes.

They claim that their experiments demonstrated modality specific processing and they found that the organization of stimuli in cognitive processes partly depends on the sensory modality in which they are presented, but also that normal children can transpose information between representational codes and children with sensory deficits will transpose to their preferred modality.

In previous work O'Connor and Hermelin had found that severely subnormal children tended not to use speech as a mediator in cross modal tasks. In their later series of experiments (1978) they found that autistic children could sometimes resemble deaf children and sometimes blind children.

> The experiments reported indicated in addition . . . that autistic children, although able to perceive the complete range of sensory stimulation, nevertheless seemed not to use such data to derive internal representations from it. This failure to evoke appropriate image codes made them appear on occasion functionally blind as well as deaf. (Pp.136)

Hermelin (1978) suggested in a chapter in another book exclusively on autism, that autistic children have difficulty not only with internal representations, but with transposing from one code to another. It is claimed that such children tend to respond only in the mode in which the information is presented.

If this is the case, then this finding could be extended to consider the drawings of the autistic children in this study and it can be seen that restricted transposition and inflexible use of one representational code may help to account for the fact that their drawings are much more photographically realistic and spatial information is more accurately portrayed. Presumably, the autistic children are using the visual/spatial modality without the interaction or contamination of the temporal/verbal mode as may perhaps occur normally.

The problem, of course, is to prove and establish this hypothesis conclusively. Autistic children are, in the first place, notoriously difficult to work with, and it is very difficult to know whether they have a genuine intrinsic cognitive difficulty with a task, or whether they are poorly motivated or have withdrawn into obsessional or stereotypic thought. Secondly, the hypothesis that autistic children have problems with transposition between modalities is only one of a number of theories and explanations offered for their disabilities. Theories of autism have been reviewed by Prior (1979). She points out that the general conclusion from studies of coding processes in autistic children, including Hermelin and O'Connor's work, tends to show that performance deficits are related to the subjects' mental ages and their I.Q. Lower mental age subjects behave like younger normal children with respect to the cross-modal transfer of information, and Prior therefore claims that retardation effects tend to override any effects that could be characteristic of and attributable to autism. However, Prior also remarks that this area is "valuable and worthy of extension".

In summary, it is clear that Hermelin and O'Connor's theory is only one among many theories of autism. Although they have some experimental evidence for their theory, this evidence is slight and further work is needed. Nevertheless, their theory, taken in conjunction with Paivio's "dual coding hypothesis", at least offers an explanatory framework for the phenomena observed in this study and, *ipso facto*, the evidence of this study provides support for these two complementary theories.

## Visual Imagery and Drawing

Another assumption that is made in the explanation of the data suggested at the beginning of this chapter, is that visual imagery plays an important part in drawing and picture making.

This theory needs to be critically examined. In the first place, there is no evidence that children known to have special powers of visual or eidetic imagery are able to draw well. (Although the author's own observation of children with higher performance scale I.Q.s than verbal scale I.Q.s on Wechsler Intelligence Scale for Children and their drawings leads her to suspect that there is such a correlation.) There is also evidence in this study that some members of the autistic group show a remarkable ability to remember and reproduce a picture. This group of children were chosen for their extreme proficiency at photographic realism, but their ability to remember and reproduce incidental details suggests that visual imagery and visual memory are vital factors.

From an intuitive viewpoint, it seems likely that when the young child is drawing, he must have some notion of what he is aiming to achieve in his drawing and it is assumed that some form of imagery helps to guide this production, or it may, at least in the passive sense, tell the child when he is going wrong in drawing. However, as was alluded to in the opening chapters, most other commentators on the subject of children's drawings (Freeman, 1980; Goodnow, 1978, etc.) do not describe the drawing process in terms of mental images and their projection. Generally, the drawing process is described in terms of the observable behaviour. Production rather than an assumed internal guiding process is emphasized. Discussion is therefore mainly focussed on the gradual acquisition of "structural equivalents", "units" or graphic symbols, rather than on the acquisition of underlying cognitive abilities.

One of the major stumbling blocks to the idea that visual imagery may mediate or inform graphic representation is that, while the finished product of drawing is presentational in Langer's sense (1949), the process is essentially sequential. The drawing is set down line by line and feature by feature. The child therefore has to order his production and the process is sequential and discursive in the sense that each movement and each line has to be temporally ordered. Young children tend to draw a "list" of features or units, and the process therefore has more in common with writing or other discursive processes like speech than with image projection or imaging in Paivio's sense of these terms. However, a more constructivist view of imaging, such as that proposed by Pylyshyn, is more easily reconciled to these reflections on the drawing process, since imaging is conceived as a selective and reconstructive process where temporal ordering may play a part. In considering Stephen's drawings, Dwgs 11–16, for example, it can be seen that his drawings and his "image" of the particular places depicted may be close, but that his drawing is a coherent construction of the actual scene, and such a construction has a

necessary temporal component. These ideas could be pursued much further, but the enterprise is considerable, and this chapter can only raise such speculations.

Drawing can be seen to be a discursive process as well as an imaginal one. Moreover, the units and features depicted are often freely associated with verbal labels. Young children frequently say a list of items as they draw and it would appear that for many children verbal processes mediate the graphic production.

Buhler (1930) contends that verbal mediation in drawing restricts and limits the product.

> By the time the child can draw more than a scribble, by age 3 or 4 years, an already well formed body of conceptual knowledge formulated in language dominates his memory and controls his graphic work. The highly schematic drawings of childhood result from this fact. Drawings are graphic accounts of essentially verbal processes . . . Language has first spoilt drawing and then has swallowed it up completely.

Vygotsky (translated and edited by Cole *et al.*, 1978) took a very similar view. He says

> our analysis of children's drawings definitely shows that from the psychological point of view we should regard such drawings as a particular kind of child speech.

Vygotsky refers to the work of the early researcher, Sully, who stated that children's drawing not only disregard but often contradict the actual perception of the object, and children are in no way concerned with "complete and exact similarity" desiring rather to produce "superficial indications of an object". Vygotsky says that in drawing, children try to name and designate rather than represent.

> A child's memory does not yield a simple depiction of representational images at this age. Rather it yields predispositions to judgements that are invested with speech or capable of being so invested. We see that when a child unburdens his repository of memory in drawing, he does so in the mode of speech — telling a story. A major feature of this mode is a certain degree of abstraction, which any verbal representation necessarily entails. Thus, we see that drawing is graphic speech that arises on the basis of verbal speech. The schemes that distinguish children's first drawings are reminiscent in this sense of verbal concepts that communicate only the essential features of objects.

Vygotsky sees speech as the pre-eminent symbolic process. What he called "primary symbolic representation", and young children's drawings are conceived as a parallel symbolic process heavily dependent on speech. He neglects imaginal thinking and, as was quoted earlier, both Langer (1949) and Arnheim (1970) have criticized the view that language is the pre-eminent and sole means of representing experience.

However, Vygotsky also says that symbolization or conceptualization is a primary cognitive process of which language and drawing are examples, and

in this respect his views are not at variance with those of Langer. Vygotsky is also right to highlight the role of verbal mediation in drawing. In the Draw-a-Man test (1963) young children will frequently actually say aloud a list of the features while drawing. At the same time, important spatial aspects of the representation, proportions, perspective and occlusion are only primitively represented. Verbal processes generalize experience and, as has been said, are inadequate in describing spatial configurations.

The autistic children in this study have all had serious difficulties with language acquisition and expressive language skills remain severely impaired for the majority of them. It is therefore proposed that without the hypothesized domination of language and verbal mediation in the early years when graphic competence was being acquired, these subjects were able to attend to the spatial characteristics of their optic array and to represent these aspects in their drawings. They have therefore mastered many of the problems of representing space at an early age. These children therefore have a more direct access to visual imagery in the sense that their drawings are not so strongly "contaminated" by the usual "designating and naming" properties of normal children's drawings.

Moreover, the autistic children's drawings tend to show that there can be a well articulated intelligent comprehension and representation of spatial relationships from an early age, and in the absence of a commensurate level of expressive skill or comprehension in the sphere of language. This may indicate that imaginal thinking can be highly organized and complex as Arnheim (1970) proposes.

It is also proposed that the identification of these children and their phenomenal ability can be shown to lend support both to Paivio's dual coding hypothesis (1971) and to O'Connor and Hermelin's model of cognitive processing (1978).

It is also possible to use this model to help to explain individual differences in normal children's drawings. Clearly, children will vary in the degree to which they make use of verbal mediation or visual/imaginal processes in drawing. Some children may approach drawing more as a spatial than as a verbal/conceptual task and they may use less verbal mediation. One might expect such children to show some facility with the depiction of spatial aspects.

It is interesting to speculate on whether it would be possible to teach normal young children to attend to spatial features in their drawings. It is likely that habits in drawing are culturally conditioned (Deregowski, 1980), and it is certainly true that verbal mediation is consciously encouraged in Western schools as Buhler (1930) claims.

The ability to depict photographic realism could be conceived as a continuum with this particular group of autistic children at one extreme end and the ability to use imaginal information without involving verbal mediation, forming a parallel continuum.

Finally, from the foregoing one might expect other new insight or understanding. It is usually those works of art where a craft has been gradually acquired and where the artist has gone on to express his ideas through his art

as something we too have experienced or which we dimly grasp or towards which we have been travelling that gains our admiration. Leonardo's Mona Lisa is universally admired for its marvellous technical accomplishment and because she represents the ineffable mystery and unknowability of other human beings. Such art is deeply enriching and subversive because it captures and instructs us in another human being's perspective. The greater the artist's technical accomplishment and the greater the artist's insight into human nature, the greater the impact of his work.

In this sense, children's drawings can never be high art. What we respond to in children's drawings is their first attempts to organize and express their experience and what is revealed is the conceptual and symbolic dominance of their thinking. Adults cannot recapture their ability to represent these early canonical structures but we have memories of childhood and early attempts at drawing. We also respond to their aesthetic qualities: the instinctive use of colour, for instance. The autistic children in this study show us something else. They possibly demonstrate visual experience untrammelled by conceptual analysis and reorganization. One very important lesson is that such visual experience as is portrayed, is rich and articulate. The child with defective linguistic and conceptual development may be able to perceive and organize his spatial world to an unexpectedly elaborate level.

The author believes that what is communicated in drawing and painting is the common, shared experience. That is why we talk of art as communication. What we respond to is that which we can relate to, so that art is essentially social in nature. Some artists can only be understood and appreciated by a few, but it is enough that those few understand.

However, it is also true that the artist is unconscious in representing other aspects of his experience. These sometimes come through the work unbidden and unstrived for. Rembrandt scrutinized his own face and painted it many times, but what he produced was much more than a self-portrait: a symbol of suffering, endurance and irony.

With these six autistic subjects, they communicate and share their visual experience of perspective. But this is only possible because their abilities in other areas are retarded. We are dazzled by their ability to produce perspective and photographic realism, untrained and at so young an age, but we should not be blind to the fact that any other communication through their art is really severely limited. Understanding is concentrated into spatial awareness; social, conceptual and symbolic communication is absent. Their drawings exercise some charm precisely because they are odd and obsessive, just as Munch's vision of humanity shocks and appalls us but we do not feel part of it.

The problem of what the artist intends and what the perceiver "reads" into a work of art is very difficult, especially in the case of these autistic subjects since we cannot ask them why they draw. Pariser (1979) concludes that it is an "unwarranted assumption that similar aesthetic effects proceed from similar aesthetic aims". When we look at the drawings of these autistic children, we are first misled into thinking that these are the drawings of "mature intelligence";

that here is possible proof of a psychogenic model of autism; of "frozen intelligence". Pariser points out that normal children regularly produce drawings and paintings that are similar to Miró, Klee or Picasso, but no one assumes that "behind the child's amusing and intuitive use of form lie the same concerns and capacities as underlie those of a mature artist". Can we claim that Nadia intended that her cockerels should be fierce and eloquent? These are *our* concepts and interpretations, and all the evidence is that we sadly cannot impute such sophisticated concepts to her.

The study has also been very instructive in demonstrating that the naïve and widely held notion that realistic renderings of the visual world are to be regarded as an ultimate aim in drawing or in art is misguided and fallacious. Realism is only one possible stage, and it could be argued that the symbolic representations of normal young children in fact show more advanced thinking where conceptual understanding is strived for. For the author's part, she has come to regard children's early drawing as impressive demonstrations of human intelligence. The ability to make a two-dimensional circle "stand for" something else entirely different, such as a human head, and to generalize this to all round things is essential in reducing and organizing experience. Vygotsky, Bruner and Langer say that such symbolization is the primary intelligent activity. Langer said

> symbolization is the starting point of all intellection in the human senses . . . it is the work of the brain.

And yet on one level these autistic children's drawings are undoubtedly symbolic. They are two-dimensional representations of their visual experiences of edges, lines, contours and forms. Symbolization appears to fail at the level of recognizing objects as members of categories. Arnheim (1980) says:

> Spectacular though Nadia's case was, it would be naive to assert that her drawings automatically disprove the rule that had been demonstrated in the work of thousands of children all over the world. A scientific rule or law we must remember is an If-then proposition. It asserts that if a particular constellation of conditions prevails, certain consequences will necessarily follow. When an instance occurs that contradicts the expectation everything depends on whether or not the premises — the "independent variables", as they are called by psychologists — were in force. If they were, a single contrary case will undo the rule forever. If the were not, the particular causality of the maverick case needs to be investigated.

The identification of several other similar anomalous cases has enabled the author to describe stable characteristics of the phenomenon and thereby to construct a model which could possibly account for both normal and anomalous drawing development. As has been shown in this chapter, this model may prove to be a "house of cards". At least the ground has been cleared and some foundations have been laid and hopefully, some puzzling building-bricks have been added to the pile.

# APPENDIX I

*Questionnaire on Family Details
and Pre- and Postnatal History*

## Schedule 1
## University of Nottingham Child Development Research Unit
## Brief History and General Information about Your Child

(1) Name . . . . . . . . . . . . . . . . . . . . . . . . . . . . . . . . . . . . . . . . . . . . . . . . . . . . . . . . . . . . . . . . .

(2) Address. . . . . . . . . . . . . . . . . . . . . . . . . . . . . . . . . . . . . . . . . . . . . . . . . . . . . . . . . . . . . . . .

(3) Date of Birth . . . . . . . . . . . . . . . . . . . . . . . . . . . . . . . . . . . . . . . Sex. . . . . . . . . . . . .

*Birth History*

(1) *Pregnancy*

Was your child a premature, full term or late baby?
Please give details.

. . . . . . . . . . . . . . . . . . . . . . . . . . . . . . . . . . . . . . . . . . . . . . . . . . . . . . . . . . . . . . . . . . .

Did you have any illnesses during pregnancy?
Please give details.

. . . . . . . . . . . . . . . . . . . . . . . . . . . . . . . . . . . . . . . . . . . . . . . . . . . . . . . . . . . . . . . . . . .

Any other relevant information about this pregnancy.

. . . . . . . . . . . . . . . . . . . . . . . . . . . . . . . . . . . . . . . . . . . . . . . . . . . . . . . . . . . . . . . . . . .

. . . . . . . . . . . . . . . . . . . . . . . . . . . . . . . . . . . . . . . . . . . . . . . . . . . . . . . . . . . . . . . . . . .

(2) *Birth*

Can you give some estimation of the length of labour?

. . . . . . . . . . . . . . . . . . . . . . . . . . . . . . . . . . . . . . . . . . . . . . . . . . . . . . . . . . . . . . . . . . .

Where there any complications (forcepts, drugs etc.)?
Please give details.

. . . . . . . . . . . . . . . . . . . . . . . . . . . . . . . . . . . . . . . . . . . . . . . . . . . . . . . . . . . . . . . . . . .

What was the birth weight? . . . . . . . . . . . . . . . . . . . . . . . . . . . . . . . . . . . . . . . . . . . . . .

206

Were there any abnormalities diagnosed at or just after birth?

.......................................................................................

.......................................................................................

Were there any perinatal complications?...................................

.......................................................................................

(3) *Family details*

Do you have other children? If so please give details.

|  | *Name* | *Date of Birth* |
|---|---|---|

(i)     .......................................................................................

(ii)    .......................................................................................

(iii)   .......................................................................................

(iv)    .......................................................................................

(v)     .......................................................................................

(vi)    .......................................................................................

Have any of your other children shown special abilities? Please give details.

.......................................................................................

.......................................................................................

.......................................................................................

.......................................................................................

.......................................................................................

Have any of your other children had learning difficulties? Please give details.

.......................................................................................

.......................................................................................

.......................................................................................

.......................................................................................

.......................................................................................

(4) *Details of parents*

    (a) Father's occupation . . . . . . . . . . . . . . . . . . . . . . . . . . . . . . . . . . . . . . . . . . . . . . . . . . . . . . . . .

    (b) Mother's occupation . . . . . . . . . . . . . . . . . . . . . . . . . . . . . . . . . . . . . . . . . . . . . . . . . . . . . . . . .

    (c) Father's age . . . . . . . . . . . . . . . . . . . . . . .

    (d) Mother's age . . . . . . . . . . . . . . . . . . . . . . .

(5) Do either of you possess artistic talent? Please give details.

    . . . . . . . . . . . . . . . . . . . . . . . . . . . . . . . . . . . . . . . . . . . . . . . . . . . . . . . . . . . . . . . . . . . . . . . . . . . .

    . . . . . . . . . . . . . . . . . . . . . . . . . . . . . . . . . . . . . . . . . . . . . . . . . . . . . . . . . . . . . . . . . . . . . . . . . . . .

(6) Is there any family history which you believe may be relevant to my understanding of your child?

    . . . . . . . . . . . . . . . . . . . . . . . . . . . . . . . . . . . . . . . . . . . . . . . . . . . . . . . . . . . . . . . . . . . . . . . . . . . .

    . . . . . . . . . . . . . . . . . . . . . . . . . . . . . . . . . . . . . . . . . . . . . . . . . . . . . . . . . . . . . . . . . . . . . . . . . . . .

    . . . . . . . . . . . . . . . . . . . . . . . . . . . . . . . . . . . . . . . . . . . . . . . . . . . . . . . . . . . . . . . . . . . . . . . . . . . .

    . . . . . . . . . . . . . . . . . . . . . . . . . . . . . . . . . . . . . . . . . . . . . . . . . . . . . . . . . . . . . . . . . . . . . . . . . . . .

    . . . . . . . . . . . . . . . . . . . . . . . . . . . . . . . . . . . . . . . . . . . . . . . . . . . . . . . . . . . . . . . . . . . . . . . . . . . .

Any details on family handedness:

Which hand does mother use for writing? . . . . . . . . . . . . . . . . . . . . . . . . . . . . . . . . . . . . . . . . . . . .

Which hand does father prefer? . . . . . . . . . . . . . . . . . . . . . . . . . . . . . . . . . . . . . . . . . . . . . . . . . . . .

Are the siblings right- or left-handed? . . . . . . . . . . . . . . . . . . . . . . . . . . . . . . . . . . . . . . . . . . . . .

*Further Details About Your Child:*

(1) Which side does your child have a preference for in:

            Writing? . . . . . . . . . . . . . . . . . . . . . . . . . . . . . . . . . . . . . . . . . . . . . . . . . . .

            Kicking a ball? . . . . . . . . . . . . . . . . . . . . . . . . . . . . . . . . . . . . . . . . . . . . . . .

            Looking through a telescope? . . . . . . . . . . . . . . . . . . . . . . . . . . . . . . . . . . . .

(2) Significant illnesses: Has he/she had —

Measles? ......................... At what age? ...............

Mumps? ......................... At what age? ...............

Chickenpox? ...................... At what age? ...............

Whooping cough? .................. At what age? ...............

Others (please specify illness and age)

...................................................................

...................................................................

...................................................................

...................................................................

(3) Has your child seen:
   (i)    Your family G.P.? Please give details with address and date of last visit.

...................................................................

...................................................................

   (ii)   A psychologist? Please give details and date of last visit.

...................................................................

...................................................................

   (iii)  A psychiatrist? (probably at a Child Guidance Clinic)

...................................................................

...................................................................

   (iv)  A paediatrician (probably at a hospital)

...................................................................

...................................................................

   (v)   An audiologist for a hearing test? .....................................

...................................................................

(vi)   A speech therapist? ...............................................

........................................................................

(vii)  An opthalmologist? ...............................................

........................................................................

(viii) Others (please specifiy) ...............................................

........................................................................

........................................................................

........................................................................

........................................................................

Would you have any objection to an approach being made to any of the above with a view to obtaining previous records and reports where possible? (These would be treated in the strictest confidence.) Any further details which would enable me to track down these records would be most helpful.

I have no objections to Dr L. Selfe approaching the following individuals:

........................................................................

........................................................................

........................................................................

........................................................................

........................................................................

........................................................................

Any further details?

........................................................................

........................................................................

........................................................................

........................................................................

# *APPENDIX II*

*Questionnaire on General
Cognitive Development*

The questionnaire was compiled from the following sources so that normative comparisons were available:

Bayley, N. (1965). "Bayley Infant Scales of Development", (Revised) Psychological Corporation, New York.

Buehler, C. and Hetzer, H. (1935). Testing Children's Development from Birth to School Age. Allen & Unwin, London.

Cattell, P. (1960). "The Measurement of Intelligence of Infants and Young Children". Psychological Corporation, New York.

Dekaban, A. (1959). "Neurology of Infancy", Williams Wilkins, Baltimore.

Gesell, A. (1947). "Developmental Diagnosis — Normal and Abnormal Child Development", Hoeber Inc, U.S.A.

Griffiths, R. (1954). "The Abilities of Babies", University of London Press Ltd., London.

Illingworth, R. (1966). "Development of the Infant and Young Children, Normal and Abnormal", Churchill & Livingstone Ltd., Edinburgh.

Stutsman, R. (1948). "Merrill-Palmer Scale of Mental Tests", Stoelting Co., Illinois.

Sheridan, M. (1960). "The Developmental Progress of Infants and Young Children", H.M.S.O., London.

Banham, K. (1960). "Quick Screening Scale of Mental Development", Psychometric Affiliates, Chicago.

Terman, L. and Merrill, M. (1960). "Stanford-Binet Intelligence Scale", 3rd Edition. Form L.M. Harrap & Co. Ltd.

Valentine, C. (1958). "Intelligence Tests for Children", Methuen & Co. Ltd., London.

Doll, E. (1953). "Vineland Social Maturity Scale", Educational Test Bureau, New York.

General items taken from Wood, H. "The Development of Children from Birth to Six Years of Age", (unpublished M.A. Thesis — University of Nottingham).

## Schedule 2
### University of Nottingham Child Development Research Unit
### Developmental Interview Schedule for Children
### with Unusual Drawing Ability

Child's Name:                                      Date of Birth:

Address:

Interviewer: I should like you to help me get as good a picture as possible of N's
development from the time he was born to the present. I am interested in
the development of his speech; how he learned to do things; how he
learned to get on with other people and how his drawing developed. Can
we start by thinking back to the time when N was a very young baby.

(1)     Could N hold his head up and look around him under 2 months?

        Can you remember when he did start to do this? When did his head stop being
        floppy?

(2)     Did he seem to be alert; did his face brighten when he heard your voice before he
        was 3 months-old?

        Can you remember when that started?

(3)     If he was lying down and you were moving about, would he follow you with his
        eyes?

        When did he start to do this?

(4)     Could you have a little game cooing and gurgling with him at this stage?

        (Would he coo back in response to you?)

(5)     Did he increase his activity, waving his arms and legs, when you approached him
        to pick him up before he was three months old?

        If no, when did he do this?

(6)     Can you remember his first smile?

        When was this?

213

(7)    Did he react to a loud noise almost from birth?

He  If no, how old was he when you first noticed he would react?

(8)    Did you have any problems over breast feeding or bottle feeding?

Details

(9)    Did you feel that there was anything unusual about N right from the start?

Details

(10)   Did you ever think he felt unusual when you were holding him?

(Did you feel that N was a floppy baby, or too stiff and resistant to you?)

(11)   Would you have described him as an active baby?

If yes, could you have called him overactive?

If no, were you ever worried that N seemed *too* quiet and passive?

(12)   Was he an irritable baby?
Details

(13)   Was he sleeping through the night by 3 months?
Did he sleep much during the day?

(14)   How would you sum up the kind of baby he was up to 3 months?
Details

(15)   Can you remember some of the milestones in his development; the first time he crawled; the first time he walked?
Let's try and fix those:

(16)   Can you remember when:

He could sit up with support?

He could sit up comfortably without support?

He started to crawl or shuffle — he could get around on the floor?

He could manage to pull himself up into a sitting position?

He could manage to pull himself up to stand in his play pen or by a chair?

He could walk holding on to the furniture?

He started to walk on his own?

He could get himself up from sitting to standing without holding on to anything?

Now let's go back and think about the time when N was around 6 months-old:

(17)  Can you tell me how he played when he was first sitting up?

(18)  What sort of thing did he do? What did he play with?

(19)  If he dropped a toy and it rolled a little way, would he try to get it back?

I'd like to ask you about the beginnings of language next.

(20)  Did he respond if you held him on your knee and you talked to him?

What did he do?

(Did it seem to take a very long time for that kind of conversation-without-words to come? — or did it never come?)

(21)  Did he babble and talk to himself in his cot or pram?

When did he do this?

(22)  Could N make several different sounds starting to use his tongue and his lips at about six-months-old? (demonstrate)

(23)  Can you remember when he started to make lots of different sounds? When was that?

(24)  Did N start to imitate the sounds you made, like blowing a raspberry or smacking your lips at about six months?

(25)  Could N copy one syllable sounds you made (da da da) when he was about six months?

(26)  Did you have any difficulty in getting his attention by calling his name?

Details

Is that something that went on being a problem?

If so, what did you do instead to get his attention?

(27)  Could you tell when he was frustrated by about six months?

How?

If "cry and grizzle" ask "Any other way?"

(28)   Could he easily be comforted when he was feeling frustrated?

If no, what did comfort him?

(29)   Did he cry a great deal?

Details

(30)   Was there anything unusual about his crying?

Details

(30b)*Was N aware of strangers before his first birthday?

(30c)  Did N say ''Bye Bye!'' and wave his hand before his first birthday?

(31)   Was there a time when you were anxious about N's speech development?

If yes, when?

why? (details)

(32)   Can you sum up for me the kind of baby he was when he was six-months-old?

Details

Now let's move on to think of the time when he was about 9 months to a year-old —
just before his first birthday:

(33)   Was he beginning to understand things that were said to him?

Details

Did he understand ''Bye Byes'' for bedtime?

Are you certain that he actually understood the words or was it really the
situation that he understood?

(34)   Did he enjoy and respond to games like ''Pat-a-cake'' and ''Walk around the
garden'' before his first birthday?

(35)   Did N understand No! about this time?

(36)   Were there any other words he understood?

(37)   Did he have any words of his own that he could use that meant something?

Details

(38)   Could you hear a lot of scribble talk when he was on his own?

(39)    Would he have a little game of give and take with a toy at this stage?

         If no, can you remember when he could do this?

(40)    When he was about 9 months would he try to look for a toy that had dropped out of sight?

(41)    Did he like to play peek-a-boo?

         From what age?

(42)    Would you have said that he was neat fingered around his first birthday?

         Why would you have said that?

         What sort of thing was he doing?
         (Prompt — picking up currants? Turning pages?)

(43)    Could he use his forefinger to explore objects by the time he was 9-months-old?

(44)    Can you tell me something about the way he was playing around his first birthday?

Let's move on to around one year to 18 months:

(45)    Did you have any problems in getting him to feed himself?

         When did he eat with a spoon and his fingers?

         When did he start to chew?

         If problems ask ''Couldn't or wouldn't''?

(46)    When was he eating without dribbling or spitting?

(47)    Did N use to put everything in his mouth?

         Did this stage last longer than you expected?

         Details

(48)    How old was N when he was dry during the day?

         How old was N when he was dry at night too?

         Details

(49)    If he was in his pushchair and you pointed at something for him to look at, could he?

         From what age?

Let's talk about his early sense of rhythm:

(50)   Did he have a sense of rhythm from an early age?

       Can you remember when this happened?

(51)   Did he make noises imitating rhythmical sounds?

       (For example, Brm, brm, brm,! or police siren (demonstrate))

       What age was that?

(56)   If you played pat-a-cake would he clap his hands *in time* with you?

       Was this before his first birthday? (emphasize)

(57)   Did he bang his spoon and sort of sing before his first birthday?

(58)   How old was he when he started to enjoy nursery rhymes?

(59)   When did he start to join in nursery rhymes, perhaps completing the end of the line?

       P. Was this before his first birthday or later?

(60)   Did he start to show some interest in pictures around his first birthday?

       When did he start to look at pictures as if the pictures meant something to him?

       If appropriate, you said N had some first words before his first birthday, how did he go on from there?

       If no first words before first birthday continue . . .

(61)   What was N's first word?

(62)   Can you remember his age?

(63)   How did he go on from there?

       Details

       Did he gain a lot more words?

(64)   So by the time he was . . . (as appropriate) . . . how many words did he know?

       What sort of words?

       Details

(65)    Did he use the words for the right things?

(66)    How and when did N put two words together?

Details

Prompt if necessary: "That's the kind of thing he'd have learned as a complete phrase — what about two words he could put together for himself, like "Mummy chair" or "N hurt"?

(67)    Was he older than 2 years when he first began to do this?

(68)    Could he use a word like "gone" with different words attached to it? (Daddy gone; car gone; etc)

How old was he?

(69)    From then on did his sentences get longer?

Details

(70)    Did N ever try to explain his needs in any way other than language?

When did he do this?

(71)    Did he show you his needs by pointing?

(Prompt: This was pointing with his finger rather than reaching with his hand?)

Was this before his first birthday?

If no, you said he didn't understand your pointing — did he come to understand?

(72)    Did he have difficulty in understanding this?

(73)    What about gestures?

Did he understand a warning look?                      Age?

Did he understand a hushing finger?                    Age?

(74)    Can you sum up the sort of things he was doing when he was about 18 months old?

How was he occupying himself?

Details

Let's go on to think about N when he was a toddler. I would like to ask about his speech and any problems which he may have had as his speech developed:

(75)    Most children at an early age leave words out of sentences, like a telegram; did he go on doing that much longer than you would have expected?

(76)    Most children go through a stage of getting words in the wrong order? Did this go on longer than you would have expected?

(77)    Did you ever feel that N's facial expressions were unusual?

(78)    Did he refuse to use certain words?

       Details

(79)    Did he seem to have his own private rules about the way he said things?

(80)    Did he ever use an odd tone of voice?

       Details

(81)    Did he ever have trouble in asking questions?

       Prompt: For instance, some children have difficulty in asking when? Where? or How? Or they make a statement in a questioning tone like ''Daddy coming home?''

       Details

(82)    Did he ever have trouble in answering questions?

       Details

(83)    Was there a time when he couldn't say ''yes!'' or ''no!'' when you asked him a question but seemed as if he had to answer in a full sentence?

(84)    Did he ever ask the same questions over and over again?

       Does he still?

       Details

(85)    Was there ever a time when he was always echoing what you said to him?

       How long did that go on?

       Details

(86)    Did he echo part of your question for his answer, for instance if you said ''Do you want a biscuit?'' he might say ''Want a biscuit?''

       Details

(87)    Did N ever get "I" and "you" mixed up?

Details

(88)    Did he often come out with a sentence which you knew he had heard somewhere else and not made up for himself?

Details

(89)    Did the sentence make sense in that it was connected with the situation at that time?

(90)    Did you feel that N had difficulty in understanding what was said to him?

Details

(91)    Was there also a difficulty in getting his attention?

Details

(92)    What was the main difficulty? (understanding or attention?)

(93)    Did N understand and respond to simple requests like, "Stop that", "Come here", when he was about 2-years-old?

(94)    Could N follow simple instructions? Such as:

Come and have a sweetie (simple orthodox)                          Age?

Come and have a sweetie and give one to Anne
(complex orthodox)                                                Age?

Go and get the biscuits, they're in the kitchen table (C. visible)   Age?

Go and get the biscuits, they're in the kitchen cupboard
(c. unortho, invis.)                                              Age?

Go and get the biscuits, they're in the sewing box
(c. unortho, invis.)                                              Age?

(95)    Did N show moments of understanding what you said when you didn't expect him to?

(96)    When N was a toddler did you feel that you could have a normal children's conversation with him?

Could strangers have a normal children's conversation with him?

(97)    Did N respond to your mood as a young child?

If you were unhappy would he try to comfort you?

Details

(98) Did N come to you when he was hurt or upset?

(99) Did N take a normal interest in toys?

(100) Did he show a normal interest in presents or in new toys?

(101) Did he play make-believe with toys? (e.g. making a cup of tea with a toy tea set; playing cars and garages.) When did he start to do this?

Before school?

Details

(102) You said earlier that you were anxious about N's speech development, did you consult your doctor or any other professional person?

Details

(103) Did N ever have any speech therapy or any remedial help with language?

Details

I'd like to talk next about N's development from the time he started school but first can we run through his schooling: which schools he's been to and when he started:

(104) Details

(105) Could N tell you the names of four colours by the time he was 5 years old?

(106) Could N recite numbers up to 10 before he went to school?

(107) Could he count out ten objects correctly by 5 years?

(108) By the time he went to school did you feel that N's speech development was different from most children's?

*(109) How did N's speech development compare with children's at his school?

Details

(110) Was there a time when you thought that N might be deaf?

Details

(111) Did N sometimes behave as if he were deaf although you knew he wasn't

When was this?

(112) Did N sometimes seem not to respond to loud sounds although he would notice rustle of a sweet paper?

(113) Did you wonder whether N had any sort of problem with his eyes?

Have N's eyes been tested?

Details

Did N ever have a squint?

Details

(114) You said earlier that you were anxious about N's speech development, did you consult your doctor or any other professional person?

Details

(115) Did N ever have any speech therapy or any other remedial help with language?

(116) Was there a time when N's speech development seemed to be going backwards rather than forwards?

Details

(117) How did his speech develop at school?

Details

(118) Would you say that N was an affectionate child during his early school years?

(119) Did N often have inconsolable temper tantrums when he was a child?

What were they usually about?

Did that go on much longer than you expected?

(120) Did N like to play with other children?

From what age?

(121) Once he'd started school could you have said that he had a best friend?

(122) When he was older did he have ordinary friendships with other children?

If no, why was that?

(123) How did he get on with other members of the family?

(124) Did he have a particular closeness to one member of the family?

Does he now (same person?)

(125) Could you trust him to go to the corner shop when he was about seven?

Prompt: Would he have to cope with traffic to do that?

(126) Did he respect other people's property?

From what age?

(127) Was he possessive about his own things?

From what age?

(128) Did N have any real obsessions?

For certain objects? Details

For certain actions? Details

For people? Details

(129) Has N ever had an exaggerated liking for some particular kind of object?

(130) Would he look for these things to a degree that made life difficult?

Details

(131) Did he have any other obsessional interest?

Would he carry this so far as to involve strangers?

Details

(132) Did he ever get unduly upset if you made any changes in routine or in the home?

Details

(133) Has he ever seemed not to recognize a familiar object or person?

Details

(134) Did N ever walk straight past people he knew without apparently noticing them?

(135) Did you often need to wave or call to attract his attention?

(136) Did N ever have any unusual habits that worried you?

Can you tell me about them?

Details

(137) Has N ever had any unusual mannerisms?

Details

(138) Has N ever had any unusual movements like turning round and round on the spot persistently?

Running up and down without purpose?

Jumping up and down on the spot?

(139) Did he flap his hands during any of these movements or hold them up in any way?

(140) Has N ever twiddled his fingers or objects in the corners of his eyes?

If yes, was it particularly difficult to get through to him when he was doing this?

(141) Did he have any other unusual movements or habits with his hands?

Details

(142) Was N ever unnecessarily terrified of objects?

Of bright lights?

Of some noises?

(143) Has he found busy places like a big store or busy street particularly confusing?

Details

(144) Has he ever hurt himself badly and not complained at all so that you thought it was odd?

Details

Now I should like to find out how N learned to do things. Can we go back to the time when he was a toddler.

(145) When N was a toddler could he build a tower with blocks?

(146) When N was a toddler could be thread marble sized beads on a string?

(147) Could he use any lacing toys before he went to school?

(148)  Did N play with jig-saw puzzles?

Inset puzzles?                                From what age?
Four piece jig-saws?                          From what age?
Twelve piece jig-saws?                        From what age?

(149)  Any other construction toys? (Prompt, Meccano, Lego?)

(150)  Could N eat with a spoon easily by the age of 2 ½ years?

From what age?

(151)  Could N eat with a knife and fork by the age of 5 years?

When?

(152)  Could he do up buttons on his coat by the age of 4 years?

From what age?

(153)  Could he tie his own show laces by the time he went to school?

Did you have any difficulty in teaching him this?

When could he tie a bow that wouldn't come undone?

(154)  Could N use scissors before he went to school?

Did he hold them properly?

(155)  Could he write a few letters and a few numbers before he went to school?

Details

(156)  Was he agile on his feet by the time he was 5-years-old?

If no, by what age?

(157)  Did he seem generally well co-ordinated in movements or was there any clumsiness about them?

(158)  Was there any kind of awkwardness or stiffness when he walked around?

(159)  Did he ever run on tip-toe to an exaggerated extent?

(160)  Was his balance good by 5 years of age?

(161)  Could N climb on playground apparatus before he went to school?

If no, at what age would he start to attempt this?

(162) Could N try to climb a tree when he was older?

Can you remember how old he was?

(163) Did he seem to take much longer than other children to learn to climb the stairs?

(164) Could he walk upstairs normally by the time he went to school at the age of 5 years?

How old was he when he could do this?

(165) Could he dress himself by the time he was 5?

If no, was this because he couldn't or because he wouldn't?

If yes, would you have to continually encourage him through out?

(166) Did N have access to a trike?

If yes, was he able to pedal it before 5 years?

(167) Has N learned to ride a bike?

Is he allowed to go out on the road on his own?

Local small quiet roads?                                        Age:

Busy main roads?                                               Age:

(168) Could N throw a ball accurately before he was 5?

(169) Could he catch a ball?                    Would he attempt to?

(170) Could he unwrap a chocolate marshmallow biscuit without dropping it or squashing it before he was 5?

(171) Looking back, would you say that N was much better on skills using one hand on its own than using two together?

(172) Did he often get into difficulties:

Climbing too far?

Squeezing into small spaces?

Running into danger?

(173) In an open space, like a beach would he run on and on without looking back to see whether anyone was followed?

Finally, I'd like to ask you about some of the things that N can do now. First of all, can we think about the various ways in which he uses speech now.

(174) How normal would you say his speech is nowadays?

(If nearly normal, does he . . . if not, can he . . .)

(175) Does/can N let you know what his needs are? For example, how does he tell you that he is hungry and what he wants to eat?

(176) Does/can N use speech to make sure that things will happen the way he wants them to happen? For instance, if he wanted you to wait until the ice-cream van came along what would he say?

Details

(177) Can N name most of the objects in a picture book if you pointed to them?

(178) Can he tell you the names of at least six items in this room without you helping with each one in turn?

(179) Could he give you a list of at least six items in the kitchen while he is sitting here?

(180) If he saw something unusual and interesting like a traction engine, could he tell you several things about it?

(181) Can he tell you something he's done when you are not there?

(182) Can he tell you about something someone else did when you were not there?

(183) Can he tell you about something a group of people did when he was with them but you were not there?

How would he tell you about a school outing, for instance?

(184) Could he tell you about another child getting into trouble in school: what the boy did and what the teacher did?

(185) Can he tell you about several incidents in the day that led on from one to another?

Would he get the sequence in reasonable order? (prompt if necessary)

(186) Can N tell you the most important events and ideas in a story, so that it makes sense?

(187) Can N use speech to explain how something works?

For instance, can he explain how something, like a pencil sharpener or an egg-timer works?

(188) If you and he were both locked out of your house, would N be able to tell you what to do? Could he suggest a suitable solution?

(189) Can he explain and give you reasons why he has done something? (I did it because . . .?)

(190) Can he explain and give you reasons why he is going to do something?

(191) Can he use speech to make excuses for himself?

(192) Can N criticize other people?

(193) Can he make threats using speech?

(194) Can he talk to you about the fact that he is expecting something to happen?

(Prompt: what might he say when he knows it is his birthday tomorrow?)

(195) Can he tell you what he expects to happen in detail?

(196) Can he tell you what he is expecting to happen in the right order?

(197) Can he use language to talk about possible problems that might arise but haven't yet?

(Prompt: Does he ever say "What if . . .?")

(198) Can he say that and then work out what might be done to solve the problem?

(199) Has N ever mimicked someone else?

Did he do this intentionally, to be funny or to tease?

Or did he do that unconsciously?

(200) Does N usually understand a joke that is told to him?

What sort of joke?

How subtle can they be?

Details

(201) Can he tell a joke successfully?

(202) Can he repeat a story that he has heard?

(203) Can he make up a story?

(204) Can he express sympathy for someone else?

How?

(205) Has he got a good imagination?

What makes you feel that?

Details

(206) Can N read?

Does he read aloud?

Does he read words?

Does he read silently without mouthing?

(207) When did he learn to read simple first reading books?

When did he learn to read simple stories?

Can he enjoy a book for its story?

Can he read a book with more story than pictures?

Does he like story books or does he prefer information books?

Details

(208) What sort of thing can he write?

Can N write his own name?

From what age?

When did he start to *copy* short sentences?

When could he write down short stories or write a two sentence letter?

Details

(209) Is N clumsy on his feet?

Is he quick and skilful with his hands now in other things than drawing?

(210) Can you have a normal conversation with N?

Can strangers have a normal conversation with him?

If no, how is it different?

If yes, is there any way in which it's different?

(211) Can N tell the time?

When did he learn?

Does he understand when you say:

"In a little while . . ." Would he remind you at a reasonable time?

"Later . . ." Would he remind you?

"Tomorrow . . ." Would he remind you when it came to the next day?

(212) Would he remember if you had made a promise to do something further into the future?

(213) Can N go out on his own?

How far can he go out?

(Prompt: Could he go shopping in town? Could he go to the library?)

Details

# APPENDIX III

*Questionnaire on Drawing Behaviour*

# Questionnaire on Drawing Behaviour

Child's Name  _____

I should like you to help me to build up as complete a picture as possible of the development of N's drawing ability.

(1)    How old was N when he first started to draw?

(2)    What did he draw with right at the beginning?
       Pencil              Coloured pencils       Paint
       Ballpoint           Fibre pen              Anything else?
       Wax crayon          Felt pen

(3)    Did he scribble before he could draw anything recognizable?

(4)    Was there a time when he was scribbling as well as drawing?

(5)    Did he spend a lot of time scribbling and drawing circles and squiggles? Could you call it one of his favourite activities?

(6)    How much time did he spend doing this?
       Hours per day?      Days per week?

       How long did this go on?

(7)    How old was N when he first drew a picture that was meant to be something?

(8)    And was he doing a lot of drawing and scribbling around that time?
       Most days?              Several times a week? Only occasionally?

(9)    What were his very first drawings?
       First drawing:

       Early drawings: (with ages if possible)

(10)   What did he draw on to start with? (details)

(11)   Did you have any difficulty getting him to draw on paper instead?

(12)   You said he liked drawing with a ..................... Did he have a definite preference for one drawing material rather than another?

(13)   Did he seem to draw much more skilfully with one thing rather than another?

How did that go on; did he continue to have definite preferences?

If so, would you say that he as a little bit rigid in actually refusing to use other materials?

(14)   How did he first hold a pencil?
       Did he hold it between his thumb and first two fingers or in his whole fist?
       Or in some other way?

(15)   How old was he?

(16)   Was it difficult to get him to hold the pencil more normally?

       How old was he when he regularly held it in the normal way?

(17)   How often did he draw at first?

       Once a day?              Once a week?              Less often?

(18)   Did he name the object he was drawing?

       How did you know what it was?

(19)   Was he interested in your reaction to his drawings?

       Would he come and show it to you without your asking to see it?

(20)   Did he need encouragement to draw, or would he get on with it entirely on his own?

(21)   Going back before he was drawing, did he show any interest in pattern at that time?

       In what way?

       Did he produce patterns in any way before he was drawing — by arranging objects, for instance?

       Did he intend these patterns to represent anything?

(22)   Once he was drawing recognizably, did he draw lots of different things or did he seem fascinated by just one or two things? (details and ages)

(23)   Where had he seen his drawing subjects?

       In real life?
       In a picture book?
       On TV?
       Other?
       Don't know?

(24)    Did N ever actually *copy* his drawings?

Where did he copy his drawings from?
Pictures?
Models?

(25)    What did he copy? (subjects)

(26)    Did he copy with the subject in front of him, or did he usually draw from memory? (details)

(27)    What did N draw after his early drawings?

Can we try to get a timetable of his drawings over the next few years?

| *Subject* | *Frequency* | *Age when first drawn* |
|---|---|---|
| | | |

(28)    Has he had phases of drawing a lot and then gaps, or has he gone on steadily?

(29)    What was N's attitude when he was drawing at his most productive?

Did he seem to get a lot of pleasure out of drawing?

(30)    How did he show that?

(31)    Was he excited by drawing?

How did you know?

Did he seem different in his mood when he was drawing, from how he was at other times?

(32)    Did you feel his skills in drawing were very different from his skills in other ways?

Could you say that in some ways he was definitely a clumsy child?

(33)    When did he start writing letters of the alphabet or numerals?

(34) Did he ever use them as a part of his drawings (in any other way than writing a title or his name)?

(35) Which hand did he draw with at the beginning?

Has he gone on using this hand?

(36) Did he seem to have an early understanding of perspective — how to make an object look solid or to show depth and distance? (details)

(37) Did he seem to have an early understanding of:

— How to draw people or animals?
— How to get a recognizable likeness of a person?
— How to show things or people in different positions?
— How to convey humour?

Let's talk about his more recent drawing activity:

(38) Has he drawn less recently?

At what age was he most enthusiastic about drawing?

How often does he draw now?

(39) What does N do with the drawings when he's finished one?

(40) Did he ever destroy the drawings or scribble on them?

Why did he do this, do you think?

What about nowadays?

(41) Does he come and show you his drawings nowadays?

How do you react?

Does N ever draw to please you?

(42) Would you say that N's drawing style is swift and sure, or slow and painstaking?

Is it sometimes swift and careless?

(43) How long does each drawing take?

(44) Does he complete the drawing all in one go, or with breaks in his concentration?

(45) Does he ever come back and finish a drawing or add to it?

(46)    Does he seem to take a pride and pleasure in his drawing when he looks at them a day or two later, or does he lose interest once they're done?

(47)    Were there things that he could draw but would refuse to do on request?

(48)    How does he react now when you ask him to draw a particular thing?

(49)    Have you noticed how he plans his drawings? Does he usually start in one place, for instance? (details)

(50)    When he was younger, would N distort or squash his drawing to make it fit onto the paper?

(51)    How close did he get to the paper to draw?

(52)    (If very close) Do you think he is a bit short-sighted or was it for some other reason?

And nowadays?

(53)    What size paper did he like best?

(54)    What does he like to draw with nowadays?

| | |
|---|---|
| Pencil | Fibre tip |
| Ballpoint | Felt tip |
| Crayon | Paint and brush |
| Pen ink | Anything else |

(55)    What does he prefer?

Do you have any idea why?

(56)    Has N ever used any other art materials?

Plasticine?
Clay?
Collage?
Carving?

(57)    Can N trace with tracing paper?

Has he shown any special interest in this? (details)

(58)    How interested did he seem in other materials?

Did he take it very far?

(59)    Do you think he showed any special talent with these materials?

(60)    Does he ever make anything else with his hands?

Would you say that he was skilful nowadays with his hands?

Would you call him neat-fingered?

(61) Did N ever colour his drawings?

At what age?

Were the colours he used appropriate? (e.g. green for grass, blue for sky)

(62) Did N colour in colouring books? (details)

(63) Did he do it particularly neatly, or in particularly pleasing colours? (age?)

(64) Did N ever decorate his pictures or the border of the page?

At what age?

(65) Was that something that specially interested him?

(66) Did N ever explain what his drawings were about in some detail?

(67) Would he use drawings as illustrations of something he wanted to write about, or make up a story around them?

Which came first usually: the drawing or the story to go with it?

(68) Did he usually write down the story?

(69) N's figures now seem to be about the right size; the heads and bodies in proportion. Was this always so?

(70) Did N draw scenes where these proportions were wrong: people too big for houses, etc?

(71) Would he see the difference between two patterns of material, say, that were almost alike?

(72) Does he notice details of patterns? (details and examples)

(73) Does he enjoy looking at pictures? What kind?

(74) Does he have any difficulty understanding pictures?

Can he understand a map or a diagram?

(74) Has he ever drawn maps or diagrams? (details)

Has he ever drawn maps or diagrams for any other reason apart from the pleasure of drawing them? (details)

(75) Can he make sense of any other kind of visual pattern: using a camera, looking down a microscope?

(76) Can he make any sense of written music?

(77) Do you think he has any special ability at other kinds of patterns?
In music?
With numbers?

(78) Does he draw as much nowadays as he used to?

(79) (If no) What do you think made N less enthusiastic about drawing?

(80) Did he seem to become dissatisfied with his drawings? (For what reasons?)

(81) Does he ever draw for pleasure nowadays?

(82) Has he ever been self-conscious about drawing?

(83) Does he ever doodle? (details)

(84) What would you say was special about N's drawings?

Before he was five:

Between 5 and 11 years:

During his adolescence:

Now:

# References

Alberti, L. B. (1584). "Trattato della Pittura", Milan.

Ames, L. B. and Ilg, F. L. (1963). The Gesell Incomplete Man Test as a measure of developmental status. *Genetic Psychology Monographs*, **68**, 247–307.

Arnheim, R. (1954). Art and Visual Perception. University of Berkeley Press, Berkeley, California.

Arnheim, R. (1967). Art and visual perception: a psychology of the creative eye. Faber and Faber, London.

Arnheim, R. (1970). Words in their place — relationship of language to thinking. *Journal of Typographic Research*, **4**, 199–212.

Arnheim, R. (1970). "Visual Thinking", Faber and Faber, London.

Arnheim, R. (1971). Visual perception and thinking. *Viewpoints*, **47** (4), 99–111.

Arnheim, R. (1977). "The Dynamics of Architectural Form", Berkeley. University of California U.P.

Arnheim, R. (1980). The Puzzle of Nadia's Drawings. *The Arts in Psychotherapy.* **7**, 79–85.

Ausubel, D. (1964). The transition from concrete to abstract cognitive functioning: theoretical issues and implications for education. *J. Res. Sci. Teaching*, **2** (3), 261–6.

Ballard, P. B. (1912). What London children like to draw. *Journal of Experimental Pedagogy*, **1**, No. 3, 185–197.

Ballard, P. B. (1913). What children like to draw. *Journal of Experimental Pediatrics*, **2**, 127–129.

Barrett, M. and Light, P. (1976). Symbolism and intellectual realism in children's drawings. *British J. of Ed. Psychol.*, **46**, 198–202.

Barnhart, E. (1942). Developmental stages in compositional construction in children's drawings. *J. exp. Educ.* **11**, 156–184.

Bassett, E. (1977). Production strategies in the child's drawing of the human figure: towards an argument for a model of syncretic perception. *In* "The Child's Representation of the World", (G. Butterworth, ed.), Plenum, New York.

Bender, L. (1938). A visual motor gestalt test and its clinical use. *American Orthopsychiat. Ass. Monogr. 3*.

Benton, A. L. (1955). "The Revised Visual Retention Test: clinical and experimental applications", Psychological Corporation, New York.

Berger, P. and Luckman, T. (1967). "The Social Construction of Reality", Penguin, Harmondsworth.

Britsch, G. (1930). Theorie der bildenden Kunst. (E. Kornmann, ed.) 2nd Ed. Bruckmann, Munich.

Brown, L. B. (1969). The 3D reconstruction of a 2D visual display. *J. of Genetic Psychology*, **115**, 257–262.

Brown, R. (1958). "Words and Things", Free Press, Glencoe, US.

Bruner, J. (1964). The course of cognitive growth. *American Psychologist*, **19**, 1–15.

Bruner, J., Olver, R. and Greenfield, P. (1966). "Studies in Cognitive Growth", Wiley, New York.

Bryant, P. (1974). "Perception and Understanding in Young Children", Methuen, London.

Buffery, A. and Gray, J. (1972). Sex differences in the development of spatial and linguistic skills. *In* Gender Differences; their ontogeny and significance", (C. Ounstead and D. Taylor, eds), Livingstone, London.

Bugelski, B. (1970). Words and things and images. *American Psychologist*, **25**, 1002–12.

Buhler, K. (1930). "The Mental Development of the Child", Routledge & Kegan Paul, London.

Bull, G. (1965). "Vasari — the Lives of the Artists", Penguin Books, Harmondsworth.

Burt, C. (1921). Mental and Scholastic Tests, R. S. King & Son, London.

Butterworth, G. E. (ed.) (1977). "The Child's Representation of the World", Plenum, New York.

Churchill, D. (1978). Language: the problem beyond conditioning. *In* "Autism: A Reappraisal of Concepts and Treatment", (M. Rutter and E. Schopler, E. eds). Plenum, New York.

Clark, A. (1897). The child's attitude towards perspective problems. *In* "Studies in Education", (E. Barnes, ed.). Stanford University Press, Stanford.

Cole, M., Steiner, V., Scribner, S. and Souberman, E. (eds) (1978). "Mind in Society", L. S. Vygotsky. Harvard University Press, Cambridge, Mass.

Connolly, K. and Elliott, J. (1972). The evolution and ontogeny of hand function. *In* "Ethological Studies of Child Behaviour", (N. Blurton Jones, ed.). Cambridge University Press, Cambridge.

Cox, M. V. (1978). Spatial depth relations in young children's drawings. *Journal of Experimental Child, Psychology*, **26**, 551–556.

Cox, M. V. (1981). One thing behind another: problems of representation in children's drawings. *Educational Psychology*, **1**, 4. 275–287.

DeMyer, H. K. (1976). The measured intelligence of autistic children. *In* "Psychopathology and Child Development", (E. Schopler and R. J. Reichler, eds). Plenum, New York.

Dennis, N. (1978). Portrait of the Artist. *The New York Review of Books*, 8–15.

Deregowski, J. B. (1972). Orientation and perception of pictorial depth. *International Journal of Psychology*, **6**, 111–114.

Deregowski, J. B. (1980). Illusions, Patterns and Pictures: a cross-cultural Perspective. Academic Press, London and New York.

Dinnage, R. (1977). The autistic artist. *Times Literary Supplement*, **9**, December, 1977.

Donaldson, H. (1978). "Children's Minds", Fontana, London.

Dubery, F. and Willats, J. (1972). "Drawing Systems", Studio Vista, London.

Eisner, E. W. (1971). "Confronting curriculum reform", Boston, Little, Brown.

Eisner, E. W. (1972). "Educating Artistic Vision", MacMillan, New York.

Eisner, E. W. (ed.) (1976). "The Arts, Human Development and Education", University of Berkeley Press, Berkeley, California.

Elliott, C., Murray, D. and Pearson, L. (1978). British Abilities Scales. N.F.E.R., Slough.

Elliott, J. and Connolly, K. (1974). Hierarchical structure in skill development. *In* "The Growth of Competence", (K. Connolly and J. Bruner, eds). Academic Press, London and New York.

Eng. H. (1931). "The Psychology of Children's Drawings", Routledge & Kegan Paul, London

Farber, J. and Rosinski, R. R. (1978). Geometric transformations of pictured space. *Perception*, **7**, 269–282.

Freeman, N. H. and Janikoun, R. (1972). Intellectual realism in children's drawings of a familiar object with distinct features. *Child Development*, **43**, 1116–1121.

Freeman, N. H. (1972). Process and product in children's drawing. *Perception*, **1**, 123–140.

Freeman, N. H. (1975). Do Children draw men with arms coming out of their head? *Nature*, **254**, 416–417.

Freeman, N. H. (1976). Children's drawings: cognitive aspects. *Journal of Child Psychology and Psychiatry*, **17**, 345–350.

Freeman, N. H. (1977). How young children try to plan drawings. *In* "The Child's Representation of the World". (G. E. Butterworth, ed.). Plenum, New York.

Freeman, N. H., Eiser, C. and Sayers, J. (1977). Children's strategies in drawing 3D relations on a 2D surface. *Journal of Experimental Child Psychology*, **23**, 305–314.

Freeman, N. H. and Hargreaves, S. (1977). Directed movements and the body proportion effect in preschool children's human figure drawing. *Quarterly Journal of Experimental Psychology*, **29**, 227–235.

Freeman, N. H. (1980). "Strategies of Representation in Young Children. Analysis of Spatial Skills and Drawing Processes", Academic Press, London and New York.

Gablik, S. (1976). "Progress in Art", Rizzoli, New York.

Gardner, H. (1980). "Artful Scribbles", Jill Norman Ltd., London.

Gesell, A. (1954). "The First Five Years of Life", Methuen, London.

Gesell, A. and Ames, L. (1946). The development of directionality in drawing. *J. Genet. Psychol.* **68**, 45–61.

Gibson, J. J. (1979). "The Ecological Approach to Visual Perception", Houghton-Mifflin Company, Boston, Mass.

Gogel, W. C. (1976). An indirect method of measured perceived distance from familiar size. *Perception and Psychophysics*, **20**, 419–429.

Golomb, C. (1974). Young Children's Sculpture and Drawing", Harvard University Press, Cambridge, Mass.

Gombrich, E. H. (1950). "The Story of Art", Phaidon Press, London.

Gombrich, E. H. (1960). "Art and Illusion", Phaidon Press, London.

Goodenough, F. (1923). "Children's Drawings as Measures of Intellectual Maturity", Harcourt Brace and World, New York.

Goodman, N. (1976). "Languages of Art", Hackett Publishing Company, Indianapolis.

Goodnow, J. J. (1977). "Children's Drawing". Open Books, London.

Goodnow, J. J. (1978). Visible Thinking: Cognitive Aspects of Change in Drawings. *Child Development*, **49**, 637–641.

Gray, C. and Gunnerman, K. (1975). The enigmatic Eidetic image: A critical examination of methods, data and theories. *Psychological Bulletin*, **82**, 3, 383–407.

Gregory, R. and Wallace, J. (1963). Recovery from early blindness — a case study. *Exp. Psychol. Monograph* **2**.

Gregory R. (1966). Eye and Brain. Weidenfeld and Nicolson, London.

Gregory, R. (1974). Concepts and Mechanisms of Perception. Duckworth, London.

Gregory, R. and Gombrich, E. (eds) (1973). "Illusion in Nature and Art", Duckworth, London.

Gregory, R. (1977). An isolated talent. *New Scientist*, **76**, 1.12.77.

Gridley, P. (1938). Graphic representation of a man by four-year-old children in nine prescribed drawing situations. *Genetic Psychology Monographs*, **20**, 183–350.

Haber, R. (1969). Eidetic imagery. *Scientific American*, **202**, 36–44.

Hagen, M. A. (1976). Development of ability to perceive and produce pictorial depth cue of overlapping. *Perceptual and Motor Skills*, **42**, 1007–1014.

Hargreaves, D. (1978). Psychological studies of children's drawings. *Educational Review*, **30** (3), 247–254.

Hargreaves, D., Jones, P. and Martin, D. (1981). The air-gap stereotype in children's landscape drawings. *J. of Exp. Child Psychol.* **32**, 11–20.

Harris, D. B. (1950). Intra-individual vs. inter-individual consistency in children's drawings of a man. *American Psychologist*, **5**, 293.

Harris, D. B. (1963). "Children's Drawings as Measures of Intellectual Maturity", Harcourt, Brace and World, New York.

Havighurst, R. J., Gunther, M. K. and Pratt, J. E. (1946). Environment and the Draw-a-Man Test: the Performance of Indian Children. *Journal of Abnormal Social Psychology*, **41**, 50–63.

Hebb, D. (1968). Concerning Imagery. *Psychological Review*, **75**, 466–77.

Hermelin, B. and O'Connor, N. (1970). "Psychological Experiments with Autistic Children", London, Pergamon.

Hermelin, B. and Frith, V. (1971). Psychological studies of childhood autism: can autistic children make sense of what they see and hear? *Journal of Special Education*, **5** (2), 107–117.

Hermelin, B. (1978). *In* "Autism: a Reappraisal of Concepts and Treatments", (M. Rutter and E. Schopler, eds). Plenum, New York.

Hogg, J. (ed.) (1969). "Psychology and the Visual Arts — Selected Readings", Penguin, Harmondsworth.

Israelite, J. (1936). A comparison of the difficulty of items for intellectually normal children and mental defectives on the Goodenough drawing test. *American Journal of Orthopsychiatry*, **6**, 494–503.

Jaensch, E. (1930). "Eidetic Imagery and Typological Methods of Investigation", Routledge & Kegan Paul, London.

Kanner, L. (1943). Autistic disturbances of affective contact. *Nervous Child*, **2**, 217–50.

Kellogg, R. (1970). "Analysing Children's Art", National Press, Palo Alto, California.

Kemp, H. (1978). Science, non-science and nonsense. *Art History*, **1**, 134–161.

Kirk, S., McCarthy, J. and Kirk, W. (1968). "Illinois Test of Psycholinguistic Abilities", (Revised Ed.). University of Illinois Press.

Koppitz, E. (1968). Psychological Evaluation of Children's Human Figure Drawing. Grune and Stratton, New York.

Kosslyn, S. H. (1978). Imagery and internal representation. *In* "Cognition and Categorization", (E. Rosch and B. Lloyd, eds). Lawrence Erlbaum, Hillsdale, New Jersey.

Langer, S. (1949). "Philosophy in a New Key", Pelican, London.

Langer, S. (1957). "Problems of Art", Routledge & Kegan Paul, London.

Lark Horowitz, B., Barnhart, E. & Sills, E. (1939). "Graphic work sample diagnosis", The Cleveland Museum of Art, Cleveland, Ohio.

Lark Horowitz, B., Lewis, H. and Luca, M. (1967). "Understanding Children's Art for Better Teaching", Charles Merrill Books Inc., Colombus, Ohio.

Leask, J., Haber, R. N. and Haber, R. B. (1969). Eidetic imagery in children. *Psychonomic Monographs Supplement*, **3**, 25–48.

Leroy, A. (1951). Representations de la perspective dans les dessins d'enfants. *Enfance*, **4**, 286–307. 213.

Lewis, H. (1963). Spatial representation in drawing as a correlate of development and a basis for picture preference. *Journal of Genetic Psychology*, **102**, 95–107.

Light, P. and MacIntosh, E. (1980). Depth Relationships in Young Children's Drawings. *Journal of Experimental Child Psychology*, **30**, 79–87.

Light, P. and Humphreys, J. (1981). Internal Spatial Relationships in Young Children's Drawings (in press).

Linke, R. D. (1975). Replicative studies of hierarchial learning of graphic interpretation skills. *British Journal of Educational Psychology*, **45**, 39–46.

Lobsien, M. (1905). Kinderzeichnung und Kunstkanon. *Z. f. pad Psychol.*, **7**, 393–404.

Lowenfeld, V. (1957). "Creative and Mental Growth", (3rd edition). MacMillan, New York.

Luquet, G. (1913). Les dessins d'un enfant. Alcan, Paris.

Luquet, G. (1927). Le réalisme intellectuel dans l'art primitif. 1. Figuration de l'invisible. *J. de Psychol.*, **24**, 765–797.

Luquet, G. (1927). Le dessin enfantin. Alcan, Paris.

Luria, A. R. (1968). The Mind of a Mnemonist. New York, Basic Books.

Machover, K. (1949). Personality Projection in the Drawing of the Human Figure. Thomas, Springfield, Illinois.

Maitland, L. M. (1895). What children draw to please themselves. *The Inland Educator*, **1**, 77–81.

Malrieu, P. (1950). Observations sur quelques dessins libres chez l'enfant. *Journal de psychol.*, **43**, 239–244.

McCarty, S. (1924). "Children's Drawings", Williams & Wilkins, Baltimore.

Mead, G. H. (1934). "Mind, Self and Society", The University of Chicago Press, Chicago.

Menyuk, P. (1978). Language: What's wrong and why. *In* "Autism — A Reappraisal of Concepts and Treatment", (M. Rutter and E. Schopler). Plenum, New York.

Mittler, P. (1970). *In* Carmichael's Manual of Child Psychology. 3rd Ed. (P. Mussen, ed.). John Wiley & Sons Ltd, London.

Morishima, A. and Brown, L. (1976). An idiot savant case report: A retrospective view. *Mental Retardation*, **14**, 46–7.

Neisser, U. (1976). Cognition and Reality: principles and implications of cognitive psychology. Freeman, San Francisco.

Newson, E. (1977). Diagnosis and early problems of autistic children. Communication XI.

Newson, E. (1980). Making sense of autism: an overview. Child Development Research Unit. University of Nottingham.

Newson, J. and Newson, E. (1975). Intersubjectivity and the transmission of culture: On the social origins of symbolic functioning. *Bulletin of the British Psychological Society*, **28**, 437–446.

O'Connor, N. and Hermelin, B. (1978). "Seeing and Hearing and Space and Time", Academic Press, London and New York.

Olson, D. (1970). "Cognitive Development: The Child's Acquisition of Diagonality", Academic Press, London and New York.

Ounstead, C. and Taylor, D. (eds) (1972). "Gender differences: Their Ontogeny and Significance", Churchill Livingstone, London.

Paivio, A. (1971). "Imagery and Verbal Processes", Holt, Rheinhart and Winston, New York.

Panofsky, E. (1970). "Meaning in the Visual Arts", Harmondsworth, Penguin.

Pappas, G. (ed.) (1970). "Concepts in Art and Education", MacMillan, London.

Pariser, D. (1979). A Discussion of Nadia. "Technical Report No. 9", Harvard University Project Zero, Cambridge Mass.

Park, C. (1978). Book Review of Nadia: A Case of Extraordinary Drawing Ability in an Autistic Child. *Journal of Autism and Childhood Schizophrenia*, **8**(4), 457–473.

Phillips, W. A., Hobbs, S. B. and Pratt, F. R. (1978). "Intellectual realism in children's drawings of cubes", *Cognition*, **6**, 15–34.

Piaget, J. and Inhelder, B. (1956). "The Child's conception of Space", Routledge & Kegan Paul, London.

Piaget, J. and Inhelder, B. (1971). "Mental Imagery in the Child", Routledge & Kegan Paul, London.

Pickford, R. W. (1972). "Psychology and Visual Aesthetics", Hutchinson, London.

Prior, M. (1979). Cognitive abilities and disabilities in infantile autism: a review. *Journal of Abnormal Child Psychology*, **7** (4), 357–380.

Pronko, N., Ebert, R. and Greenberg, G. (1966). A critical review of theories of perception. *In* "Perceptual Development in Children", (J. Kidd and J. Rivoire, eds). University of London Press, London.

Pylyshyn, Z. W. (1973). What the mind's eye tells the mind's brain: a critique of mental imagery. *Psychological Bulletin*, **80**, 1–24.

Raven, J. (1978). Standard Progressive Matrices (Revised Manual) N.F.E.R., Slough.

Richardson, J. T. (1980). "Mental Imagery and Human Memory", MacMillan Press Ltd, London.

Richer, J. (1978). The partial non-communication of culture to autistic children — an application of human ethology. *In* "Autism. A Reappraisal of Concepts and Treatment", (M. Rutter and E. Schopler, eds). Plenum, New York.

Rouma, G. (1913). Le langage graphique de l'enfant. Misch et Thron, Bruxelles.

Runyon, R. and Haber, A. (1967). "Fundamentals of Behavioural Statistics", Addison-Wesley Publishing Company, London.

Rutter, M. and Schopler, E. (eds) (1978). Autism — A Reappraisal of Concepts and Treatment. Plenum, New York.

Rutter, M. (1978). Diagnosis and Definitions. *In* "Autism — A Reappraisal of Concepts and Treatment", (M. Rutter and E. Schopler, eds). Plenum, New York.

Schuyten, M. (1901). Early drawing as a contribution to child analysis. *Paedologisch Jaarboek*, **2**, 112–126.

Selfe, L. (1977). Nadia — A Case of Extraordinary Drawing Ability in an Autistic Child", Academic Press, London and New York.

Selfe, L. (1980). A review of current theories in psychology of children's drawings. *British Journal of Aesthetics*, **20** (2), 160–164.

Senden, M. von (1932). Raum und Gestalt Auffassung bei operierten Blindgeborenen vor und nach der Operation. Barth, Leipsig.

Sheehan, P. W. (1978). Mental Imagery. *In* "Psychology Survey I." (B. Foss, ed.), Allen and Unwin, London.

Siegel, S. (1956). "Non-Parametric Statistics", McGraw-Hill, New York.

Siipola, E. and Hayden, S. (1965). Exploring eidetic imagery among the retarded. "Perceptual and Motor Skills", **21**, 275–286.

Spitz, H. H. and Borland, M. D. (1971). Redundancy in line drawing of familiar objects: effects of age and intelligence. *Cognitive Psychology*, **2**, 196–250.

Stotijn-Egge, S. (1952). Investigation of the drawing ability of low grade subnormals. Luctor et Emergo, 158, 172, Leiden.

Terman, L. M. (1916). The Measurement of Intelligence. Houghton Mifflin, Boston.

Terman, L. M. and Merrill, B. (1961). Stanford-Binet Intelligence Scale. Harrap & Co. London.

Tough, J. (1975). Listening to Children Talking. Ward Locke Educational, London.

Tough, J. (1978). The Development of Meaning: A Study of Children's Use of Language. Ward Locke Educ., London.

Townsend, E. (1951). A study of copying ability in children. *Genet. Psychol. Monographs*, **43**, 3–51.

Wechsler, D. (1977). Intelligence Scale for Children (Revised) The Psychological Corporation, New York.

Willats, J. (1977). How children learn to draw realistic pictures. *Quarterly Journal of Experimental Psychology*, **29**, 367–382.

Wing, L. (1976). "Early Childhood Autism — Clinical Educational and Social Aspects (2nd ed)", Pergamon Press, Oxford.

Witkin, R. (1974). "The Intelligence of Feeling", Heinemann Educational, London.

Wittgenstein, L. (1953). "Philosophical Investigations", Blackwell & Mott Ltd, Oxford.

Whorf, B. (1956). Language, Thought & Reality. ed. by (J. Carroll, ed.). John Wiley, New York.

Wolff, W. (1946). "The Personality of the Preschool Child", Grune & Stratton, New York.

Wollheim, R. (1977). The philosophical contribution to psychology. *In* "The Child's Representation of the World, (G. Butterworth, ed.). Plenum, New York.

Wood, H. (1967). The Development of Children from Birth to Six Years of Age: A Collection of 18 Developmental Tests. University of Nottingham (unpublished M.A. thesis).

# Index

Air-gap stereotype, 81
Art education, 9, 202
Autism, 1, 7, 88, 91, 159, 160, 165, 168, 170–187, 190, 197–198, 201
  autistic savant, 7, 90
  symptoms of autism, 154–162, 159, 189
  theories of autism, 161

Behaviourist psychology, 10, 16–17
Body-part ratios, 48–57

Canonical representations, 31, 33, 57, 68, 179, 188–189, 202
Case histories, 139–140
Central vanishing point (*see also* Linear Perspective), 37, 38, 42
Cerebral lateralization, 3, 191
Computational complexity in drawing, 75
Conceptual thinking, 3, 85–87, 200–201
Copying, 6, 166
Cross-modal tasks, 197–198
  auditory/temporal cues, 197
  modes of thinking, 161
  transposition between modes, 161, 198
  visual/spatial mode, 197–198
Cultural differences in drawing, 10, 28, 38, 201

Dimensions in childrens drawings, 6, 46, 57–61, 78–87, 188
Diminishing size with distance, 6, 46, 62–68, 78–87, 188
Discursive thought, 191–192, 200
Draw-a-man test, 1, 19, 88, 163, 201
Drawing devices, 38, 39, 47, 78–87
  drawing systems, 41

Drawing behaviour and development in the anomalous group, 163–169
  doodling, 164, 169
  earliest representations, 164–167
  early representational drawing, 165–167
  other art materials, 168
  recent drawing behaviour, 167–168
Dualism, 15, 18–19, 24–29, 194–195
Dual-coding hypothesis, 190–195, 197, 201

Eidetic imagery, 3, 173–186, 196–197
Emotional aspects in drawing, 9, 10, 11, 22–23, 31, 202
Empiricism in psychology, 9, 12, 16–18
Eye-hand co-ordination (*see also* Manual Dexterity), 90, 164

Fine motor development in the anomalous group, 3, 90, 142–144, 165
Formalized drawing, 13

General development of anomalous group, 140–142
Gestalt approaches, 11, 19–22
Giftedness, 6, 87, 89
Goodnow's analysis of drawing, 22, 34–35, 199
  sequencing, 35
  space, 34
  units, 34, 199
Graphic motor schemas, 33
Gross motor development of anomalous group, 3, 142–144

Head–trunk ratios (*see also* Proportions in Children's Drawings), 48–57

Hidden line elimination (*see* Occlusion)

Iconic imagery, 197

Illusion effects, 42

Imagery, (*see* Visual Imagery, Eidetic Imagery)

Imagery retrieval before perception, 195

Imaginal and verbal processes (*see also* Dual Coding Hypothesis), 190–198

Implicit assumptions, 18

Intellectual deficits (*see* Learning Difficulties and Retarded Children)

Intellectual realism in drawing, 11, 33, 78

Interactionist approaches, 24–29

Invariants of structure, 25–29

Language development (*see also* Tough's Analysis of Language Usage), 3, 7, 189

Language development of the anomalous group, 147–155, 158–159, 201
  babbling, 147
  echolalia, 147, 160, 172
  fluency and flexibility of language usage, 153
  holophrases, 147, 148
  imitation, 148
  pronominal reversal, 160
  single-word utterances, 147

Learning difficulties (*see also* Retarded Children), 7, 45, 46, 56, 82–90, 157, 162, 177–179, 186–187, 188–190, 198–203

Manual dexterity (*see also* Eye-hand Co-ordination), 3, 164

Mental imagery (*see also* Visual Imagery, Eidetic Imagery), 12, 14, 15, 18, 34, 190–191

Motor control (*see* Manual Dexterity, Eye-hand Co-ordination)

Motivational aspects of drawing, 9, 17

Nadia, 1, 16, 92, 96, 148, 151, 152, 156, 165, 172, 176, 178, 203

Negative space, 28, 84

Neurological impairment, 160

Occlusion, 3, 27, 39, 46, 68–77, 78–87, 188, 201
  Clark's hat-pin task, 68–70
  enclosure, 69–77
  hidden line elimination, 3, 36, 37, 39, 68–77, 78–87
  interposition, 69–77
  segregation, 69–77

Optic array, 25–29, 85, 86, 186

Ordering and planning (*see also* Planning Strategies), 17

Perspective, 6, 27, 31–87, 166, 169, 201
  artificial perspective, (*see also* Linear Perspective), 27, 31
  linear perspective, 6, 31–87, 166, 169, 201
  oblique projection, 40, 43
  orthographic projection, 39, 40, 43
  natural perspective, 27, 42, 81

Photographic realism, 3, 5, 6, 31, 78, 84–87, 166, 188, 190, 198–199

Planes of arrangement, 36, 81–82

Planning strategies in drawing (*see also* Ordering and planning), 17, 32, 86

Pin-hole camera, 31, 42

Pre-schematic stage in drawing, 11, 35

Presentational forms, 192, 199

Primacy and recency effects in drawing, 35

Proportions in drawing, 6, 46, 47–57, 78–87, 166, 169, 188, 201

Propositional knowledge, 194

Psychoanalytical models, 9

Quasi-pictorial images (*see also* Visual Imagery), 193, 196

Relational responding, 17–18

Representation of depth in drawing, 30–87

Representation *vs* imitation in drawing, 19–20

Retarded children, 5, 45, 46, 56, 82–87, 88–90, 157, 160, 162, 177–179, 186–190, 198–203
Retardation (see Learning Difficulties, Retarded Children)
Retardation and drawing ability, 88–90
Retinal image, 20, 25, 28, 44
Right angles in drawing, 58, 61

Scale of the representation of photographic realism, 78–84
Schematic stage in drawing, 11, 36
Sensory motor activity, 14–16
Serial order effects in memory, 17
Sex differences, 47–87
Size constancy, 44
Size scaling, 62–63, 79
Social development of the anomalous group, 145–147
Standardized tests of intellectual functioning, 170–187
  Benton Visual Retention Test, 90, 92, 173–178
  British Abilities Scale, 90, 92, 173–178
  Haber's Test for eidetic imagery, 92, 173–186
  Illinois Test of Psycholinguistic abilities, 90, 92, 173–178
  short-term auditory memory test, 177

Wechsler Intelligence Scale for Children, 92, 173, 199
  visual recall test, 177–178
Structural equivalents, 21, 34, 85, 168, 199
Symbolic realism in drawing, 75–76
Symbolization in thinking, 3, 23, 28, 85–87, 188–203
Synthetic incapacity, 11

Tadpole stage of drawing, 19, 163
Tough's analysis of language usage, 91, 149–154
  directing, 149, 151
  imagining, 150, 153
  predicting, 150, 152
  projecting, 150, 153
  reporting on present and past experiences, 150
  self-maintaining, 149, 151
  towards logical reasoning, 150, 152

Visual abilities of the anomalous group, 144–145, 186
Visual imagery (see also Mental Imagery, Eidetic Imagery), 186–187, 190–202
Visual imagery and drawing, 199–202
Visual realism, 11, 15, 29, 33, 36